MIDDLE-EARTH LANDSCAPES

LANDSCAPES

LOCATIONS IN *THE LORD OF THE RINGS* AND *THE HOBBIT* FILM TRILOGIES

MIDDLE-EARTH LANDSCAPES

LOCATIONS IN *THE LORD OF THE RINGS* AND *THE HOBBIT* FILM TRILOGIES

IAN BRODIE

FOREWORD BY PETER JACKSON

HarperCollins*Publishers*

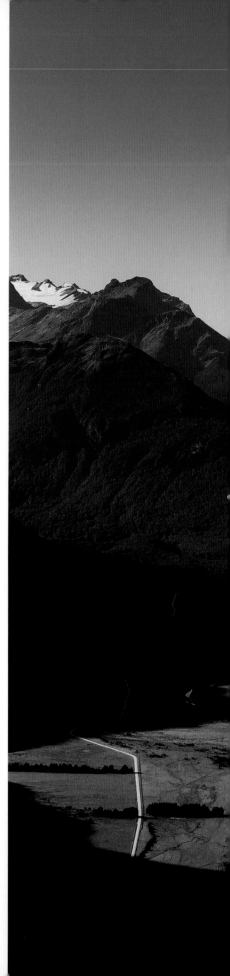

HarperCollins*Publishers*
1 London Bridge Street,
London SE1 9GF

First published in Great Britain by
HarperCollins*Publishers* 2016
1

First published as *Middle-earth New Zealand* by
HarperCollins*Publishers* (New Zealand) Limited 2015

Photographs: Dianne Brodie: page 37; Ian Brodie: pages
5, 6, 8, 12 (both), 13 (both), 16, 19, 20, 24, 30, 32–33,
36, 38 (both), 39, 49, 54 (top left, top right, bottom left,
bottom right); 55 (all), 56–57, 58, 60–61, 62–63, 64, 65
(both), 66, 68–69, 70, 71, 72, 74, 76, 78 (top), 79 (both), 80
(both), 84–85, 86 (top), 87, 88 (bottom), 90, 93, 97, 98–99,
100, 101, 102, 104, 108 (top and bottom), 110, 114–15, 116,
117, 118, 122 (both), 124, 126, 128 (both), 130, 131, 132,
134, 136 (both), 138, 140, 141 (bottom), 142, 144, 145, 146,
148, 149, 150, 152, 154, 155, 157, 158–59, 160, 162 (both),
163, 164, 166, 167, 168, 170, 171 (both), 172, 173, 174, 175
(both), 176, 178, 179, 180, 182, 184, 185, 186, 188 (top and
bottom), 189, 190, 191, 192–93, 194 (bottom), 195 (both),
196, 197, 198, 199, 200, 202, 204 (both); Ian Brodie/RST:
page 54 (middle left); Chris Coad/New Line Productions:
page 10; Alan Lee: page 27 (both); Mangaweka
Adventure Company (MAC): page 86 (bottom); New
Line Productions: pages 78 (bottom), 139, 156 (top), 201
(bottom); Pierre Vinet/New Line Productions: pages 22
(both), 28 (all), 88 (top), 89, 96 (both), 112 (both), 113, 141
(top), 156 (bottom), 194 (top), 201 (top); Warner Bros.
Pictures: pages 14, 34, 40, 42–43 (all), 44, 47, 48, 50, 52, 53
(top and bottom), 82, 106, 109, 120–21; Weta Cave: pages
54 (middle right), 94.

A catalogue record for this book is available from the
British Library

ISBN 978 0 00 811614 9

Front and back cover images by Ian Brodie
Cover design by Dominic Forbes
Internal design by Hazel Lam
Layout by IslandBridge
Colour reproduction by Graphic Print Group, Adelaide
Printed and bound in China by RR Donnelley

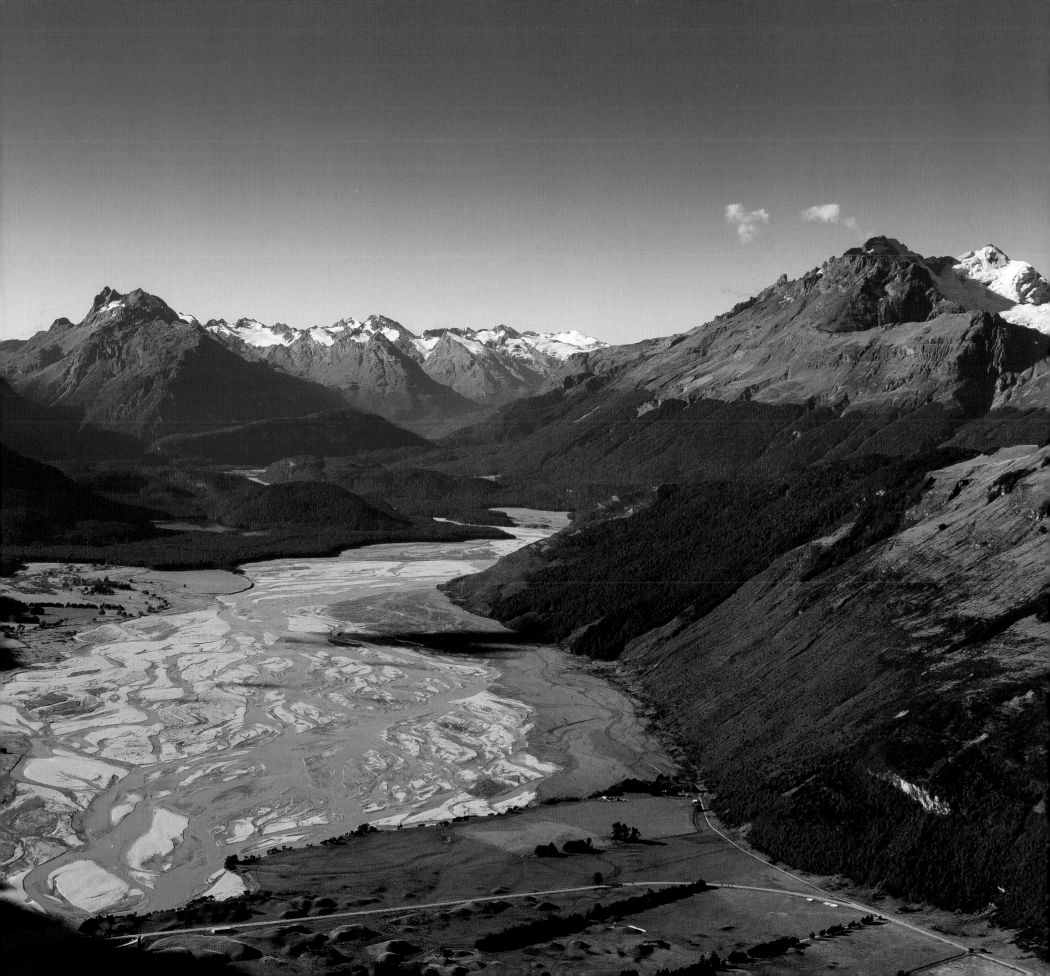

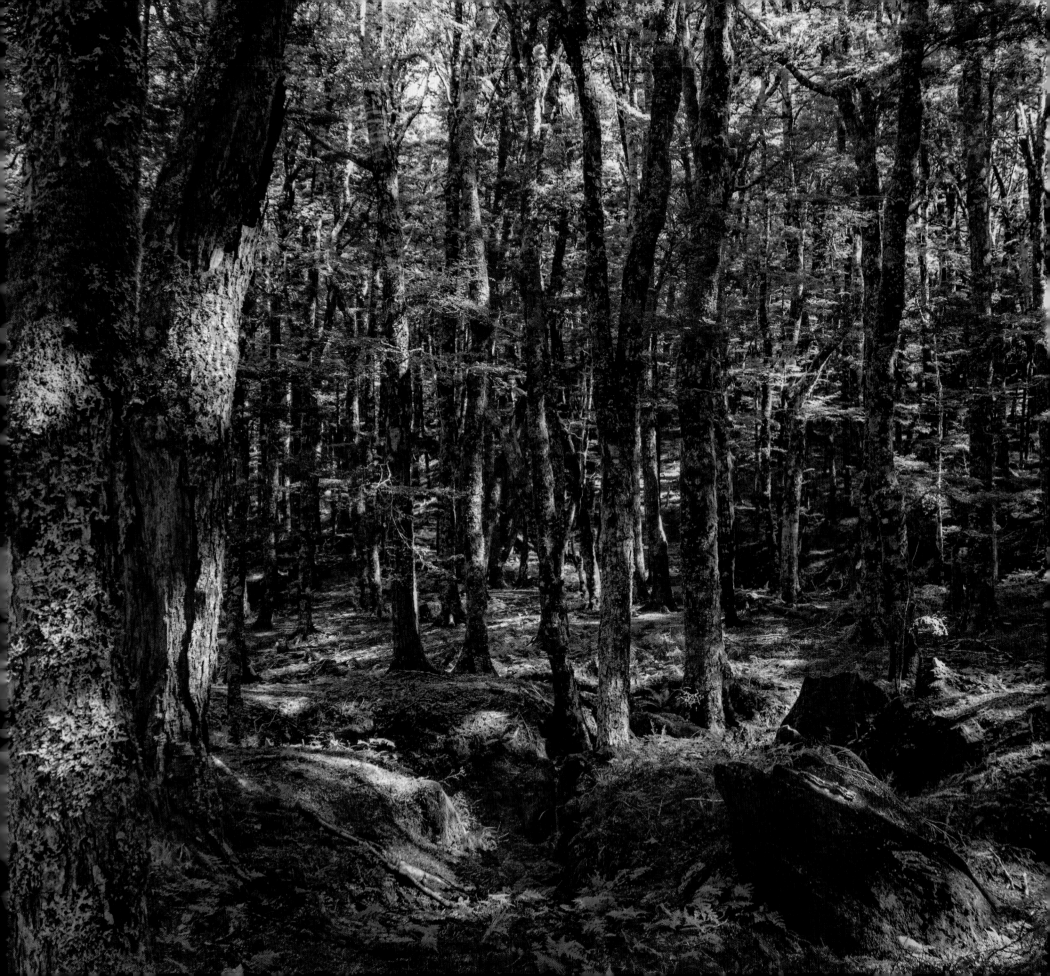

ACKNOWLEDGEMENTS

This book has only been possible through the help and support of many people and organisations. Special thanks to Sir Peter Jackson for his foreword and piece on the location-hunting process. I'd also like to thank Chris Winitana for his superb introduction, as well as Sir Richard Taylor, Alan Lee, Barrie M Osborne, John Howe, Andy Serkis and Dan Hennah for their contributions.

Thanks to Andy Serkis, Viggo Mortensen, Jan Blenkin, Erin O'Donnell, Heather Paterson, Melissa Booth, Robin Murphy and all the other members of the *Lord of the Rings* cast and crew who provided many useful suggestions. Special thanks are also due to Barrie M Osborne and Fran Walsh. Thank you to all of the team at 3 Foot 7 for providing the answers to my many questions, and allowing me to interview them. Thanks to Judy Alley for organising and helping me with these, Claire Raskind, without whose original support and enthusiasm nothing would have eventuated, and Jared Connon and Dave Comer for their assistance. Susannah Scott, Jill Benscoter and Victoria Selover at Warner Bros. worked tirelessly to provide me with imagery and final approvals for the *Hobbit* locations.

So many helped me on my journey throughout New Zealand, and to all of you — thank you. In particular, those Regional Tourism Organisations, hotels and attractions who assisted and advised, and to Jane Dent and Anita Bhatnagar from Tourism New Zealand, a very special thanks for all your invaluable assistance. Pat West, Alfie Speight, Gerry Conlan and Peter Bell from Glacier Southern Lakes Helicopters provided so much — including belief. And thanks to Toby and Rachel Reid at Reid Helicopters, Nelson, and Mark Hayes at Heliworks. Thanks to Warwick and Suzie Denize, Lisa Bankshaw, Mike Stearne, Nicole Andrews, Rita Davies, Janet Morgan, the Chartres family, Brent and Anna Gillespie, Tina Hocevar, Russell Poppe, Hamish Saxton and Lynette Deans.

I'd like to acknowledge the help and support of David Brawn from HarperCollins*Publishers*, and thanks to the team past and present — Tony Fisk, Graham Mitchell, Eva Chan, Arian Vitali, Natasha Hughes, Finlay Macdonald and Shona Martyn.

This book, which is the culmination of the work begun with *The Lord of the Rings Location Guidebook* and *The Hobbit Motion Picture Trilogy Location Guidebook*, owes much to both Lorain Day and Graeme Leather and, as always, is dedicated to my family: Dianne, Travis, Belinda and Oliver, Sally-Anne and Matthew — and, of course, to JRR Tolkien.

Ian Brodie

FOREWORD

The beauty of the New Zealand landscape has always sparked my imagination. When I was 10 years old, Mum and Dad took me down to the Nelson/Golden Bay area for the summer holidays. We had a picnic lunch at Pelorus Bridge, and the beautiful river with its crystal-clear green water, flowing through the rocky gorge, made an indelible impression. I had fallen in love with the wonderful fantasy films of Ray Harryhausen, and thought it would be the perfect home for the Cyclops or Hydra.

Eventually, that 10-year-old grew up, and got to make *The Lord of the Rings*. In the years since, the New Zealand landscape has come to represent *Middle-earth* in the imagination of millions of viewers all over the world. I understand why this has happened — when you make a movie, some locations become indelibly linked in the mind's eye with the visual world you are trying to create. For me, *Bag End*, *The Green Dragon*, *Bilbo's Party Tree* and *The Mill* at *Bywater* were inextricably nestled within the lee of a hill on a farm in Matamata.

Making the *Hobbit* films was as much about reconnecting with some of those beloved locations as it was about discovering new ones. The three new films required many different landscapes to the ones we had explored earlier in *The Lord of the Rings*, and each had to unfold in previously unseen parts of *Middle-earth*. So 10 years on from the first trilogy, I found myself once again seated in a chopper with our wonderful locations wizards, Jared Connon and Dave Comer, setting out to search for such mythic settings as *Trollshaws*, *Long Lakes* and *Carrocks*. New Zealand's infinite capacity for surprise didn't let us down.

When we discussed the sequence that sees the dwarves and one unexpectedly adventurous hobbit escaping from the *Woodland Realm* by floating down the river in barrels, I was able to say I knew the perfect location — the Pelorus River had remained vividly etched in my mind.

So thank you, Joan and Bill Jackson. Who would have known that picnic from 40 summers ago would have such a lasting impact?

Sir Peter Jackson

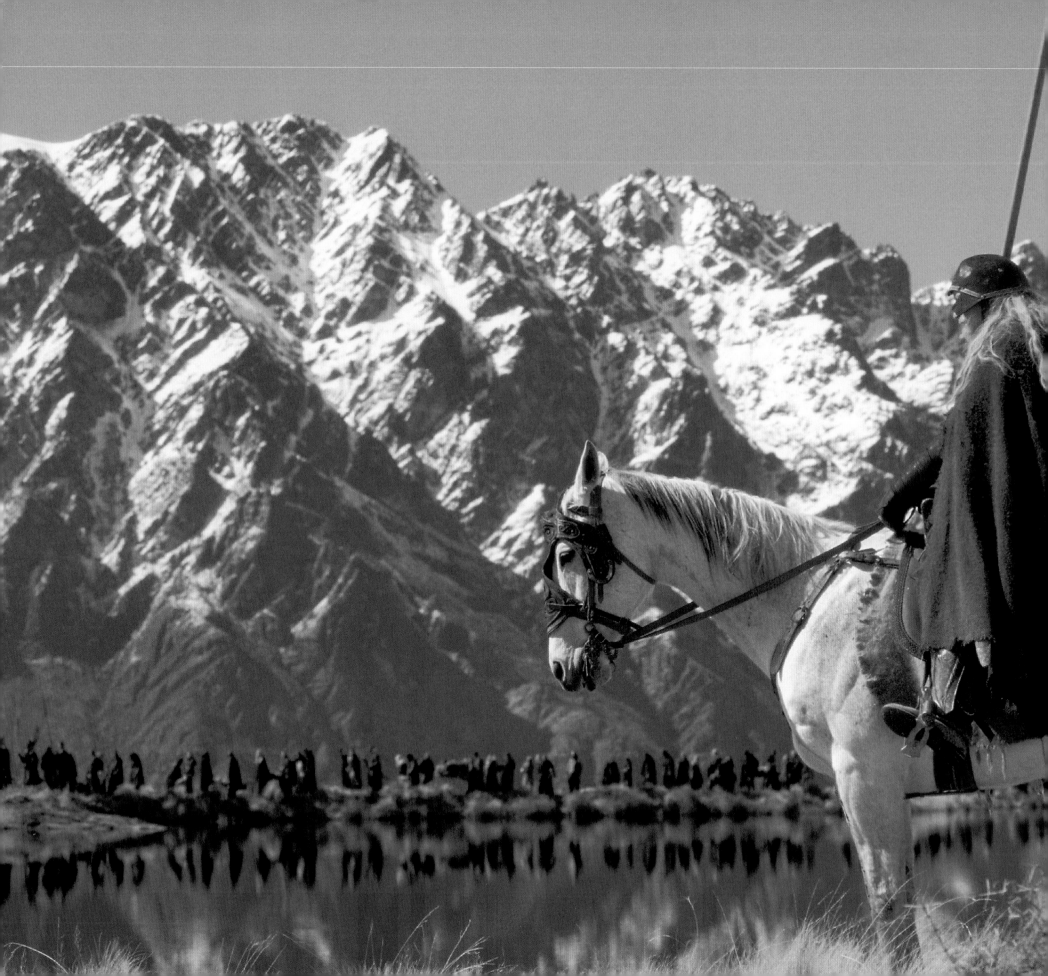

CONTENTS

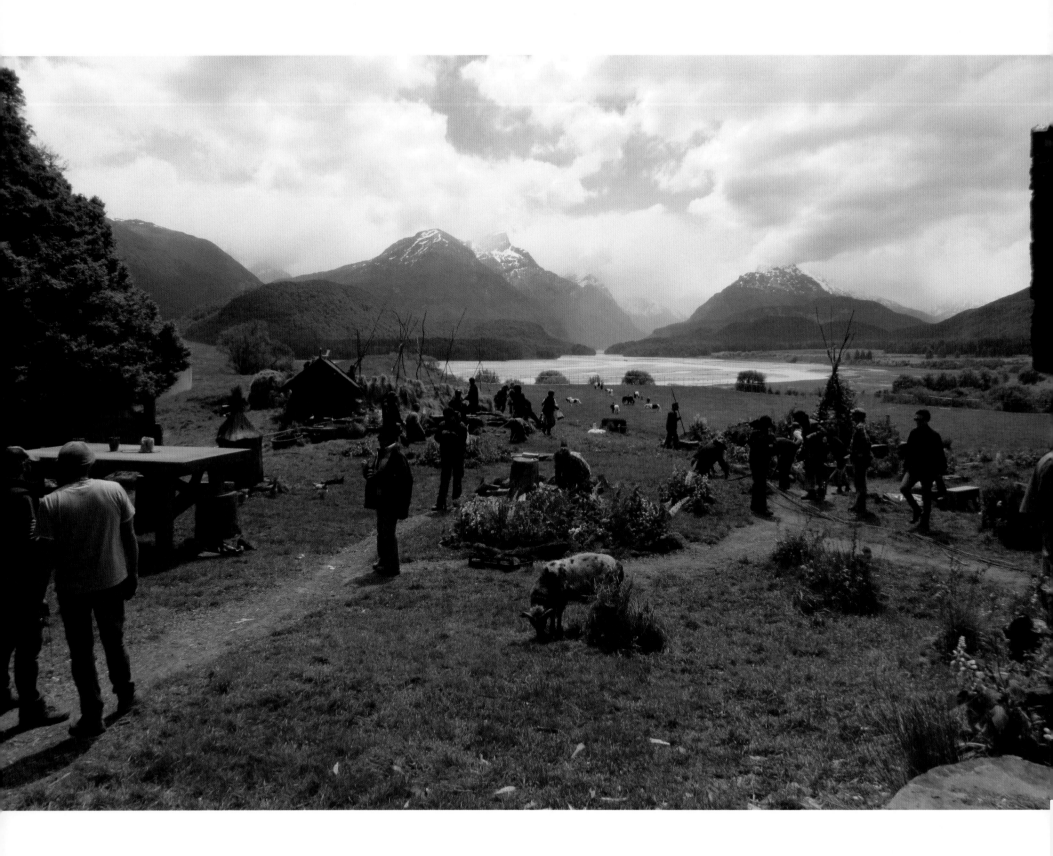

INTRODUCTION

The varied landscapes of New Zealand have captured my imagination for as long as I can remember. I still vividly recall holidays in Rotorua, an excited eight-year-old exploring the native bush and tall redwood trees of Hamurana. We often visited relatives in Palmerston North and I revelled in the journey, especially from Taupo where the mountains of Tongariro National Park beckoned like a *Lonely Mountain* or an ashen peak of *Mordor*. My imagination ran wild through the gorges of the Rangitikei as the cliffs frowned down on the mighty river below. It might have been a fantastical world that I gazed upon but it was incomplete.

Browsing in a record store in 1972, I spied an album cover featuring a beautiful illustration that featured a ring being held in the palm of a hand with a fantastical landscape receding into the distance. My curiosity was piqued. I had never heard of Swedish artist Bo Hansson or the book that had inspired this haunting music. The music continued to play in my mind and the following year I was introduced to the final two pieces of a jigsaw that would shape my life. We went on holiday to the South Island of New Zealand and I purchased a very weighty tome by JRR Tolkien.

The landscape, the book, the music all melded together and as I stood on the shores of Lake Wakatipu I realised I was standing in *Middle-earth*. It was real and I was part of it. It's now 40 years on from that moment, but that emotive feeling hasn't faded and the landscapes of my country still call out to me with their wildness, their simple untouched beauty.

I consider myself very fortunate. Travel and photography have been part of my life, have shaped my essence and have allowed me to be part of a phenomenon that 15 years ago I would never have imagined.

This book is the culmination of that journey.

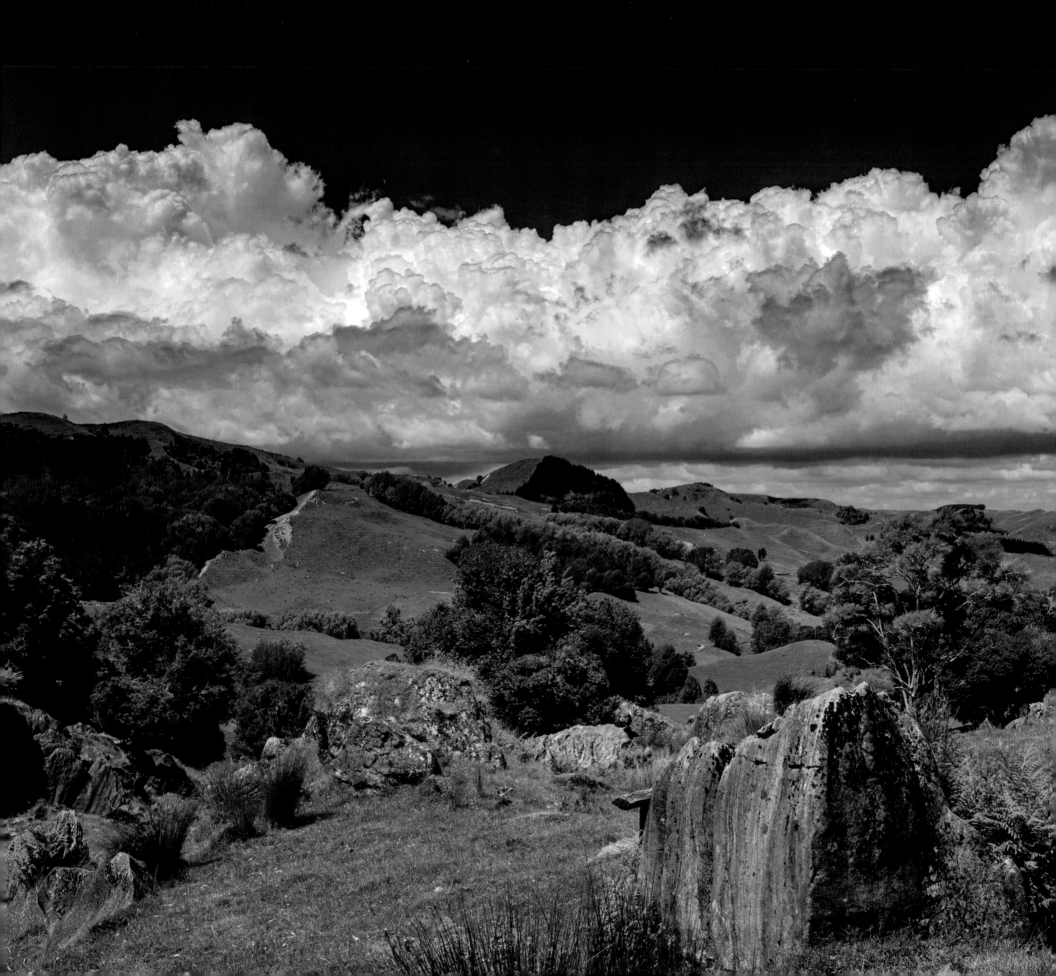

AN INTRODUCTION TO NEW ZEALAND MYTHOLOGY

Before the beginning there alone was Io, Io-the-parentless, Io-the-endless, Io-the-timeless, Io-without-limit.

He moved and the Great Nothingness was born. In the spiralling currents it followed itself and searched. It found heart and became ignited. It thought as does a mind. And desired as does a dream. It took form and breathed. And in a second that was a million years, it multiplied and grew. To become a shadow. A darkness. A night. A night of gestation. A night for bearing the Ancients.

There was Ranginui, the virile male, sky-bound and active. There was Papatuanuku, the female, land-bound and passive. They breathed together as lovers and in the Night-that-knows-no-end there were born to them 70 mighty sons. There was Whiro-the-dominant, whose wrath was as an axe upon the tree, and Tawhiri-of-the-elements, whose breath was the wind itself. There was Tangaroa-of-the-seas, whose ceaseless waves would chisel away the land. There was Tu-of-the-red-face, by whose hand mankind would know war, and Turongo-the-gentle, who would lay down the foundations of peace. There was Haumia-the-abundant, who was lord over the fruits of the earth, and Ruaumoko-the-lastborn, whose one tiny movement would cause the earth herself to quake and tremor. And there was Tane-the-thoughtful, whose actions and deeds would produce the world and all its parts.

It was Tane who separated their parents to produce the sky above and the land below. And when his grieving parents' tears filled the world, he turned his mother over to stop Ranginui from having to look upon her face and be reminded of their separation.

Tane brought light to the world by placing the stars in the sky, the sun at its zenith and the moon lower down on his father's head. He built the first house of nobility and it remains to this day the blueprint from which all homes are templated. He filled it with the knowledge of the gods, which he retrieved from the summit of the heavens at the instruction of Io-the-creator himself. He produced the trees, the birds, the insects and fish to clothe and adorn his mother, the earth. Finally, he created the first human, a woman from whom all peoples are descended. The world of eternal light where all beings were kin, no matter who or what, was born.

Many times did summer and winter struggle in rivalry before Maui-of-the-topknot, half-man, half-god, was gifted to the world. Raised by his priestly elder, Tamanui, he was shown the secrets of the universe; the kinship that existed between all things that would allow him to take on the form of the tree, the bird, the fish, the lizard. He mastered himself and returned to his family ready to conquer.

With a fearless heart he secured the magic jawbone of knowledge of his ancestress Murirangawhenua. And with it he caught and slowed down the sun, which sped across the heavens at will with little thought for the activities of man. He made fire available to people by forcing the very last flame of the Keeper-of-the-fires, Mahuika, to become imbued into the heartwood of a tree. He visited the spirit world to find his father and before his death at the hands of the Goddess-of-death, Hine-nui-te-po, he fished up these sacred isles.

Using the sacred jawbone as a hook, Maui-the-relentless hauled up his great fish from the depths of Te Moananui a Kiwa, the Pacific Ocean. But as he paid homage to the gods for having given him such a wondrous gift, with greed in their eyes and lies on their tongues his four brothers took to the fish with knives. In its death throes it became torn and shredded with gullies and gorges, hills and mountains. In time, the stingray-like fish became the North Island of New Zealand while the canoe of Maui became the South Island.

The head of the fish is at our capital city, Wellington. The ridge of mountain ranges that run down the centre of the island is its backbone. To the east coast and west to Taranaki can be seen its fins. The stomach is Lake Taupo while the heart is at Maunga Pohatu in the Urewera. Northland is the whipping tail of the stingray. From tip to tip, fish to canoe, can be seen the extremities of this once virgin land.

And many centuries ago, when the voyager Kupe with his family and wife came upon these islands shrouded in mist and cloud, they named them Aotearoa, land of the long white cloud.

Chris Winitana

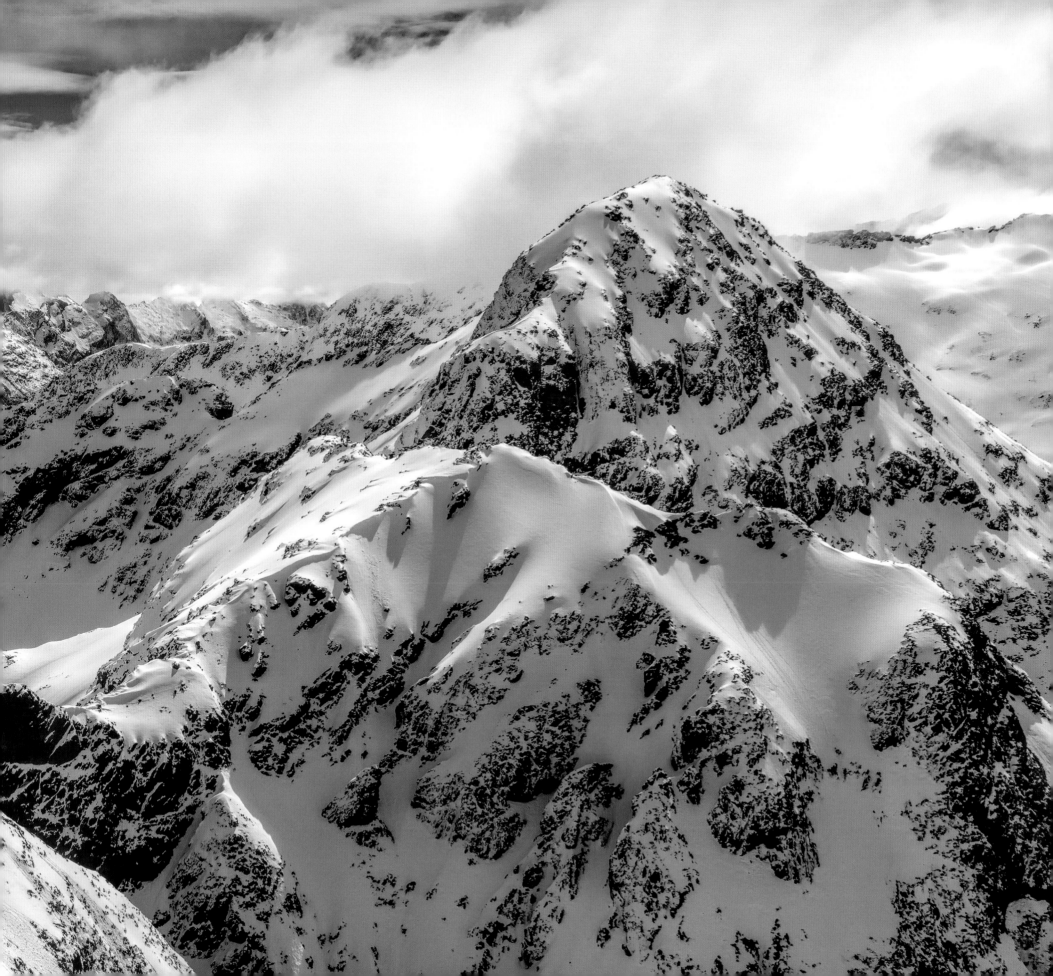

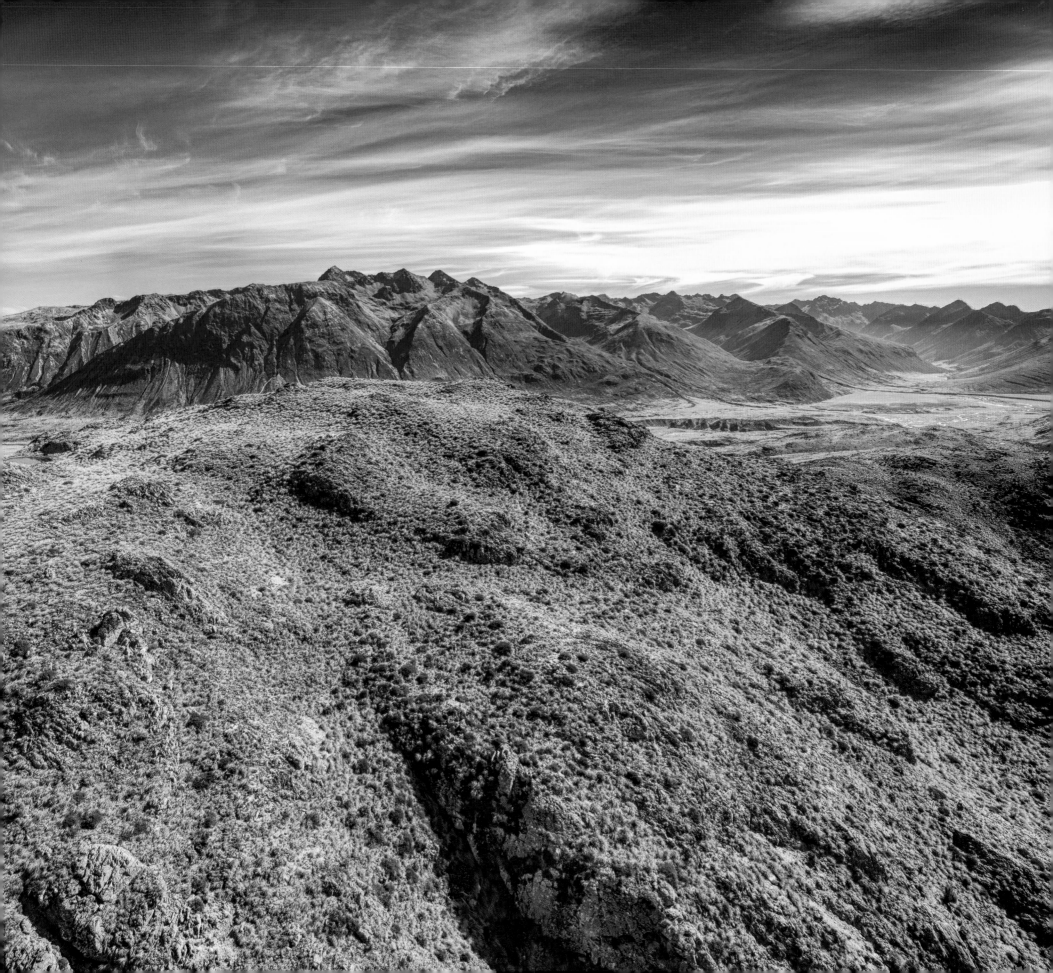

THE LOCATION-HUNTING PROCESS

The way the location process works is that generally a location scout goes out in advance and canvasses the whole country. We made up a list of what we needed, which obviously came from the books, because Tolkien describes the locations very vividly.

Dave Comer, Robin Murphy, Jared Connon and various other people scoured New Zealand and sent me photos and videos. It was almost like casting for an actor, with somebody doing the initial sweep — then when we'd narrowed down the choices, we'd go out for a recce.

A team including myself, the Director of Photography, the First Assistant Director and a whole slew of technical support people would look at the landscape, first of all from an artistic point of view. Was it suitable and did it feel as if it came from Tolkien's *Middle-earth*? Then we looked at it from a logistical point of view — because the next consideration is always where do we park the trucks? And where do we feed the crew? Is there a road in here? Sometimes there wasn't, but that didn't necessarily stop us!

My favourite locations were the helicopter-access-only ones. Norwest Lakes near Te Anau was my absolute favourite, where we shot some scenes from a helicopter, of the *Fellowship* heading towards *Moria*. Just landing there and walking around is fantastic — it's an amazingly stunning place.

Another place I loved was Poolburn, in Central Otago. We were looking for *Rohan*, which Tolkien describes as grass as far as the eye can see. We don't really have anything quite like that in New Zealand — however, near Poolburn we have an enormous space of slightly undulating hills with these really jagged rocks. They are definitely not described by Tolkien, but, nevertheless, it was a dramatic and amazing landscape. It also had a sense of scale. Whenever you can put a camera down and literally see 50 km in one direction with no power poles, no houses, no roads — it gives the film that kind of epic John Ford Western quality of tiny figures in this big landscape.

Mt Olympus and Mt Owen are also two places I would never have gone normally, because I'm not a tramper. The fact that we made these movies means I've been able to see these incredibly magical remote places, and will always be something for which I'm really grateful.

Sir Peter Jackson

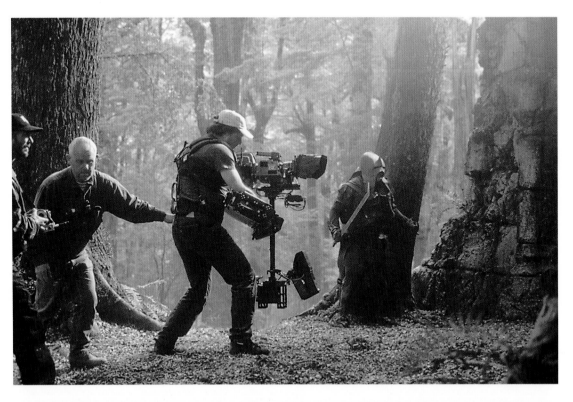

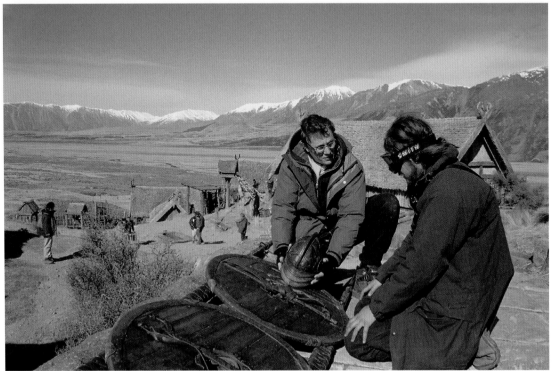

SIX FILMS, 16 YEARS

It staggers me when I stop to think that, as I write this, 16 years have passed since we first set out on our journey into *Middle-earth*. The incredible people whom we have met, the places around the world that this project has taken us, and the warmth and friendship that so many fans and enthusiasts from across the planet have shared with us are things I could never have imagined when we began. The reaction to Peter Jackson's films has made the experience of working on them all the richer. It is wonderful to hear people's reactions to the stories, the performances, the design, the costumes and the film sets, and how they might have been inspired or excited by them. But I think the moments that have stirred the greatest pride in me as a New Zealander are those times when I have witnessed people coming here from the farthest reaches of the earth, introduced to New Zealand through its starring role as *Middle-earth* in these films, and seen them fall in love with this amazing country just as we who live here have.

The making of the two trilogies has taken the cast and crew all over our small country, filming in some of the most epic and striking landscapes one could hope to find anywhere in the world. When I am overseas promoting our company [Weta Workshop] and our country I go to lengths to describe how, with a single hour's flight from the capital city of Wellington, a person can be transported to a representation of almost any environment in the world. So diverse and dramatic are the locations of New Zealand that the opportunities to film in extraordinary places with awe-inspiring natural production value are virtually inexhaustible.

It is fair to say we couldn't do a New York cop drama easily in New Zealand and we may even struggle to film *Lawrence of Arabia* in a desert that stretches to the sky (although we have some pretty mighty coastal sand dunes), but our green archipelago can offer up almost any other possible location to the film-maker hoping to work within a country that also offers extraordinary film-making services. In short, it's a great place to live and make movies.

Ian's *The Lord of the Rings* location books shared with visitors and locals alike all of the sites used in the making of the first three *Middle-earth* films. In this new publication, Ian builds upon that foundation, introducing the additional locations that were scouted, approved and utilised in the making of the *Hobbit* film trilogy. Peter said to us once, a long time ago, that his hope was for the audience to feel as if they had landed at an airport in *Middle-earth* and stepped out of the plane. There in front of them would be an extraordinary world, not steeped in a lofty and untouchable high fantasy, but possessing a tangible beauty, natural scale and exquisite realism that would make *Middle-earth* a real place and leave them longing to return when the screen turned black. It's impossible for me to imagine anywhere else in the world that could have achieved this as resoundingly as our beautiful land.

As readers open and explore the world of *Middle-earth* with Ian as their guide, I hope and fully expect that they will be transported on their own journey, and that the love for this place that we all share will be theirs as well. Welcome to our beautiful land, where fantasy and reality are one. Welcome to Aotearoa New Zealand. Welcome to *Middle-earth*.

Sir Richard Taylor

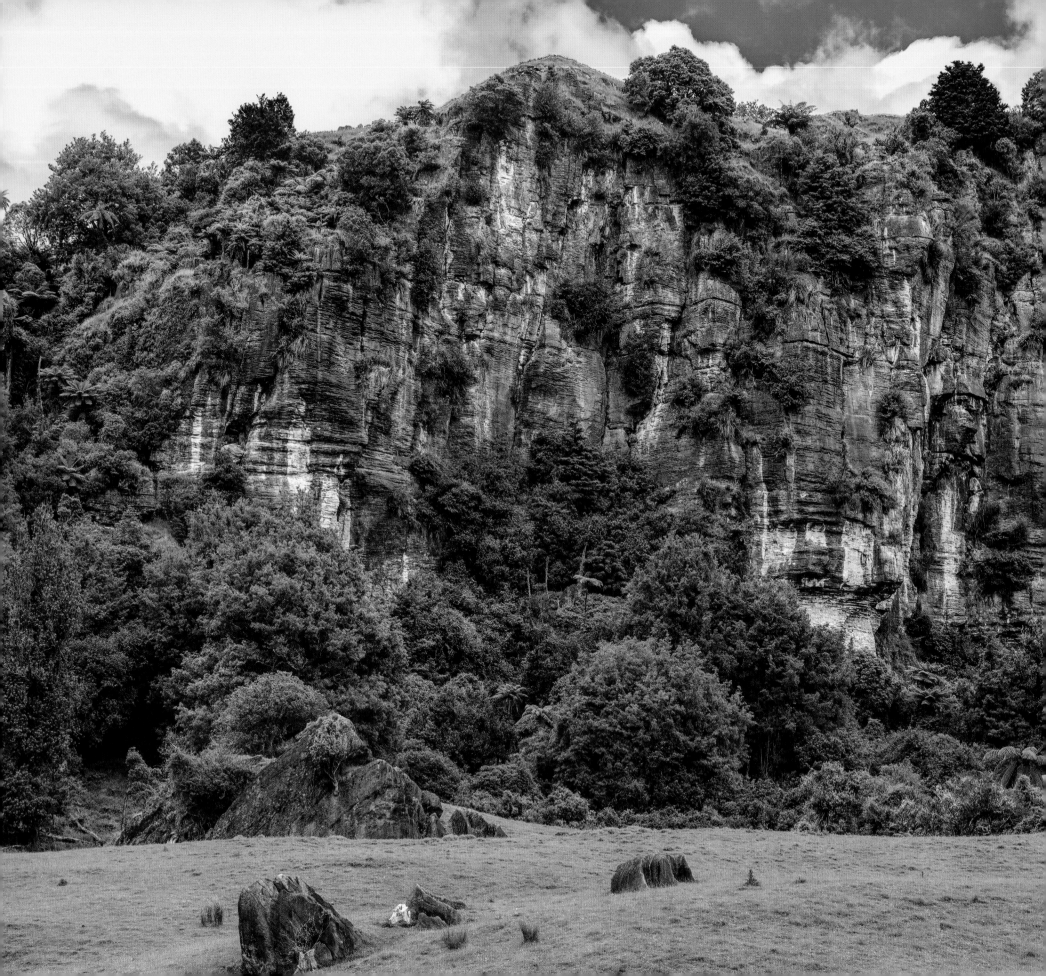

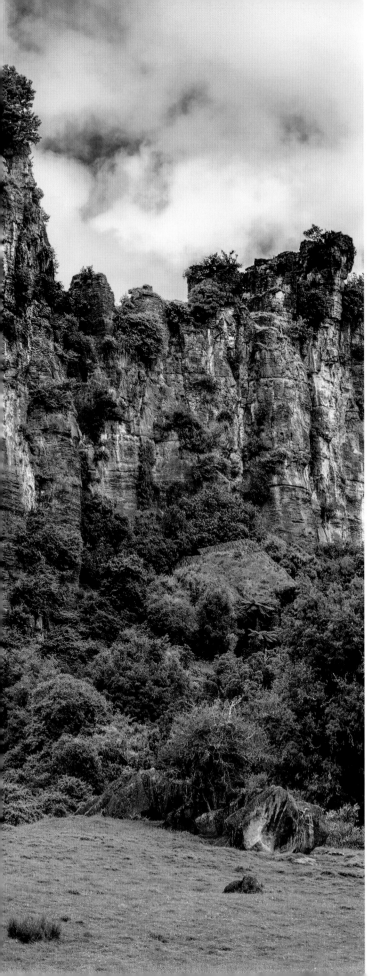

MIDDLE-EARTH IN NEW ZEALAND

The landscapes of *Middle-earth* were forged in Tolkien's imagination from a combination of memories of places he'd known and the mythical lands he encountered during his studies of ancient texts. His descriptions of the *Shire*, the *Misty Mountains* and the golden woods of *Lothlórien* are evocative enough to make these places seem tangible, but we each bring our own memories and dreams into play when we imagine them. While his love of England may have been the foundation stone of *Middle-earth*, we didn't believe we would find there, or anywhere else in Europe, a landscape that was not so steeped in its own history that it could serve as the background for his epic. As a result, I found the prospect of looking for *Middle-earth* in a country reminiscent of Europe but lacking the accumulated and overlaid evidence of thousands of years of continual habitation intriguing.

We travelled widely to far-flung parts of the country, led by our location scouts, finding a lovely location for *Hobbiton*, with hills that looked as though hobbits had already begun excavations. It had a lake with a long arm we could pass off as a river, the perfect spot for a bridge, a mill and *The Green Dragon*, a *Party Tree* and an ideal situation for *Bag End*. It only needed an ancient tree, which our Greens Department, under Brian Massey, constructed and painstakingly foliated with plastic leaves. After several months of earth moving, set building, hedge laying and gardening, the place felt as though it had been inhabited by generations of hobbits.

As we wanted a less benign and cultivated look for the countryside around *Bree* we ended up close to Wellington, where we used land owned by the military on the Miramar Peninsula for the outskirts, while the *Prancing Pony Inn* and surrounding streets were built around barracks at Fort Dorset, in Seatoun.

Mt Ruapehu was an obvious first stop in the search for *Mordor* and the site of the battle on the slopes of *Mount Doom*, with the prologue for *The Fellowship of the Ring* shot in the off-season ski field at Whakapapa. *Frodo* and *Sam* tramped back and forth over a nearby area Peter liked the look of for the *Emyn Muil* — the vast labyrinth of rocks our heroes have to find their way through on their journey to the *Black Gate*, and where they first meet *Gollum*.

The *Weathertop* scenes were shot on a station at Port Waikato, where strangely shaped limestone outcrops and disfigured trees in a green landscape wouldn't have been out of place in the background of an Hieronymus Bosch painting. We found the perfect hill for the *Ringwraiths'* attack, with the ruins of *Amon Sûl* built in a studio and the wider views established in a matte painting.

We visited Skippers Canyon several times looking for the ford where *Arwen* and *Frodo* face the *Ringwraiths*, and the digitally created flood you see in the finished movie was only slightly more impressive than the real one that swept away one of our sets after a particularly heavy rainfall! I'm always looking for interesting rock formations and textures, which I use to ensure the 'bones' of any of my pictures also have a story to tell, and so that the rocks and stones I draw don't always look the same. Skippers Canyon provided some great material, and also formed a suitably grand setting for the *Fellowship*'s journey down the *Anduin*, and for the *Argonath*.

Our search for *Rivendell* took us far and wide, but, although we found useful elements, we never found one place with everything we wanted. We eventually chose Kaitoke because of its beautiful, calm woodlands and proximity to Wellington, but its surroundings in the film are a combination of filmed elements such as waterfalls, photographs, paintings and a miniature built at Weta Workshop, long before we knew where we would be filming.

Paradise, near Glenorchy at the northern end of Lake Wakatipu, worked well for parts of *Lothlórien*, though we added larger trees, and for scenes at *Parth Galen* and *Amon Hen*. I loved the landscape around Poolburn, where many of the *Rohan* scenes were shot, with its rolling hills and dramatic granite tors reminding me of Dartmoor, although on a much grander scale. Mt Potts, near Methven, provided one of the most glorious locations, with an isolated hill in a wide valley, buttressed by sheer cliffs, which couldn't have been closer to Tolkien's *Edoras*. We built the exterior of the *Golden Hall* and surrounding buildings on top, with the gatehouse and more buildings at its foot, and everything in between was added post-production.

We were always on the lookout for wetland areas for the *Dead Marshes* between the *Emyn Muil* and the *Black Gate*. In the end all the scenes were shot on sets created by our Greens Department, with wider views shot from helicopters. Once we'd landed, we quickly realised the impracticality of filming in a place where we'd have to count the crew after each take.

I found New Zealand more than matched my hopes as a setting for *Middle-earth*. It has such a wide variety of landscapes, from lush farmland, woods and rivers to dramatic gorges, endless plains and soaring mountains uninterrupted by roads and pylons. It's a young land, primeval in places, still flexing in the aftermath of its creation. I can imagine Britain in a much earlier age, with higher peaks and the clearer light that illuminates Tolkien's pages, might have had a similar quality.

It has been a pleasure, and a privilege, to have seen so much of New Zealand's rich and beautiful landscapes with guides whose wealth of experience was matched only by their love of their country and enthusiasm for our journey.

Alan Lee

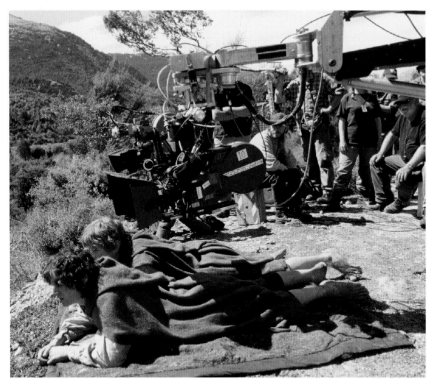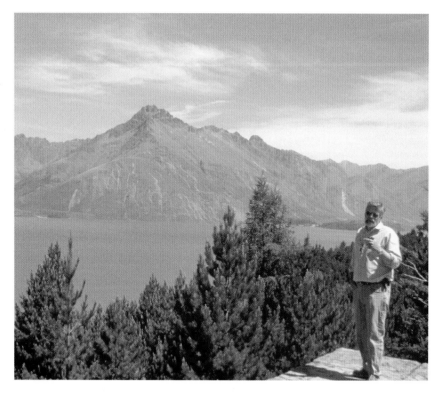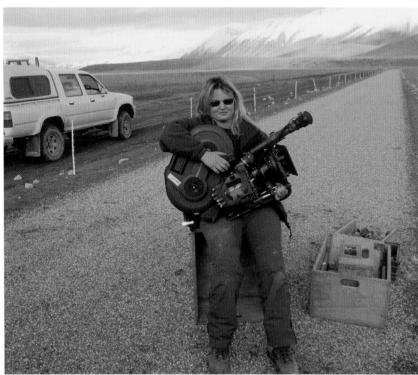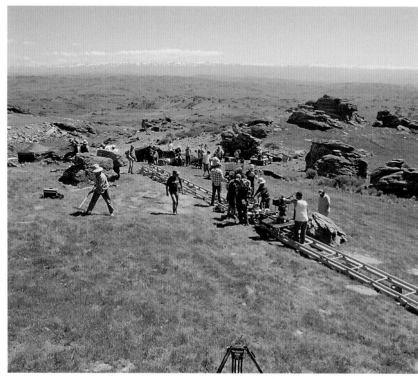

THE PRODUCER

I knew what was in store as I headed for Wellington. I'd filmed in New Zealand before and looked forward to rekindling friendships and meeting film-makers Peter Jackson and Fran Walsh to discuss the possibility of producing *The Lord of the Rings* as part of their team.

We talked over a hearty lunch, dining seaside at the Chocolate Fish Café. It was a sunny afternoon on Wellington's southern coast, with a family atmosphere — convivial and comfortable. It felt creative, cohesive and challenging. I couldn't think of a better place to mount the initial mammoth movie trilogy, *The Lord of the Rings*, nor could I imagine passing up the opportunity to work with such an innovative director as Peter Jackson.

Filming three movies at once was unprecedented at the time, an effort not to be undertaken lightly. It's hard enough to wrap one film on time, let alone three, and it's a great testament to the dedication, motivation and talent of the cast, crew and film-making team.

The landscapes of JRR Tolkien's *Middle-earth* are all here in New Zealand. We scouted locations in the North Island by car, by helicopter, on foot and by boat. We began armed with the detailed descriptive passages in Tolkien's novels, then we were guided by the illustrations produced through Peter Jackson's collaboration with conceptual artists Alan Lee and John Howe, searching for places that mirrored the unique details of their drawings. They are truly amazing.

I remember a short flight to the South Island. From the time we took off to the time we landed, Alan had sketched several illustrations showing how a proposed set would fit into the landscape. I also remember scouting *Rivendell*, walking about at Kaitoke planning how we would get our equipment into the location, figuring where sets might go and action be staged. Meanwhile, Alan and John sat quietly on a hillside producing illustrations siting the various set elements in the very landscape we were scouting.

To translate Tolkien's work from novels to screen we wanted the texture of the books to stand out as something that captured the unique land of *Middle-earth*. From the outset, Peter and I pledged to shoot in the best location rather than the easiest. Mt Potts, which is *Edoras* in *The Two Towers*, is evidence of going that extra mile. Without that commitment we might have easily, but unfortunately, shot the entire film on a back lot or a green-screen stage, instead of in the wonderful settings of New Zealand. As a film-maker, it's important to honour your financial commitment to the studio but at the same time not be blinkered by a dollar and cents mentality.

Although the bottom line is always an important factor, you equally must find the funds to shoot the essential elements of your script. On *The Lord of the Rings*, one of those elements was the breathtakingly stunning New Zealand locations. If you need to build a road to get to that isolated mountain-top at Mt Potts, you build the road. You owe it to the project to secure that raw, untouched beauty and vision on film. It certainly paid off in the appeal of the films and therefore at the box office.

No matter how specific a location Peter Jackson imagined, our locations department never came up empty-handed. There was always that isolated mountain-top, lush forest, crystal-clear lake or eerie desert just waiting to be discovered. Sometimes it felt like these remote places were just there in front of us in all their three-dimensional glory waiting to grace the camera with their natural beauty. I find it hard to believe that Alan Lee and John Howe didn't hike out to Mt Potts to sketch the illustrations for *Edoras*, or wander into Matamata to find the inspiration for *Gandalf* arriving at *Bag End*.

Barrie M Osborne

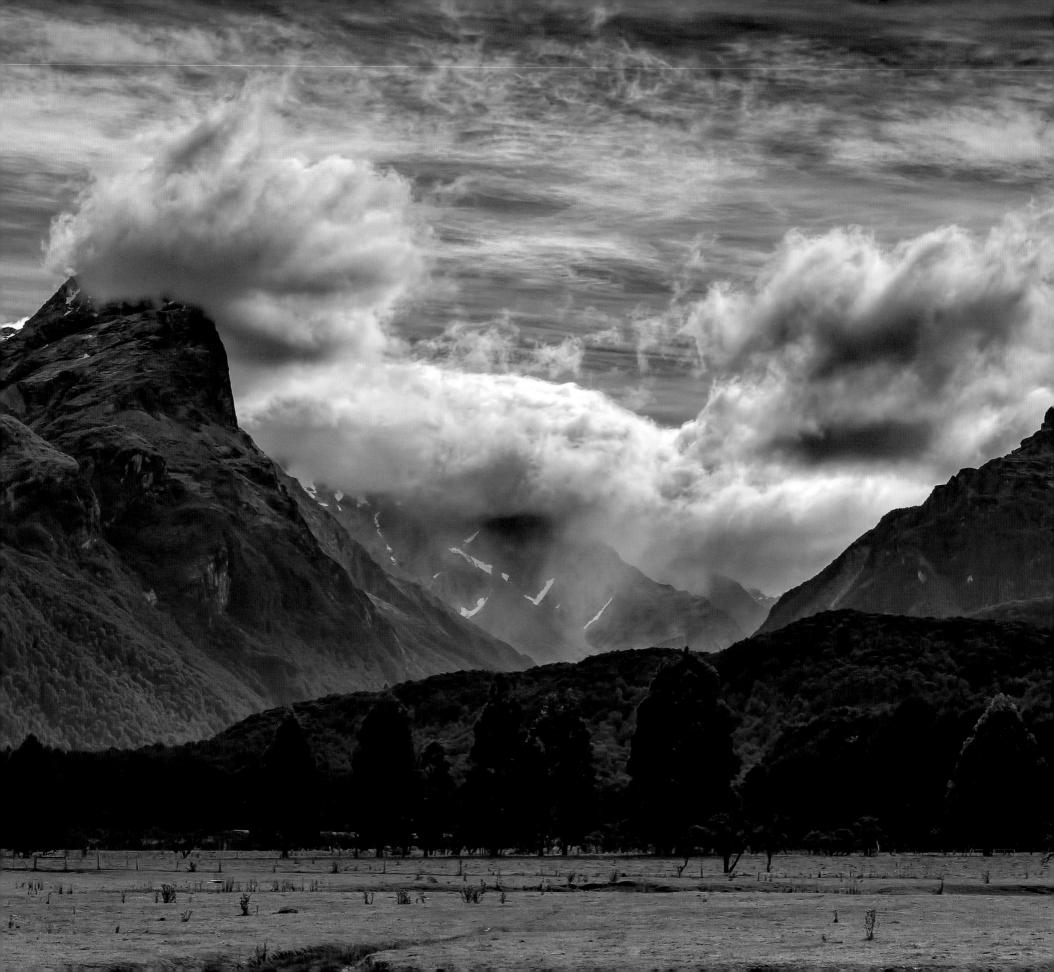

WHERE IN THE WORLD *IS* MIDDLE-EARTH?

Naturally, for any truly good question, there are several answers. The original *Middle-earth* took shape in the fertile brain and imagination of an Oxford college professor with grandchildren for whom he imagined an entertaining bedtime story. So *Middle-earth* began as a manuscript — notes, scribbled ideas and abrupt turnings — the slow process of building a story and creating an ever-widening world to set it in. For a generation, *Middle-earth* was to be found in a book, *The Hobbit*, published in 1937, with illustrations by the author.

A wider and more complex *Middle-earth*, but still purely a literary creation, followed in 1955, with the final volume of *The Lord of the Rings*. Finally, with Peter Jackson's *The Lord of the Rings* movie trilogy nearly half a century later, *Middle-earth* found a real landscape, a real land, and one at the time little known to the wider world: New Zealand. The role of the movies in the history of New Zealand's modern mythology will one day be appreciated at its worth. At no other time have two countries — a real place and a fantasy realm superimposed — emerged simultaneously before the eyes of a global audience.

Thus, today the answer to that question is definitively New Zealand. *The Lord of the Rings* movie trilogy splendidly showcased the country from north to south and firmly anchored *Middle-earth* on these antipodean shores.

Alan Lee and I made a third trip, a voyage of inspiration and imagination, drawing on New Zealand's landscape to compose many of the wider environments for *The Hobbit* — Fox River, the Rock and Pillar Range, Earnslaw Burn, the Remarkables and many more furnished the memories and the geography upon which we built *Thranduil's Realm*, the *High Fells*, the *Long Lake* and the *Lonely Mountain*, to name only a few.

I remain convinced that places people visit as part of a literary pilgrimage retain something of their respectful passage — these places are invested in the same manner they become part of us. I am certain this communion with wild places, this journey to *Wilderland*, gives us strength to preserve and the resolve to protect like places, because we are standing guard over both our natural present and our mythological past. The reverence for nature so strongly felt by JRR Tolkien is part of that mythology; it is never outdated or old-fashioned, it is here and now. It signposts our journey and should serve to remind us how precious those places have become.

New Zealand, through a fabulous and serendipitous sequence of coincidences and a few narrow escapes, is now part of *Middle-earth*. Not only is *Middle-earth* in the heart of every admirer of Tolkien's tales, now you can truly go there, to a place where the landscape allows you to superimpose your imagination, to overlay a personal vision with a real one, and to take the two, forever interwoven, away with you. The wild and beautiful places everywhere in the world can only benefit. It is also an invitation to discover the mythologies that were born here, when Maui hooked that fish and pulled it towards the surface …

Not so bad for a pair of wayward islands drifting in mid-ocean.

Welcome to *Wilderland*. Welcome to an adventure.

John Howe

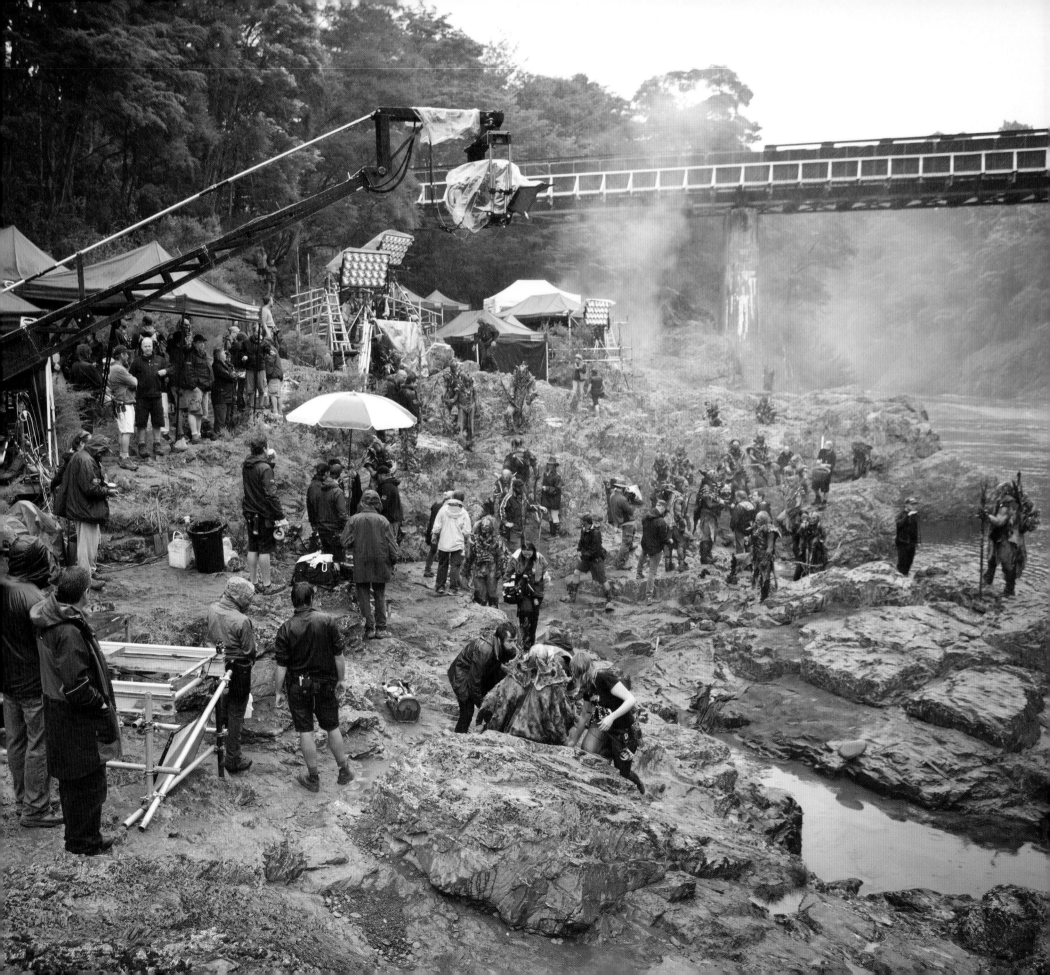

CAMERAS IN MIDDLE-EARTH

Peter Jackson loves to keep the cameras active and very wild, keeping an incredible amount of energy in the shots, as ultimately the world is never seen from a stagnant perspective in our own reality. So on film, Peter loves to keep this very organic and gritty feeling. Watching the different technicians on location, there was such a level of ingenuity brought to the day's work, but I thought that of any department, the people who really brought special skills to what Peter required were the camera department — the grips and the camera operators. They invented equipment, in the middle of nowhere, that could achieve the sort of shots Peter imagined. You have these massive sweeping landscapes with these energetic shots flying around inside the forests or across lakes, and Harry Harrison and his team would invent this equipment on the day to achieve these wonderful ideas that kept popping up in Peter's head.

The thing I loved watching more than anything else while we were filming was the flying fox camera. At Paradise, near Glenorchy, there is this massive forest where we filmed the *Uruk-hai* surging down the hill as this mighty force chasing the poor hobbits. Peter wanted the camera to film as if it were from your point of view, so the camera department built this incredible system through the treetops, where they found a direct journey, and put these massive cables that went hundreds of feet through the forest. They then suspended this huge camera off it and flew it through the trees. The poor *Uruk-hai*

were madly running as fast as they could, unaware of where the camera is in relation to them. On two occasions the camera came sweeping down a little too close to these hapless *Uruk-hai*, clipped them and sent them flying off. They ended up unhurt, thankfully, but it made for some hysterical filming.

My favourite location would have to be *Edoras*. There is no place in my life I have been to that more succinctly captured a culture than Mt Potts. It also realised, for me, the vision of the written word, and ultimately the art that was generated around *The Lord of the Rings*. To walk through this village, completely fabricated as a set, on this huge craggy piece of rock with a 360-degree panoramic view of these massive sweeping mountains covered in snow with the plains down below was an absolute treat. Then the art department had the audacity and the vision to build an amazing city on top of this huge, rocky outcrop.

To enter *Edoras* on the days I was blessed to work there, and stand amongst the villagers and the royal guards of *Rohan*, near *King Théoden* and *Éowyn*, and be a part of the crew in this magical environment, transported me well beyond standing amongst ruins in an ancient city or in the midst of a cathedral on the other side of the world.

I stood in another world — one created by a bunch of New Zealanders on the top of a mountain in the middle of nowhere, and it felt utterly real.

Sir Richard Taylor

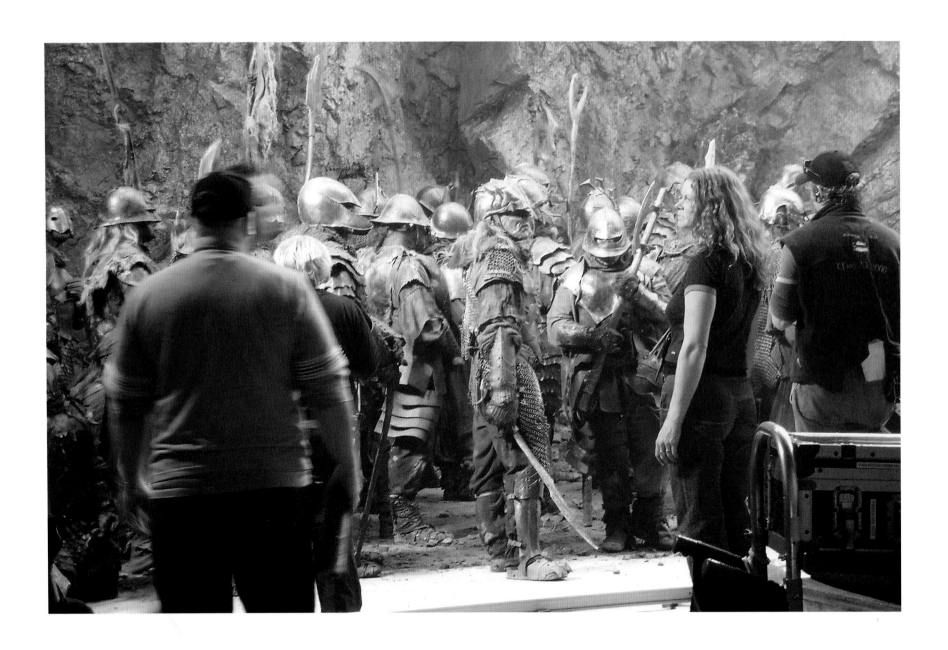

A DAY IN THE LIFE OF AN EXTRA

In June 2003, director Peter Jackson graciously allowed my then 15-year-old son Travis and me to spend three weeks on set during pick-up filming for *The Return of the King*. As well as meeting many of the cast and crew, we both obtained small parts as extras. We were like kids in a candy shop. An alarm sounding in your hotel room at 4 a.m. normally means the settings are wrong, but for Travis and me this alarm was the opening sound for a day that would allow us to become part of cinematic history. Arriving at the Stone Street Studios at 4.45 a.m. to a hive of activity and bustle was unexpected — what time do the workers start?

For Travis, the first stop is clothing — rags that would befit an orc of the army of *Sauron* marching from *Minas Ithil* to wage war on *Gondor*. These orcs are regimented and must be able to march correctly, so the team is then assembled and a former New Zealand Army Drill Sergeant spends an hour teaching them to march in unison.

Next is a visit to the Weta workers who splash mud with a brush onto the clothes before finding armour and fitting the grotesque head. This is then conveniently placed in a carry bag for later use. An army marches on its stomach, so breakfast is important — all cooked to order by Flying Trestles. It's funny in the catering tent, with the orcs all sitting together ravenously devouring all the food in sight while the *Gondorians* and *Rohirrim* are in separate corners — there will be no fraternisation with the enemy, even over breakfast.

Then the waiting commences — it's only 7 a.m. but all is ready. By 9 a.m. the call is made to Stage Q. From the outside we look at an old warehouse but walking in the door we are transported to a rocky path leading down through the desolation of *Mordor*. Two days earlier on the same stage, Travis and I watched *King Théoden* rally his troops at *Dunharrow* in preparation for the *Ride of the Rohirrim*.

A crew of hundreds are fussing with cameras, recorders, dollies and props, with Weta workers on hand to ensure all orcish features are correct. The cast are assembled on stage, torches are lit, cameras are rolling, the crew disappear from sight and the buzzer sounds. 'Shooting!' The orcs march for 20 seconds. 'Cut!' Like a wave, the crew return — retouching make-up, checking props and when all is ready again, the wave retreats.

After an hour of this, morning tea is served. Hobbits must love their parts in these films — this was a second breakfast rather than a snack. Heads are removed and orcs from all walks of life discuss the day's happenings over bacon and coffee.

The day wears on but there's no further shooting until after lunch. Another scene is shot and then all remains quiet until 5 p.m. It's 12 hours since our arrival and 45 minutes of work has been spread over the day. Who cares! All we have to do now is wait six months to see if the orc march has made the grade.

My part in this epic commenced two months before shooting. 'If you want to be a soldier of *Rohan* or a civilian in *Minas Tirith*, you need a beard,' I was told. No problems — I'd grow an extra finger if I thought it was going to get me into the movie. Arriving in Wellington, my first visit is to casting. I am to be part of the celebrations at *Edoras* following the *Battle of Helm's Deep*. Report tomorrow at 5.45 a.m.

Today the early-morning buzzer means I will be transported into *Middle-earth*. Clothing is fitted and breakfast is served but it appears this isn't to be the opening scene of my new career. No wig can be found to fit.

Disappointed, I return to the *Age of Men* and sit on the sidelines, watching *Théoden*, *Éowyn* and *Aragorn* discuss their fortunes. My disappointment disappears very quickly as I sit on stage watching Peter Jackson direct and then afterwards discuss *The Location Guidebook* with Bernard, Miranda and Viggo. I pinch myself — is this really happening?

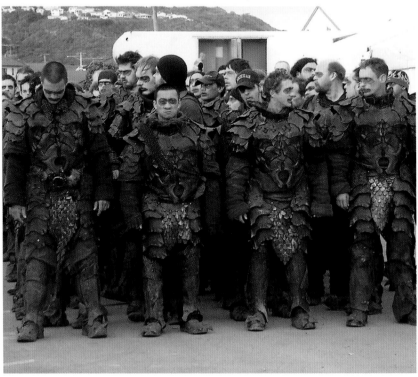

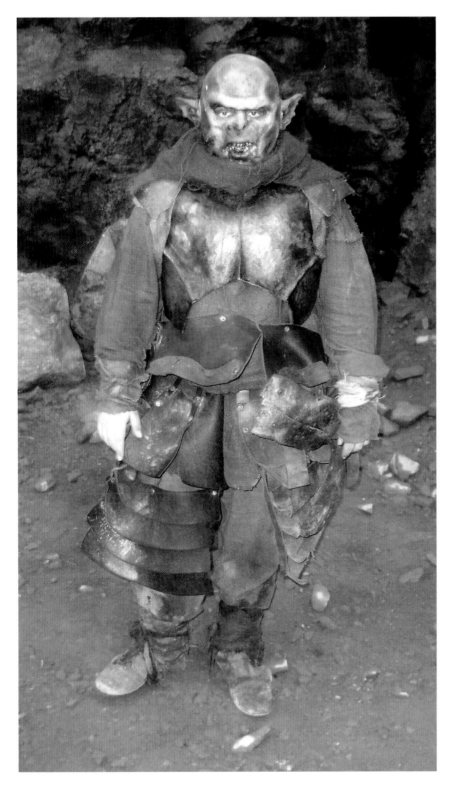

Two days later, I'm back at casting. I'm to be a *Gondorian* market seller. A wig and clothing are fitted and a Polaroid taken for continuity. Over the last few weeks I've watched the streets of *Minas Tirith* come to life from wood and polystyrene. Now the realisation I'll soon be working on them causes a huge surge of excitement.

By now, the drive through the darkened streets of a midwinter morning in Wellington to the hive of activity at Miramar is very familiar. In wardrobe my costume is fitted and then an hour is spent as the grey locks of a wig are fitted over my own grey hair. As I look in the mirror, the transformation is remarkable.

By 10.30 a.m. I'm comfortably through second breakfast and have acquainted myself with my fellow artistes. All is ready as we are ushered to the outside set. The crew arrive with their amazing portable units. Screens, tables and a comfortable chair for Peter, a computer and office on a trolley for Barrie, other wheeled units for sound and continuity. What had been a deserted set only an hour ago is now filled with that amazing wave of people preparing for action. The set is dressed down to the smallest degree and I practise my part of selling bread to other civilians who are still left in this city under siege.

All at once Peter arrives and Sir Ian takes his place next to me! *Gandalf* has sent *Pippin* to light the beacons and as he stands on the street, he watches gleefully as the first fire is lit. I sell bread.

Peter directs the scene, which is shot about six times from various angles, and then he is happy and *Gandalf* is happy in the knowledge that the *Riders of Rohan* will soon be on their way. I change back into jeans and wander over for lunch. Ten minutes of action in a day to remember.

Six months later I settle into a theatre seat for the culmination of two years of movie magic. The film is wonderful — and what makes it even more exciting are the scene of the orcs marching (with a shorter one in the front) and the view of half a grey head next to *Gandalf* in *Minas Tirith*.

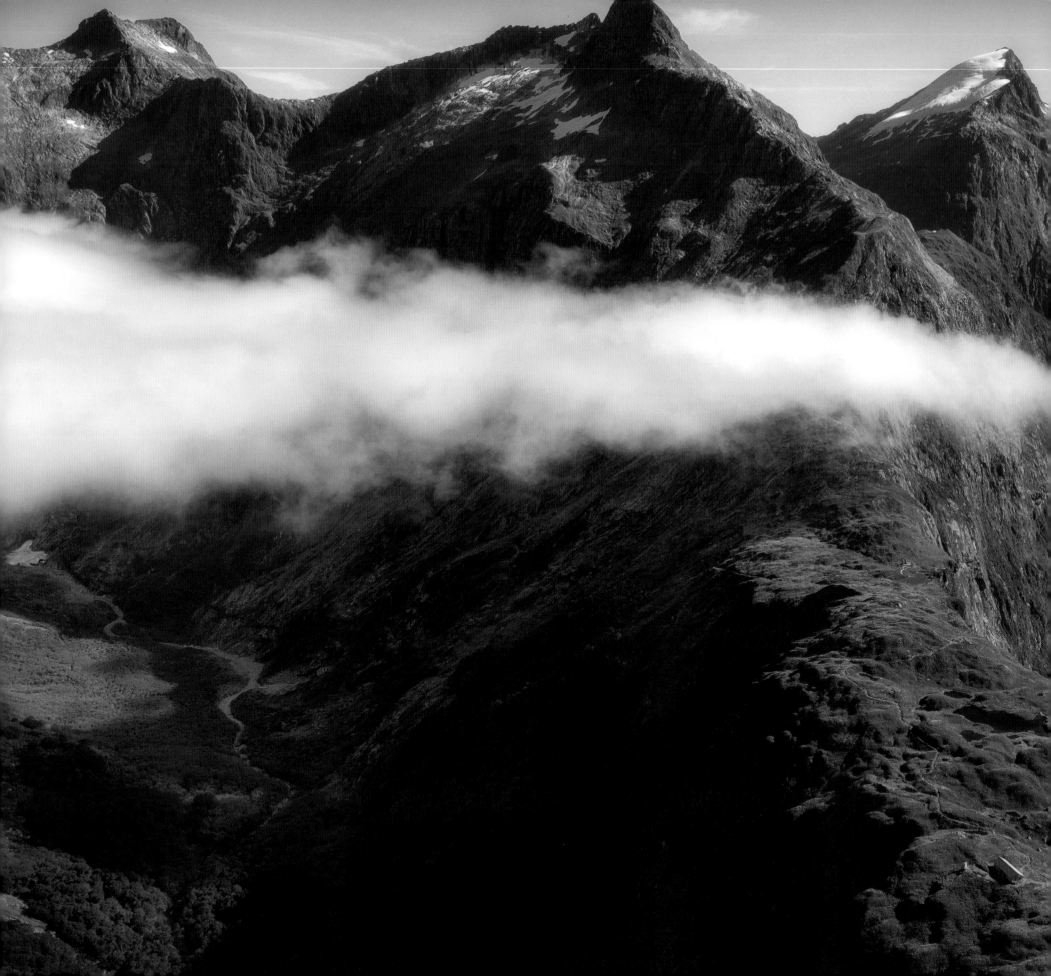

FILMING MIDDLE-EARTH

My role as second unit director was a complete surprise — but someone was needed who could understand performance, and help the actors. Thanks to our long-term collaboration and my experience in visual effects and performance capture, Peter Jackson invited me aboard.

The second unit director had a wide remit. The previsualisation Peter had worked through was a starting point; although he told me not to be hemmed in and to use it as a sounding board. I organised aerial photography on location; traditional pick-up shots when scenes hadn't been completed by the main unit and originating shots for battle sequences and chases by wargs.

One of the challenges was helicoptering the dwarves and their entourage (make-up, props and costume wranglers) to vertiginous locations, and we often had to land the choppers on some very precarious peaks to reload the camera data cards.

Fortunately, my role as *Gollum* didn't influence my filming style when I was directing — though I'd have loved to have seen the dwarves' faces if *Gollum* had hissed 'Let's do another one.'

A big change since *The Lord of the Rings* was using 48 fps (frames per second) 4K Digital data — Peter always wanted the maximum choice from the actors and as the writing continued into the edit, shooting digitally lent itself brilliantly to this way of working. Communication was also better — files could be transferred more quickly. On location we communicated via Skype, so Peter could view what we were shooting (on *Lord of the Rings*, assistant directors drove for three hours each way with a shot on a small handheld monitor for him to approve).

Shooting on location was one of the highlights. Much as it's great to shoot on a controlled set, too much green screen can drive you bonkers. New Zealand itself is one of the greatest characters in *Middle-earth*. It can't be underestimated in terms of its grandeur, its spirituality and how perfectly it reflects Tolkien's world.

One location remains indelibly etched into my memory. Earnslaw Burn, just south of Queenstown, was a magnificent, flat-bottomed valley surrounded by cliffs with hundreds of waterfalls, topped by a vast glacier. We shot the dwarves climbing up towards the *Misty Mountains*, both from the ground and the air, and helicoptered a huge crane and 150 crew up to beneath the glacier — an extraordinary adventure. Several times the wind became too strong for the choppers, and on the higher locations, clouds and bad weather would close in at an alarming rate and we would have to evacuate fast.

One of the things that struck me is the generosity, openness and willingness to overcome challenges of people working together, with little or no ego. And then, of course, if you're an outdoor kind of guy, this country offers untold riches and realms for escape and discovery in its incomparable wilderness. Soaring in a chopper along the ridges and bluffs of Treble Cone and Sutherland Falls was phenomenally exciting — it almost felt as if we were the eagles the dwarves used to escape.

Andy Serkis

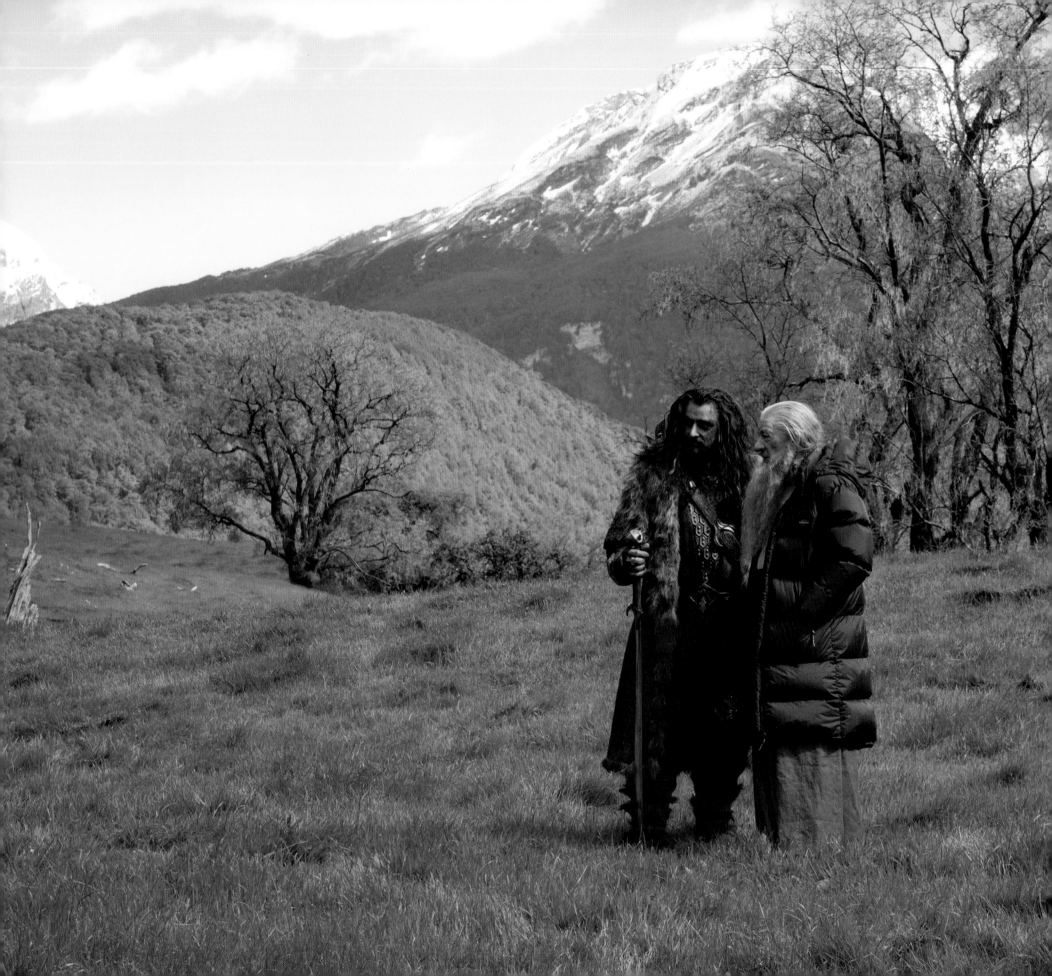

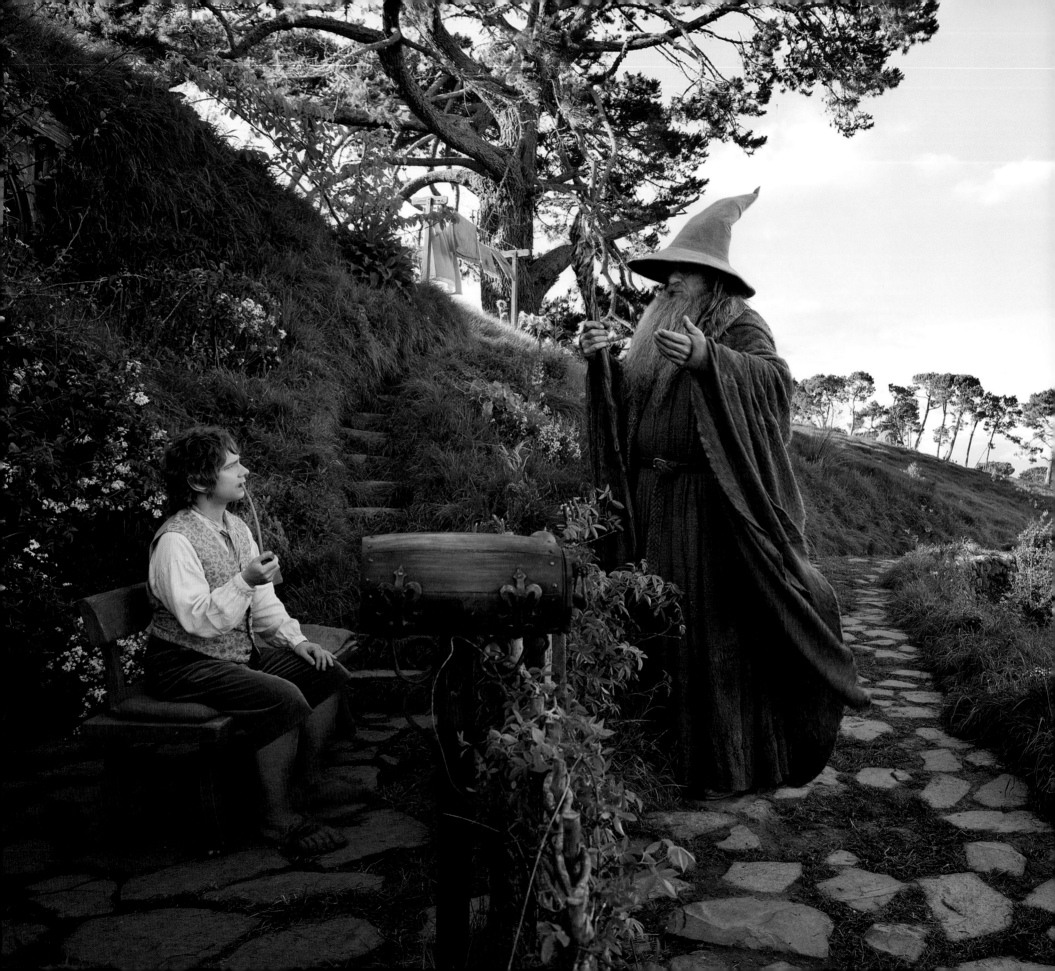

PRODUCTION DESIGN

Having worked on *The Lord of the Rings,* by the time I came to work on *The Hobbit* I had already established a working relationship with Tolkien, and a familiarity with his language, his style and his storytelling. Written for a younger audience, much of *The Hobbit* is whimsical and childlike. The journey commences in the familiar sun-kissed fields of *Hobbiton* and the ethereal Elven *Rivendell*; for both places we had already established a signature and architecture. Essentially a road movie, the film breaks into new territory once *Thorin* and his *Company* depart *Rivendell* and travel through *Middle-earth* towards the dwarves' homeland, the grand, mineral-laden, underground kingdom of *Erebor.*

With the passing of a decade between the two Tolkien projects, one of the more significant changes for the art department was that the majority of *The Hobbit* was shot inside the studios at Stone Street, Wellington. Bottom line for us was this meant more sets and fewer locations.

To erect the 120-plus sets, we pulled together a team of nearly 350 people rotating across 24 hours a day, seven days a week. In addition to this, we built a total of 94 models in either 1:16 or 1:25 scale. The models, developed from concept drawings and built as full environments, were a great tool of communication with Peter. Each show-and-tell provided a tactile experience with Peter where we could work closely with him refining detail and establishing exactly which part or parts should be realised as full-scale sets. Time with Peter is limited for everyone, so it was important to establish the most efficient shorthand process possible. For some environments it was necessary to build multiple models; in the case of *Beorn's house* a total of 12 versions were completed.

A relatively small team collaborated during early pre-production on selecting the exterior locations. To conceptualise a location we would glean everything we could from the text, the concept artists, local knowledge from location manager Jared Connon and Peter's expectations and work those things together until we came up with something that felt right. Google Earth was a remarkable tool for identifying potential sites but every possible option was physically visited by the pre-production team. There were days when we were flying in formation like something from *Apocalypse Now*, concept art folders and iPads tucked under our arms, combing the landscape looking for undiscovered *Middle-earth*. Working with Peter requires an open mind and often we would stumble on a location he loved completely by chance.

Typically each exterior location required some kind of corresponding interior set. The exterior for *Trollshaw Forest* was filmed at Denize Bluffs in the North Island, an area of distinctive topography and vegetation. The rocks are a unique shape and texture and a huge limestone cliff runs for a couple of kilometres, packed with a unique set of cracks and crevices. We built the ruins of a house on location, then married this with the *Trollshaw* lair and a cave interior in the studio. The piece of ground between the two of them is the location. We not only photographed each and every detail, but we cast trees and rocks, taking 200 square metre silicon moulds back to the studio. Everything we put together from nature was moulded from living or real elements, creating a far more authentic look.

For *Beorn's house* we needed two perspectives: the front entrance and the back of the house. We found the perfect spot at Paradise, Glenorchy in the South Island for the front gate but the back of the house didn't take advantage

of the amazing views. The solution was remarkably easy: we split the house in half and built two sets 200 metres apart. One of the sets was constructed in an L shape around a 200-year-old beech tree, four feet in diameter, of which Peter was particularly fond. Unfortunately, a week out from shooting, a massive storm ripped through the area, toppling the massive tree. Fortunately for us, the tree fell away from the house, leaving it unscathed, but it did leave us with an unexpected problem: Peter still wanted the beech tree and it was lying dead and broken, in no fit state to be a film prop. With less than a week before the shoot, using artificial and authentic materials, we constructed a new version of the old relic and trucked it to the South Island just in time for filming.

Location shots by the second unit, without set pieces, were also established during our big helicopter flyover. They tend to be travelling places, so it's important they didn't move out of character. You're increasing the jeopardy as you go, and if you put in something too mountainous before something that isn't, you're telling the wrong story.

As an 11-year-old I had dreamed of seeing *The Hobbit* as a film, so I was very passionate about being involved in making it. *The Lord of the Rings* gave us a legacy as a starting point but we really did push the envelope on *The Hobbit*. We had 10 years to refine our craft and work on techniques that allowed us to achieve better textures. We stepped up to the mark with a lot more experience and a lot more sensitivity about what we were dealing with. Part of the attraction of this role for me is that I had the opportunity to realise some of my fantasies, my visions, for *Middle-earth*. It was a great honour to be part of this process and to help realise the dream I had as an 11-year-old — to put this epic tale up on the big screen.

Dan Hennah

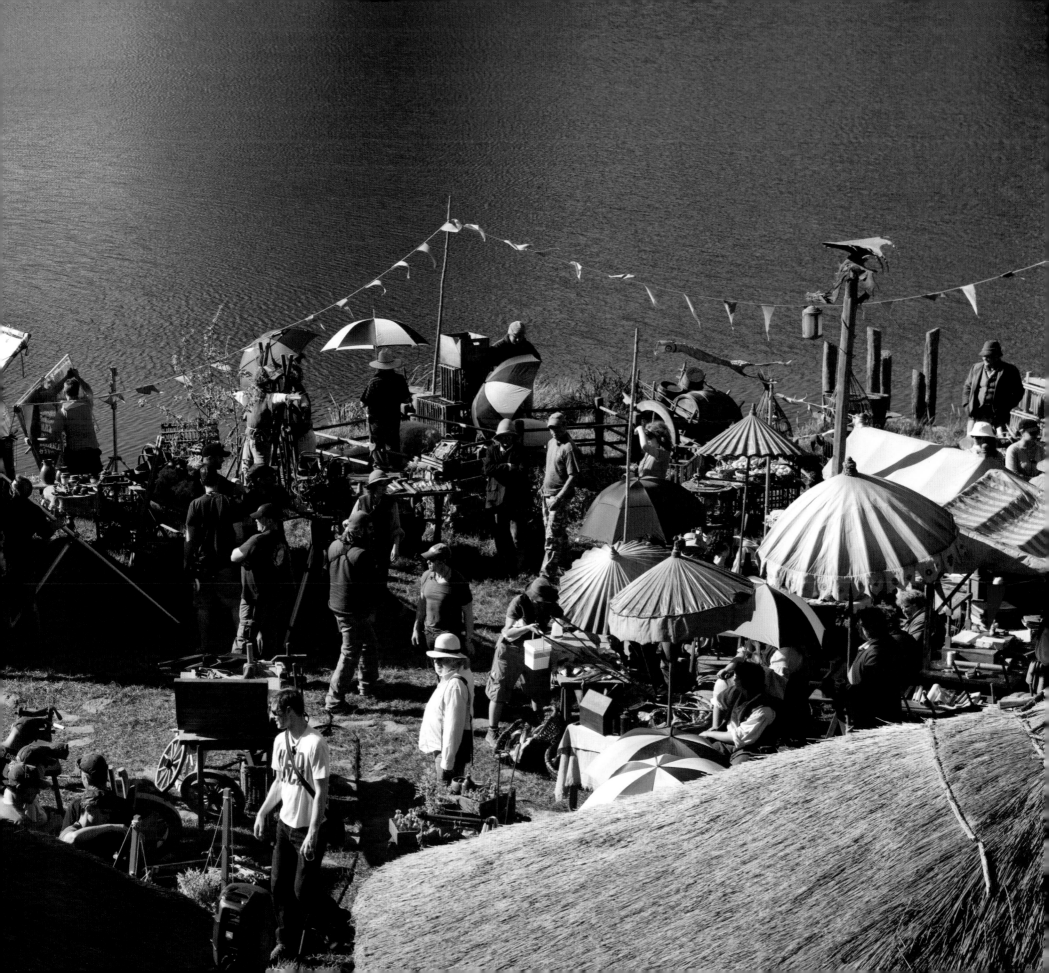

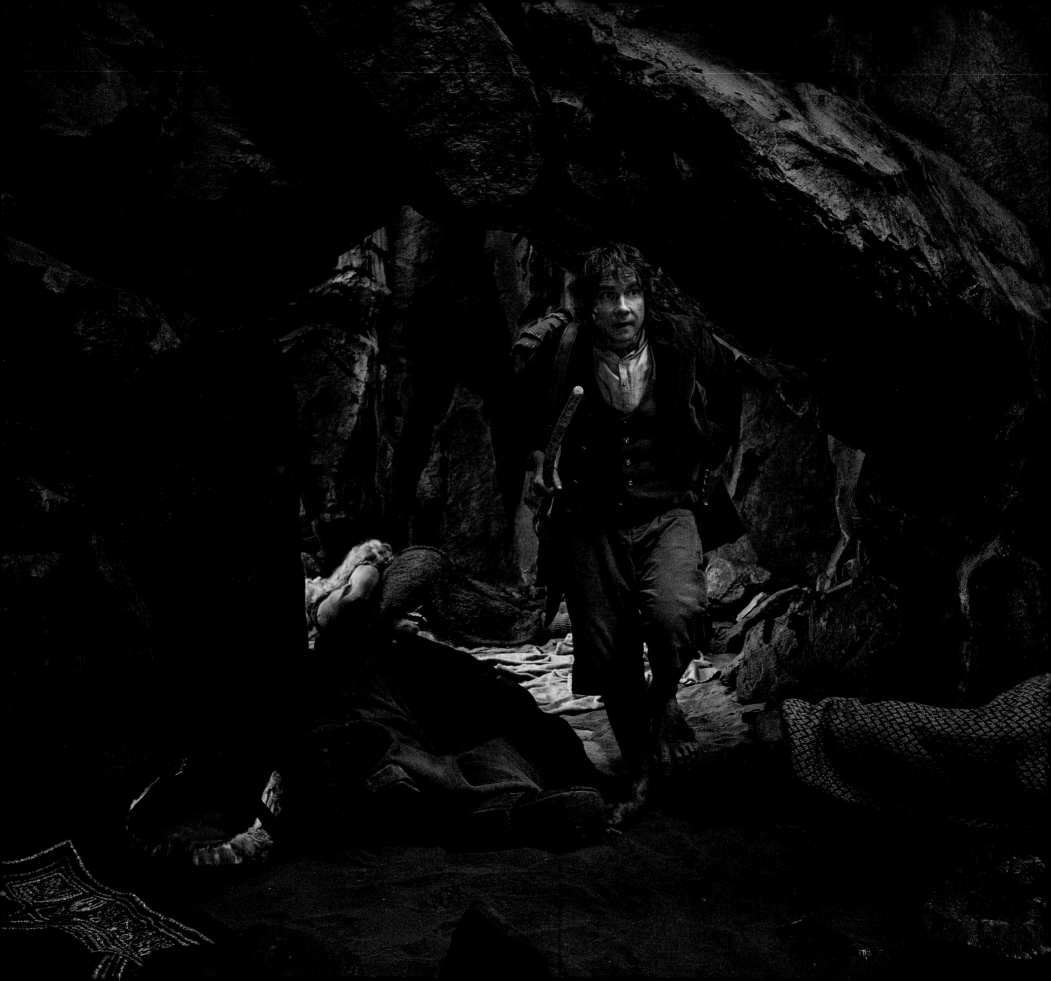

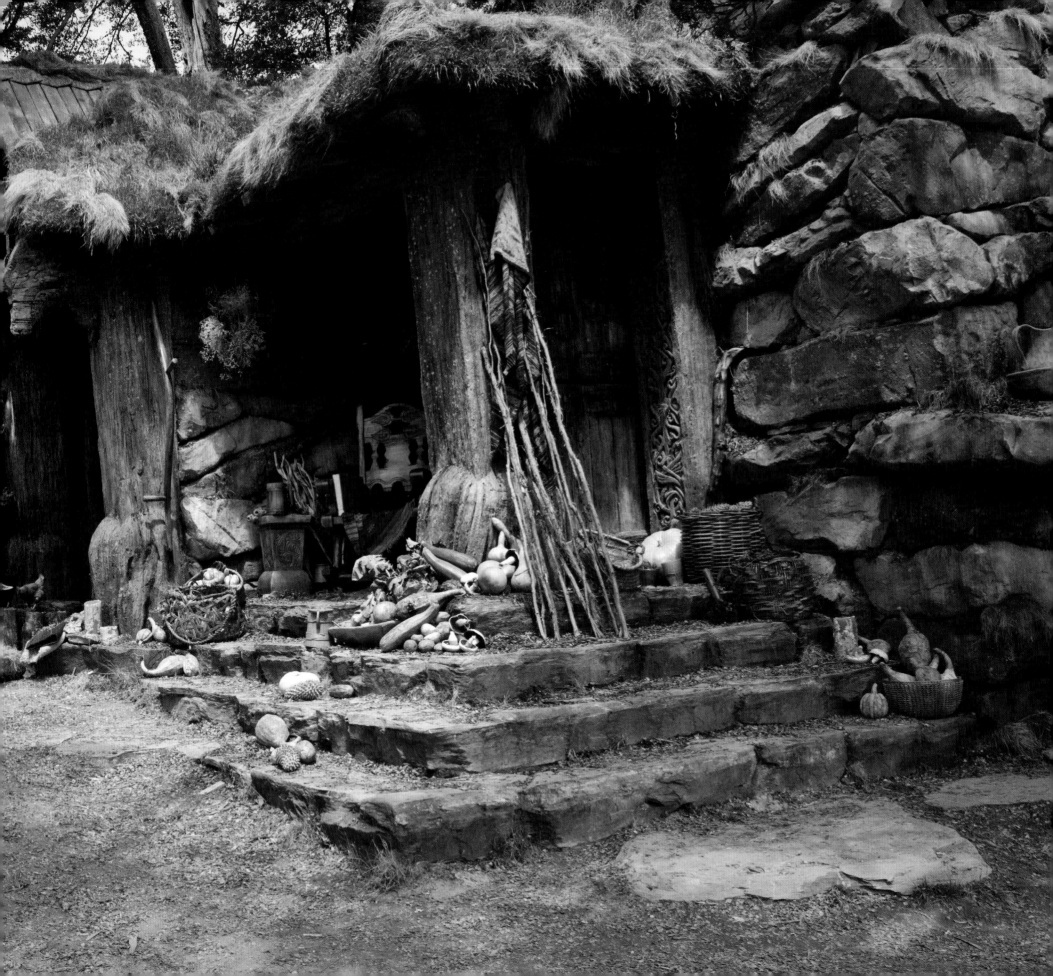

SET DESIGN

Helping prepare the locations were Brian Massey, art director; Ra Vincent, set decorator; and Simon Bright, supervising art director. Brian was concerned with location shoots and off-site builds, while Ra was responsible for handing over the polished set. Simon followed concepts from the design department through construction and fabrication.

For Ra, 90 per cent of his job was aesthetic. 'The way Peter and Fran [Walsh] adapted *The Hobbit* provided a huge amount of visual prompts.' His preparations began once he visited the set. 'Once the scenic artists pull out their tools and scaffolding, we have an intensive couple of days, making it a believable place. I'll help conceive all the objects, then get our prop makers to construct and position them. It's wonderfully satisfying, being the last one to walk off the prepared set.'

Once the art department was involved, Simon visited the set to monitor progress. At *Beorn's house*, in Paradise in the South Island, 'We modelled the environment, then went down with Peter, staked the front and back doors and took photographs. A couple of days later we built the set.' An hour's drive from Queenstown, the build was challenging, with 12 weeks to make *Beorn's house* look as if it had been there for over a hundred years.

While Brian is careful to have the right crops, Ra notes it's a travelling story. 'With *The Hobbit* we're going far from *Hobbiton* and eventually we're in a different part of the world.' By the time they reach *Mirkwood*, viewers can expect the foliage to have changed.

With the world of *Men*, there's a Tudor influence, as the designers differentiate men, hobbits and dwarves. 'By attaching them to an ethnic origin or time period,' says Ra, 'it helps with the design. We have craftsmen up and down the country — our woven fences came from Otaki, and we use a traditional rake-maker in Oamaru.'

While on location, it wasn't always possible to use their facilities in Wellington, which meant finding local craftspeople. 'Once, we had to drive from Paradise to Glenorchy to have an axehead turned around overnight.'

Theming is one of the ways of achieving an authentic look. 'Someone dressing the fishing village thinks, "What would I need if I was a fishing hobbit? They'd have an eel net, lines, a coracle, a jetty …", and those details go into the final set.'

Planning ahead meant thinking about scenarios they might encounter and throwing things inside support trucks — a chimney, a gate, a hedge, a bit of pig-sty. 'We provided options for altering landscapes — any way we could think of to key our company into their travelling story.'

Brian says, 'You're always going to get a better build by enhancing what's there as opposed to a backlot build, where you impose a landscape location.' And sometimes there might be the right foreground but the wrong backdrop. 'It's very hard to transport the background, but easy to transport the foreground.'

And thinking on your feet is critical. While having a 200-year-old tree fall down a week before filming was unforeseen, at least it meant Ra had plenty of firewood to dress *Beorn's house*.

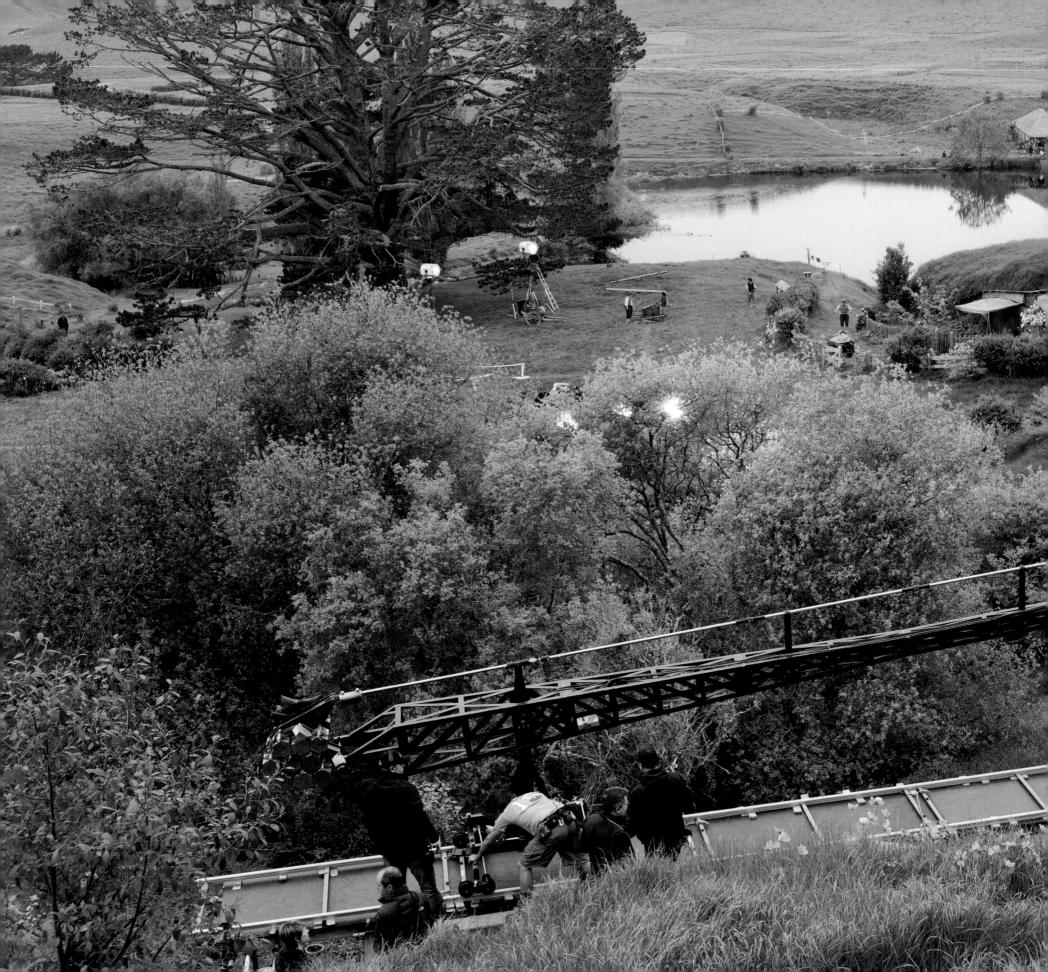

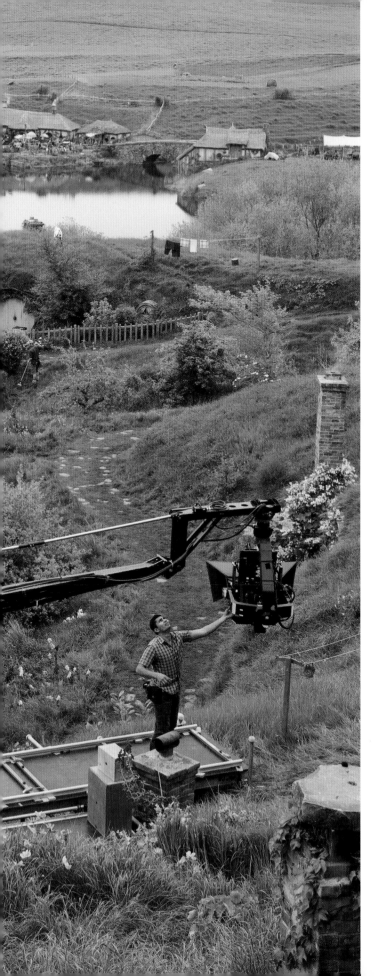

ESSENTIAL LOCATIONS

Kaitoke Regional Park

Mt Ruapehu

Hobbiton Movie Set

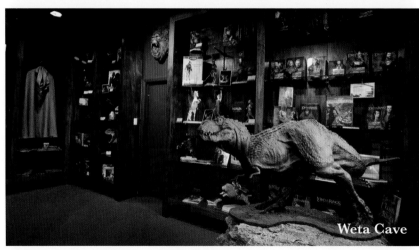

Weta Cave

Denize Bluffs

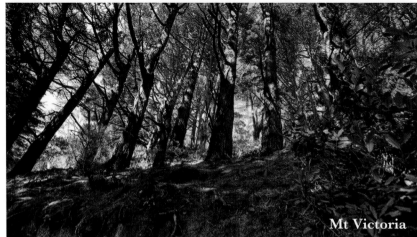

Mt Victoria

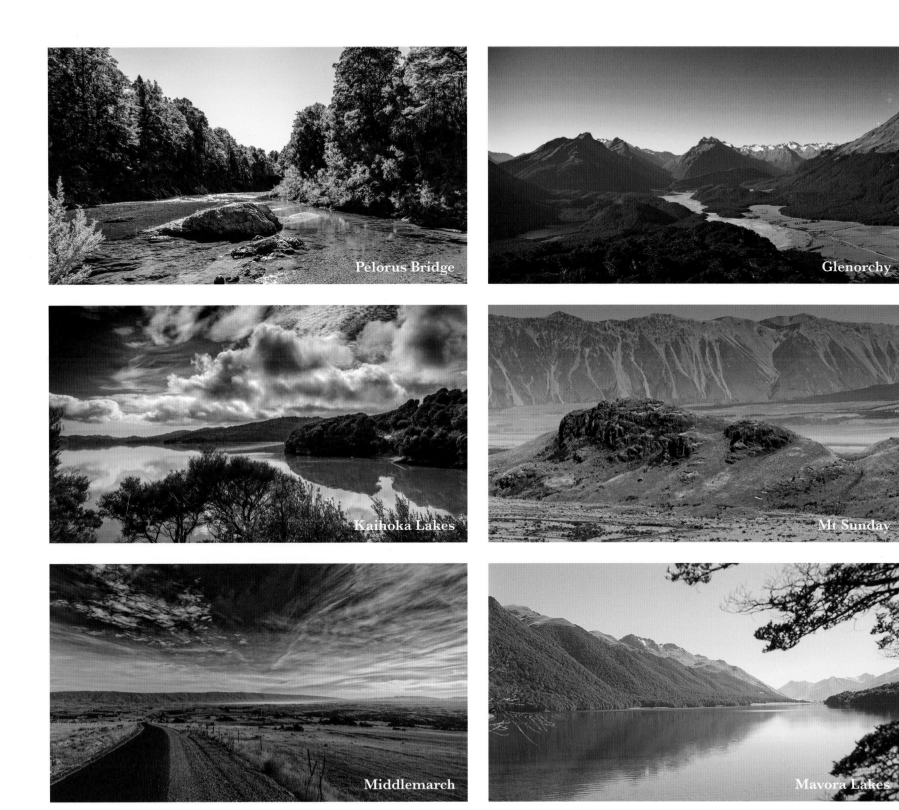

Pelorus Bridge

Glenorchy

Kaihoka Lakes

Mt Sunday

Middlemarch

Mavora Lakes

NORTH ISLAND

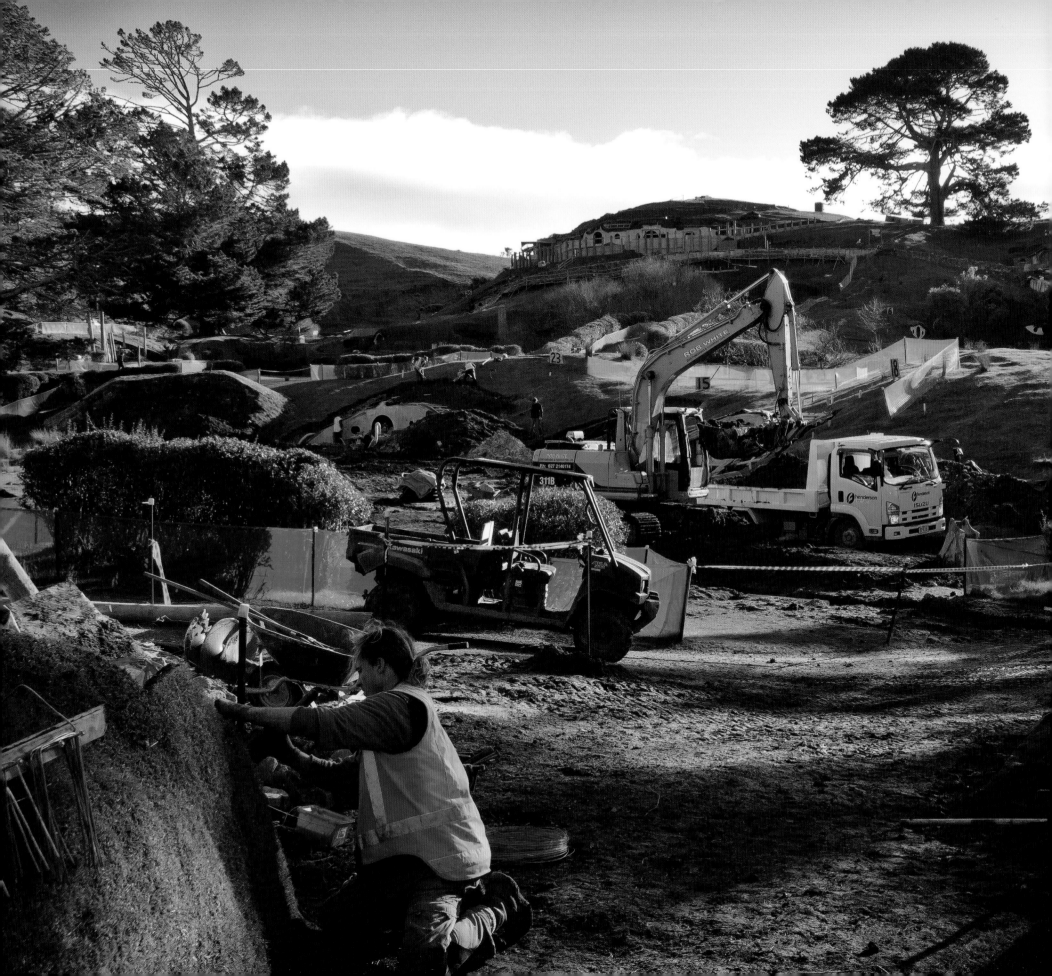

HOBBITON

Hobbiton Movie Set, the only set left standing, was partially destroyed after filming the *Lord of the Rings* trilogy, with only façades remaining. In 2010 rebuilding began, with earth removed for each hobbit hole and retaining walls and a wooden-framed roof erected. Large beams were carved using chainsaws and Skilsaws, with motifs and characters hand-carved into the doorframes. Once the framework was complete, earth and grass swathes were rolled over the roof. Wooden-framed walls were plastered, slate added to roof edges and small windows added to give an impression of depth. Bricks constructed on site were made to fit around the wooden framework, and concrete 'stones' became chimneys.

A team spent the winter creating retaining walls for paths, while the art department aged brand-new holes until they looked as if they were built 500 years ago. Layers of paint were distressed, with bricks plastered then rubbed clean in places, to give an impression of age. Window frames were filled with a special glaze, with little objects to be admired from outside placed on shelves.

Each hobbit hole has a garden, with flowers, herbs and vegetables. Roses ramble around the doors, with bright-red cosmos everywhere. Nasturtium spreads from cracks in the stones, and the hobbits' love of gardening is apparent. Although it all looks as if it's been there for centuries — thanks to the greens team — two years before it was a sheep paddock. Hedgerows were transplanted, complete with honeysuckle — creating a view across the *Party Field*, or a glimpse of the inn. Filming depicted midsummer, but visitors now experience the bare trees of winter, intense green, lush spring growth or mellow autumn.

In December 2012, *The Green Dragon Inn* was opened. While the exterior façade was built for location filming, interior scenes were filmed in Wellington. Tour visitors walk a narrow wooded lane to the mill, cross the double-arched stone bridge and drink in *The Green Dragon*, with ale, cider and ginger beer a hobbit would enjoy.

Tours of Hobbiton Movie Set depart from The Shire's Rest Café or Matamata i-SITE. Lasting over two hours, each includes a guided tour of the set and refreshment at *The Green Dragon Inn*. Tours are also available from Rotorua and Auckland.

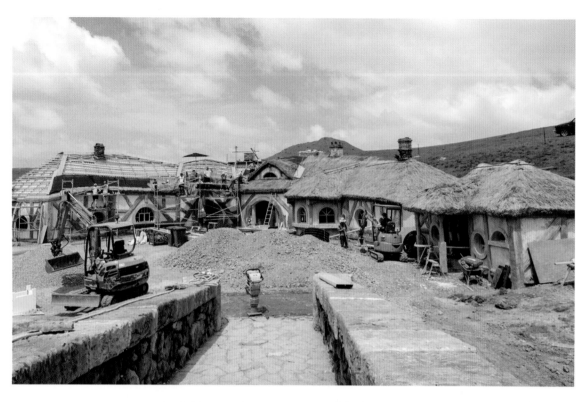

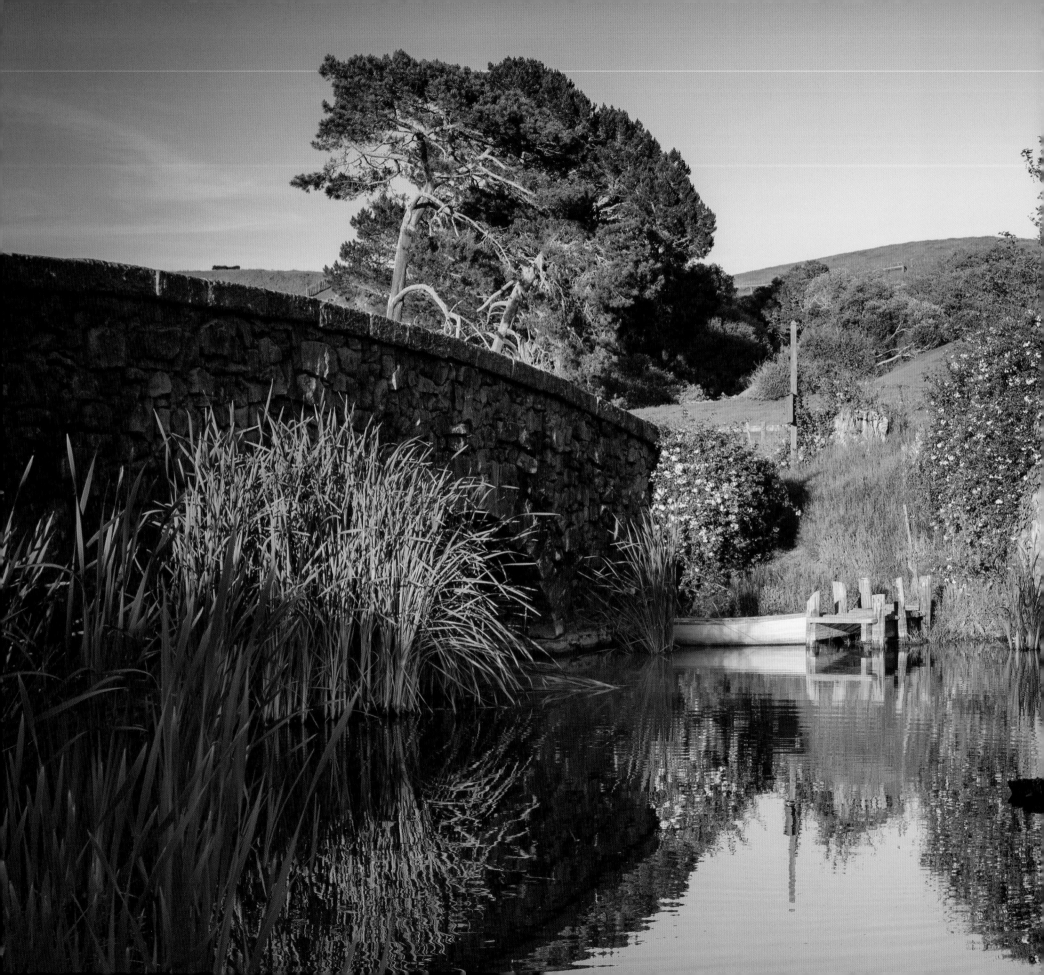

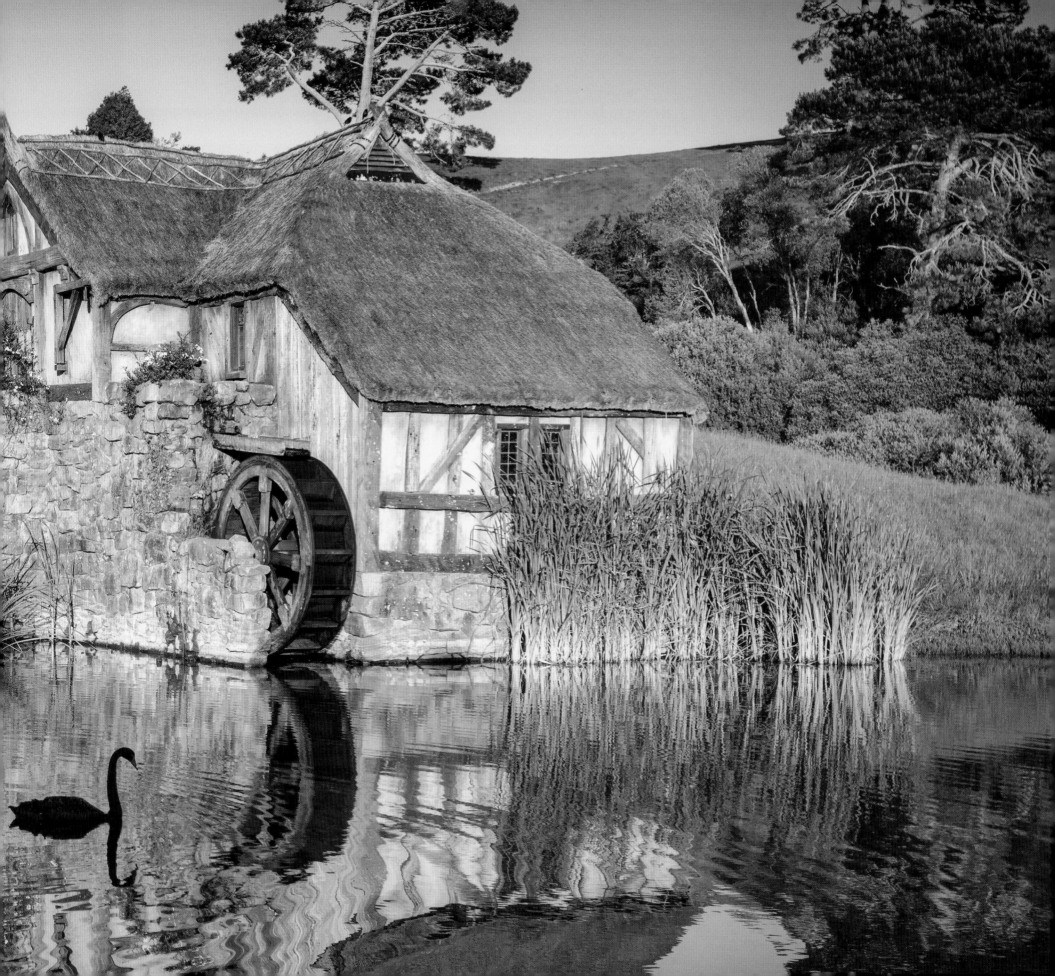

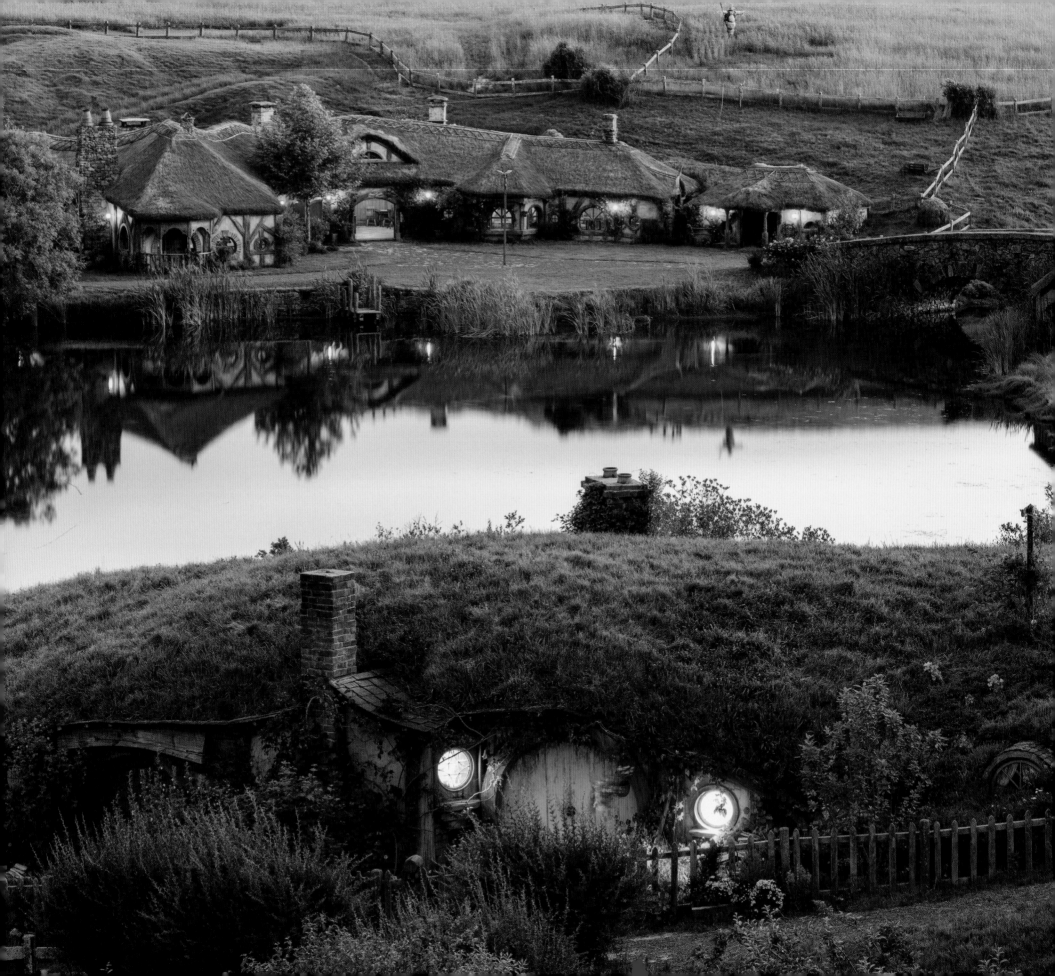

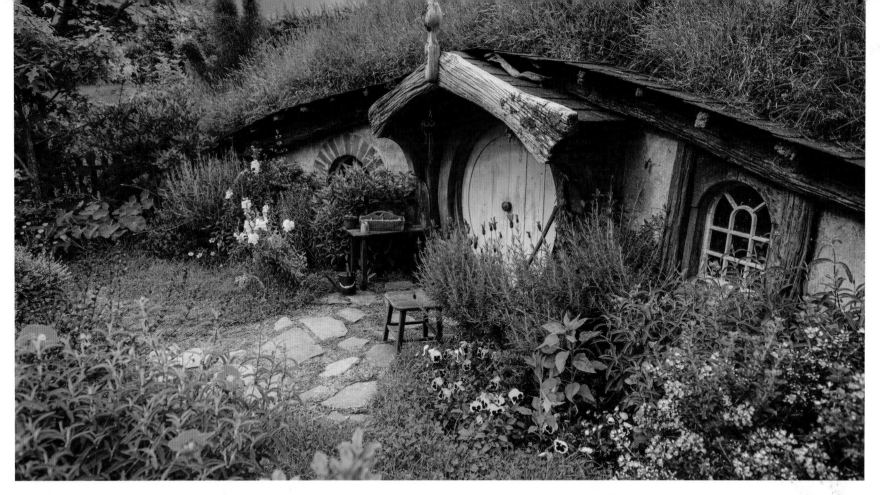

TE WAIHOU WALKWAY

Off State Highway 1, near Putaruru, is one of the most beautiful walks in the area — while not used as a location, it's worth a stop. High in the Mamaku Ranges, water from small springs and streams spends a century flowing through aquifers to become the Waihou River. This long, slow process creates the most intense blue-green water, which emerges at a rate of 42 cubic metres (9240 gallons) per minute.

The walkway follows part of the river and is 9.4 km return from the main car park at Whites Road — you can also visit the spring from a car park 3.6 km along Leslie Road.

The landscape is the epitome of *Middle-earth*. Clear, pure water flows through an intensely green valley interspersed with native bush, where the stream tumbles over small waterfalls amid moss-green rocks. Lush reeds grow in the deceptively deep stream, where they wave and twist with the water. Watch for trout, which appear suspended as they swim upstream.

Within New Zealand, there's every chance of tasting water from the Waihou — a pumping station along the walkway supplies many different water bottlers.

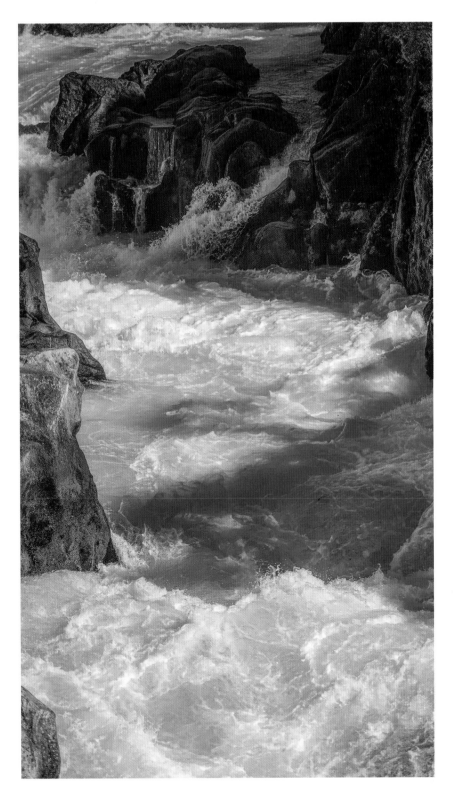

ARATIATIA RAPIDS

At 425 km, the Waikato River is the longest in New Zealand. The river's course was formed around 1800 years ago, during the great Lake Taupo eruption, when volcanic debris forced it north. Its original trail can be seen near Hinuera, where moulded cliff faces were used in a scene from *The Lord of the Rings: The Fellowship of the Ring*.

Eight dams and nine power stations are sited along the river — one of these is at Aratiatia, where the waters are released to power the turbines, creating the largest rapids in Australasia, and where sections of scenes from the infamous barrel run towards *Lake-town* were filmed.

The flow of water is extreme. Large empty barrels (and one smaller one) were painted pink and crew ejected them into the water to coincide with the floodgate release — so violent it was impracticable for actors or stunt crew to venture into the extreme conditions.

Water is released four times daily in summer (10 a.m., 12 noon, 2 p.m. and 4 p.m.) and less frequently in winter. An alarm sounds three times, then the water flow slowly increases from a trickle to a raging torrent. Over the space of one kilometre the river falls 28 metres, and in full flow is impressive. Another exciting way to view the rapids is from the river. Rapids Jet operates exhilarating jet-boat rides through the Waikato River's narrowest canyon.

Travelling upstream through Nga Awa Purua rapids seems exciting, but the high-speed return allows you to experience some of what it must have been like for the hapless *Company*.

There are a number of walking tracks and picnic areas, and for those with a fishing licence, trout abound. There is also a two-hour trail (walking or biking) following the river from Aratiatia to Huka Falls.

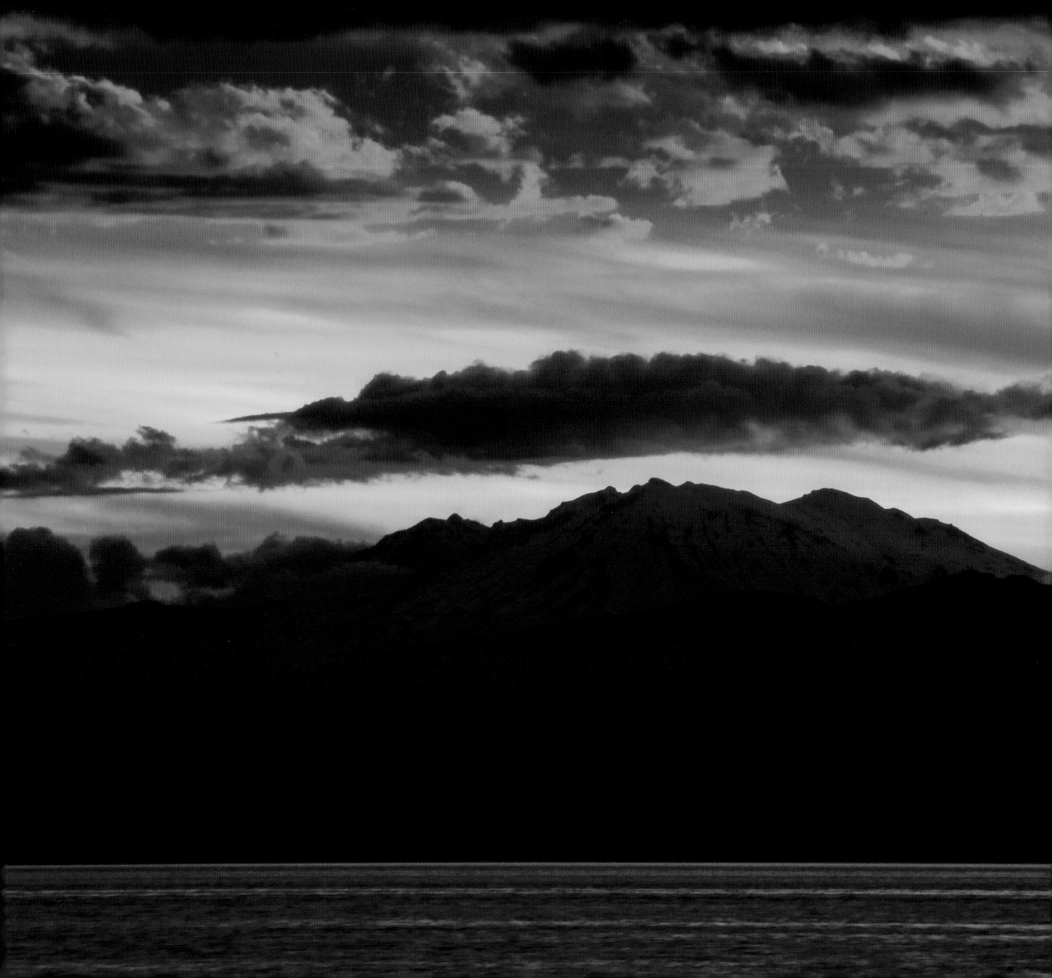

TAUPO

The Central North Island is an area of distinctive geography and contrasting scenery — from peaceful rivers, lakes and pastoral greenery to a blasted landscape of lava and volcanic ash. This was once one of the world's most prolific volcanic areas, and Lake Taupo formed as a result of the largest eruption in the last 70,000 years. The shape of the lake was created by the Oruanui eruption 26,500 years ago, then in AD 181 an explosion produced a column of pumice, ash and rock fragments 50 km high and seen as far away as Europe and China.

Sitting beside New Zealand's largest lake (619 sq km), Taupo is an ideal base for visiting the Volcanic Plateau, including Rotorua, the world-famous fishing area of the Tongariro River, or the mountainous Tongariro National Park.

Home to bubbling mud, geysers and pristine lakes, Rotorua is one of New Zealand's most popular tourist destinations and one hour to the north.

South of Taupo is Tongariro National Park, our first national park and a world heritage area. The park was created in 1887 when local iwi Ngati Tuwharetoa gifted three volcanoes — Ruapehu, Ngauruhoe and Tongariro — to the people of New Zealand.

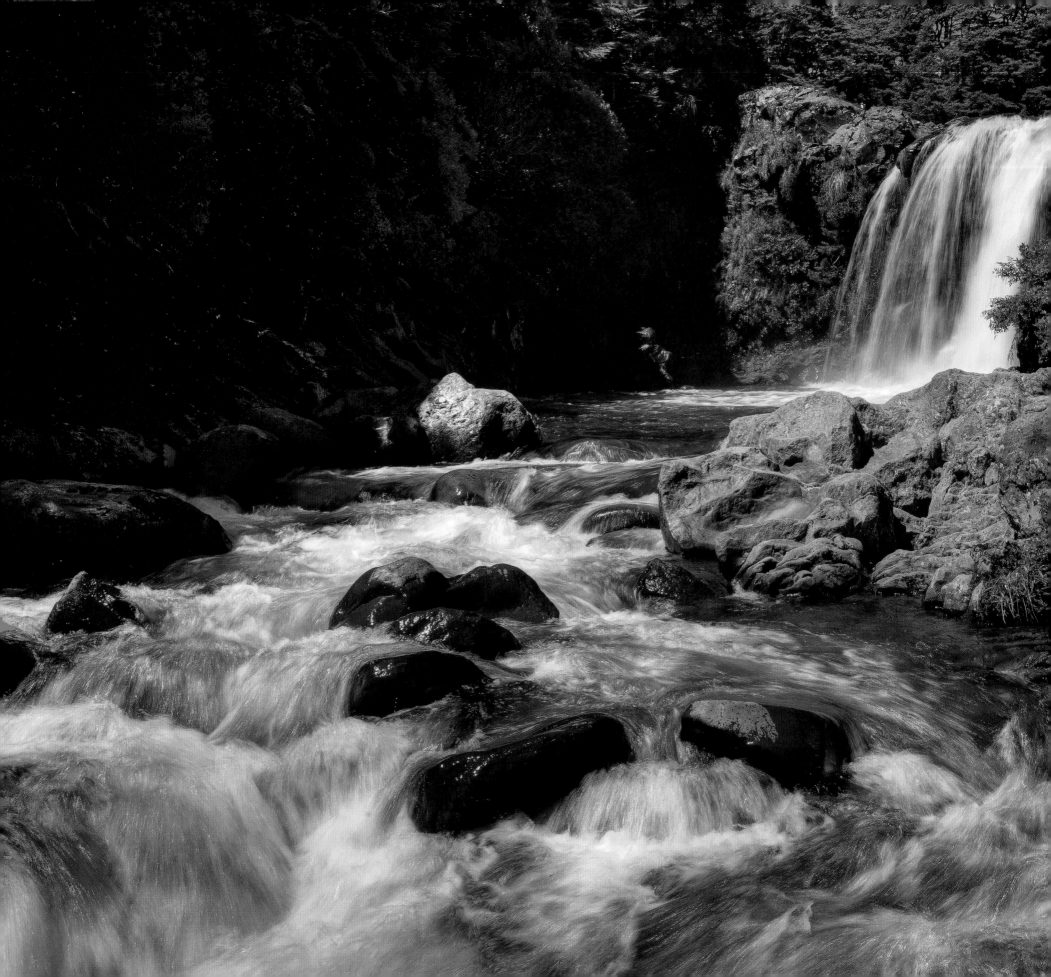

TONGARIRO NATIONAL PARK

Tongariro National Park offers a diverse landscape, centred on three volcanic cones. To the east, the main highway leads towards a very different scene, as the Desert Road crosses the Rangipo Desert. To the west, State Highway 48 passes through pine forests and small lakes before reaching Chateau Tongariro, a small village on the slopes of Mt Ruapehu. A pause at Tawhai Falls and a 20-minute walk will give you a view of the beech- and toatoa-lined forest tumbling over an ancient lava flow into a rock pool reminiscent of *Henneth Annûn*. The *Lord of the Rings* team stayed at the Grand Chateau, one of New Zealand's most iconic hotels, where they were only 15 minutes away from the slopes of *Mordor*.

A round-trip from Turangi or Ohakune provides majestic views, rushing rivers, desert — and movie locations. This can be completed in a day but to fully explore the area, break your journey for at least one night. The weather has a major impact on this road and it can be closed in winter.

From Turangi, head south on State Highway 1 towards Waiouru. The road descends into folds of beech forest before climbing into the highlands of the Rangipo Desert. Briefly disregard the stunning mountains, looking instead at the barren tussock and sandy foreground. This landscape was merged as middle ground into a final image in *The Hobbit: An Unexpected Journey* and *The Hobbit: The Battle of the Five Armies* to show the rough blasted country around *Dale*. In *The Battle of the Five Armies*, *Gandalf* can be seen riding across this desolate landscape, whereas in *An Unexpected Journey*, the foreground is near Te Anau in the South Island blended with Tongariro as the background.

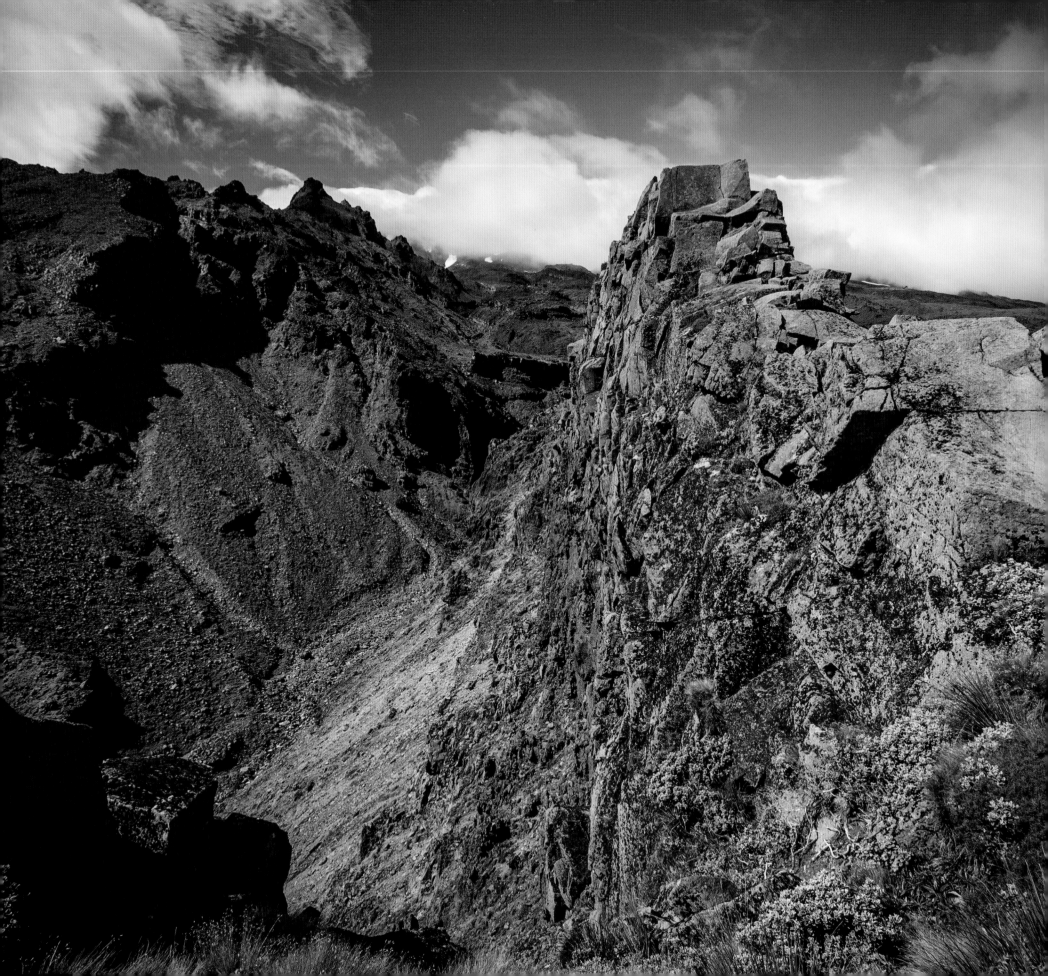

WHAKAPAPA

In winter, Mt Ruapehu attracts skiers and snowboarders — in other seasons it becomes an area of blasted volcanic rock, steep bluffs and ash. Used to portray the battle marking the end of the *Second Age of Middle-earth*, the location is easily accessible from Iwikau Village with strong walking shoes, as the area is rough, with jagged rocks and loose scree.

From the main building head north around the learner's ski slope towards Pinnacle Ridge. Before climbing, walk slightly downhill and along the ridge to a viewpoint of a tumbled area with steep escarpments. The slopes and nearby car park saw orcs attacking elves and men, with *Elrond* standing fast. The special-effects team at Weta then digitally added thousands to complete the scene. Special care was taken in all sensitive ecological areas — during filming, a special walkway of protective carpet was laid out to allow the cast and crew access without damaging the ancient moss.

The rocky outcrop known as Meads Wall beside Pinnacle Ridge was used in the scene in *The Lord of the Rings: The Two Towers* where *Frodo* and *Sam* capture *Gollum*. Actor Andy Serkis (in special clothing) was filmed climbing down the rocky face and jumping onto the hobbits. The scene was then mixed at Weta, creating *Gollum* from his actual movements.

This area was also used to show the hobbits lost in the wasteland of the *Emyn Muil* as they tried to find a way down to the blasted plain of *Dagorlad* and on to the *Black Gate*. It's particularly eerie when the weather is overcast and clouds swirl around the peaks. Close-ups of the hobbits' epic trek towards *Mount Doom* were shot here, and although filming wasn't undertaken in winter, the high altitude and unpredictable weather were a feature.

This part of the North Island is spectacular, especially in the summer. Rugged Mt Ruapehu towers over the location and often mist is attracted to the top of the peaks, creating a mystical shroud. The view in the opposite direction is astounding — the rolling hills and valleys of the King Country disappear into a gold haze. On a clear day Mt Taranaki/Mt Egmont can be seen in the distance, rising like the *Lonely Mountain*.

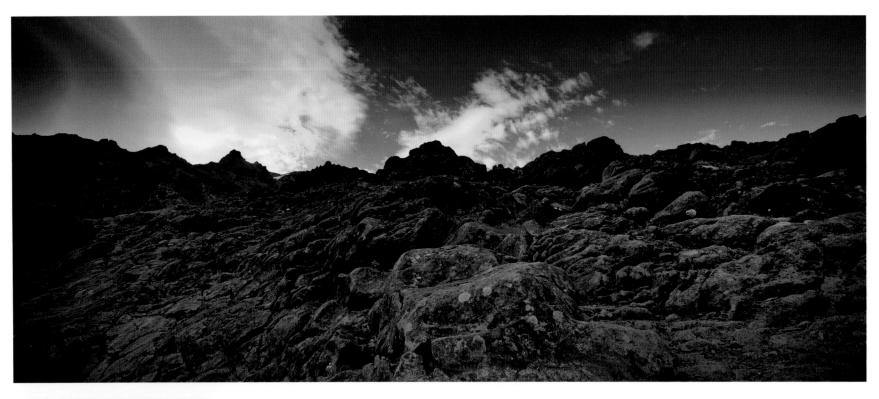
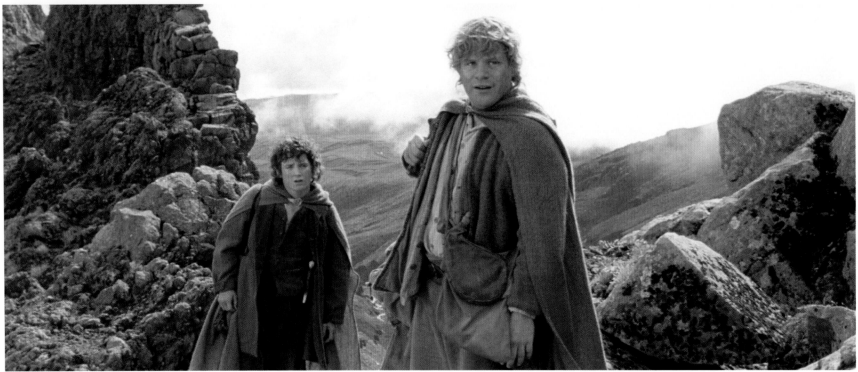

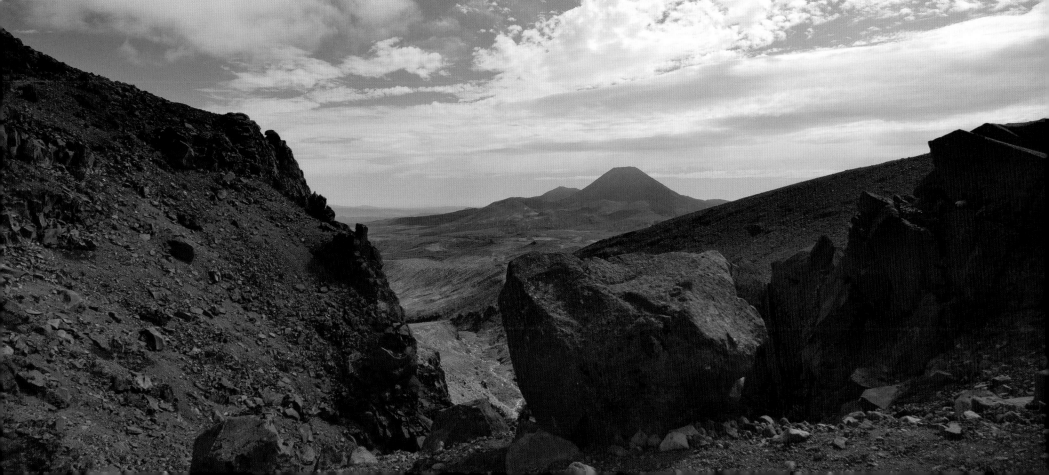

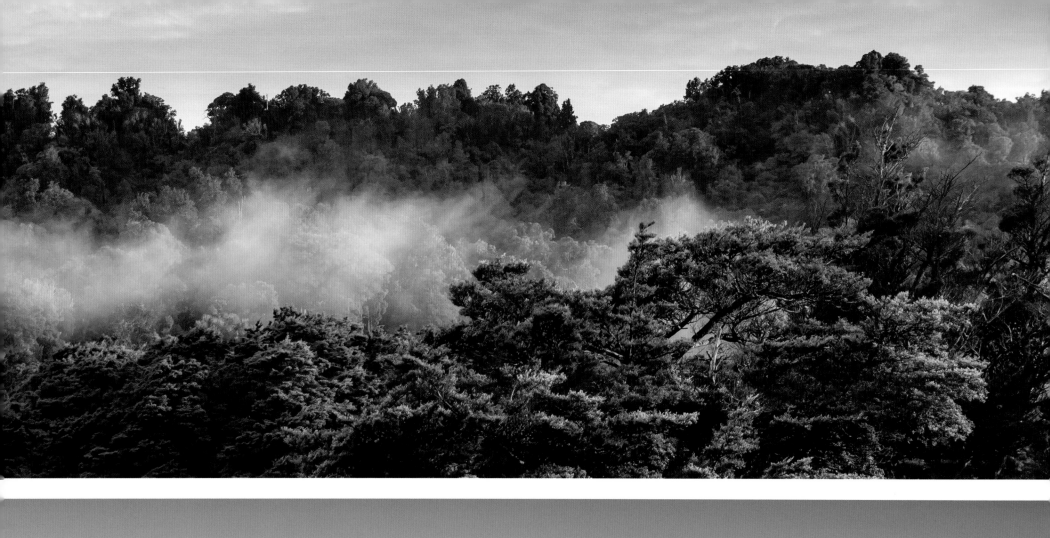

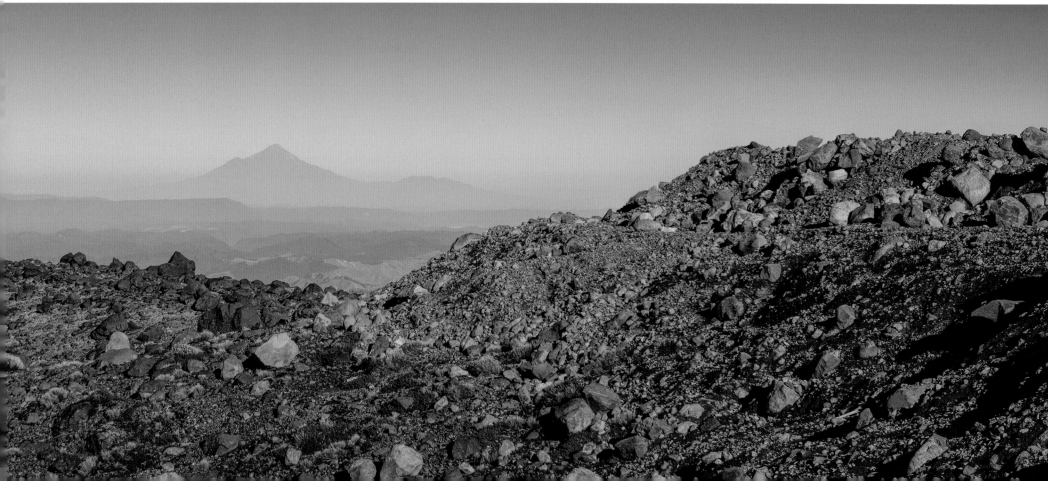

OHAKUNE

To reach the next location, take a short drive to Ohakune. Cast and crew were based in Ohakune for a number of weeks, with many staying at the Powderhorn Chateau. The hotel is the perfect base to visit *Ithilien* and *Mordor*, with the added possibility of staying in the same room that Orlando Bloom, Elijah Wood or Peter Jackson did.

To reach *Ithilien*, travel up the Turoa Ski Field Road (also known as the Ohakune Mountain Road). A number of walks and tramps lead off this road, which climbs steadily. The filming site is accessible from Mangawhero Falls. After parking in the turn-off area, go down to the riverbed, where *Sméagol* chased and caught his fish. Looking towards the waterfall the rocky scene is obvious, but for the final cut background hills were replaced by a matte painting of larger peaks.

The scene of *Sam* and *Frodo* walking through an open glade with a ruined column in the background was filmed upstream. Carefully cross the stream and walk 50 metres into a small clearing, where trees surround an open area of springy grass — the perfect interpretation of *Ithilien*.

The location of the secret door into the *Lonely Mountain* can be seen from the top of this road at Car Park 3 at the Turoa ski field. During filming, in the late spring of 2011, a special scaffolding walkway was built by production to allow the cast and crew access to the site without damaging any of the ancient moss growing in the area. The area can only be seen as it appeared in the film during the summer months, when there is no snow.

Returning to Ohakune, the *River Anduin* is an hour's drive away via Waiouru, where the National Army Museum makes a worthwhile visit, then south on State Highway 1 to Taihape.

A two- to three-day stay in Ohakune will immerse you in an area not only rich in landscape, but strong in heritage. The nearby Whanganui River was settled by Maori in the early 1100s, with the arrival of European settlers seeing the river become a major trade route and tourist attraction. Another fascinating tour is travelling the historic decommissioned Okahukura-to-Stratford railway line by rail cart — one of the remotest parts of the region, through tunnels, over bridges and into townships time has forgotten.

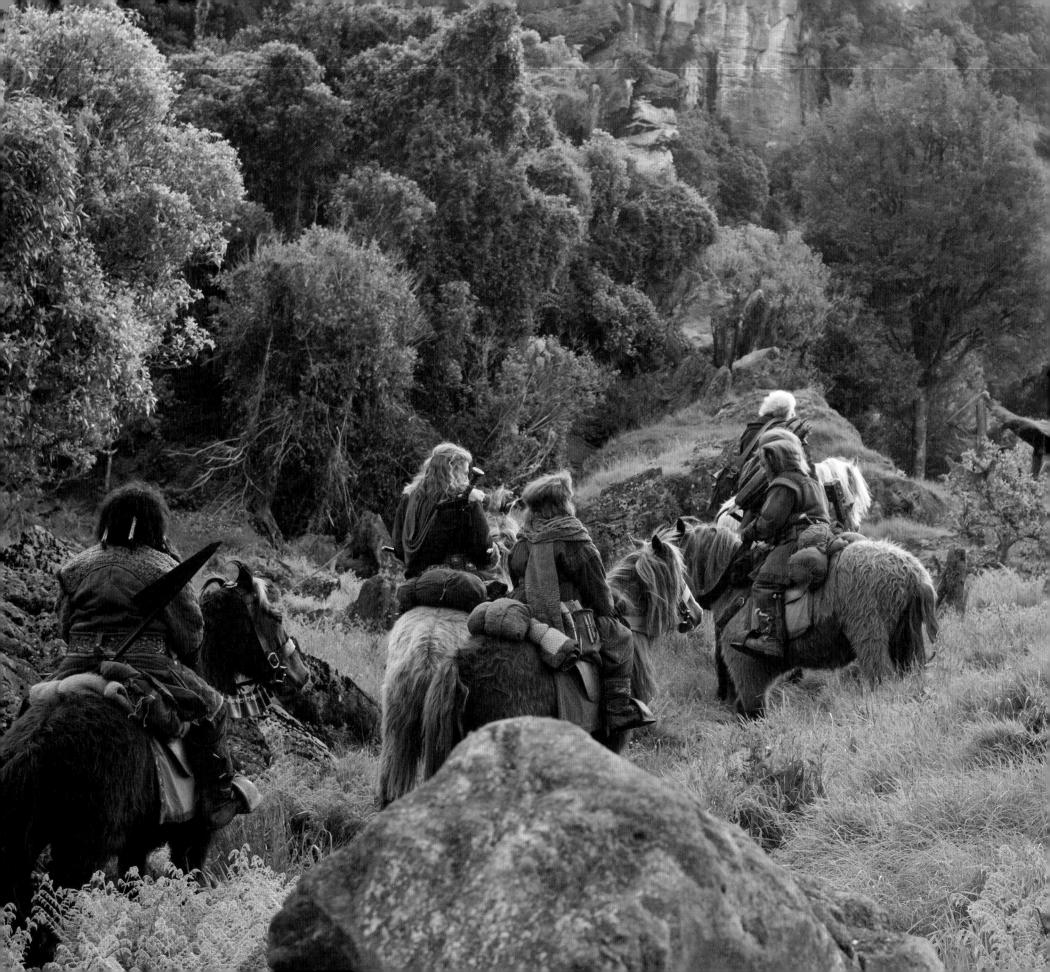

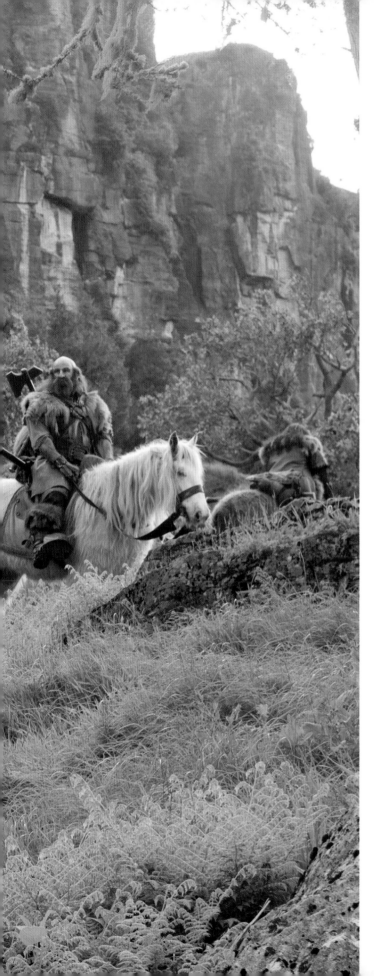

DENIZE BLUFFS

The area around Denize Bluffs is unexpected, with a rare combination of geography and botany. Large cliff faces tower over a valley pockmarked with rock columns, rising straight out of the grass. Walk down into an area of exquisitely beautiful native bush and you might have been transported directly into *Middle-earth*.

Your tour will travel to base camp, along a road built by the production company, then continue on to the main filming areas. *Staddle Farm* was created here, to be destroyed by the trolls. A team of set designers created this set at the same time as *Hobbiton*, travelling between the two.

Walking down into the bush brings you to a small *tomo* (sinkhole), where *Bilbo* received *Sting*, and *Glamdring* and *Orcrist* were discovered. While the interior was created in Wellington, the cave entrance was filmed here, where you can sit on a carpet of dry leaves and watch shafts of sunlight illuminate the mossy rocks.

Walk a little further to where *Radagast the Brown*, with his rabbit-drawn sled, warns the *Company* of approaching peril. Here, the steep landscape helped the difficulties caused by different-sized races. The much taller *Istari* were placed further down the slope, making artful use of forced perspective.

Spend as much time as you can as your guide recounts tales about the filming while you enjoy a walk among the striking yet subtly calming landscape.

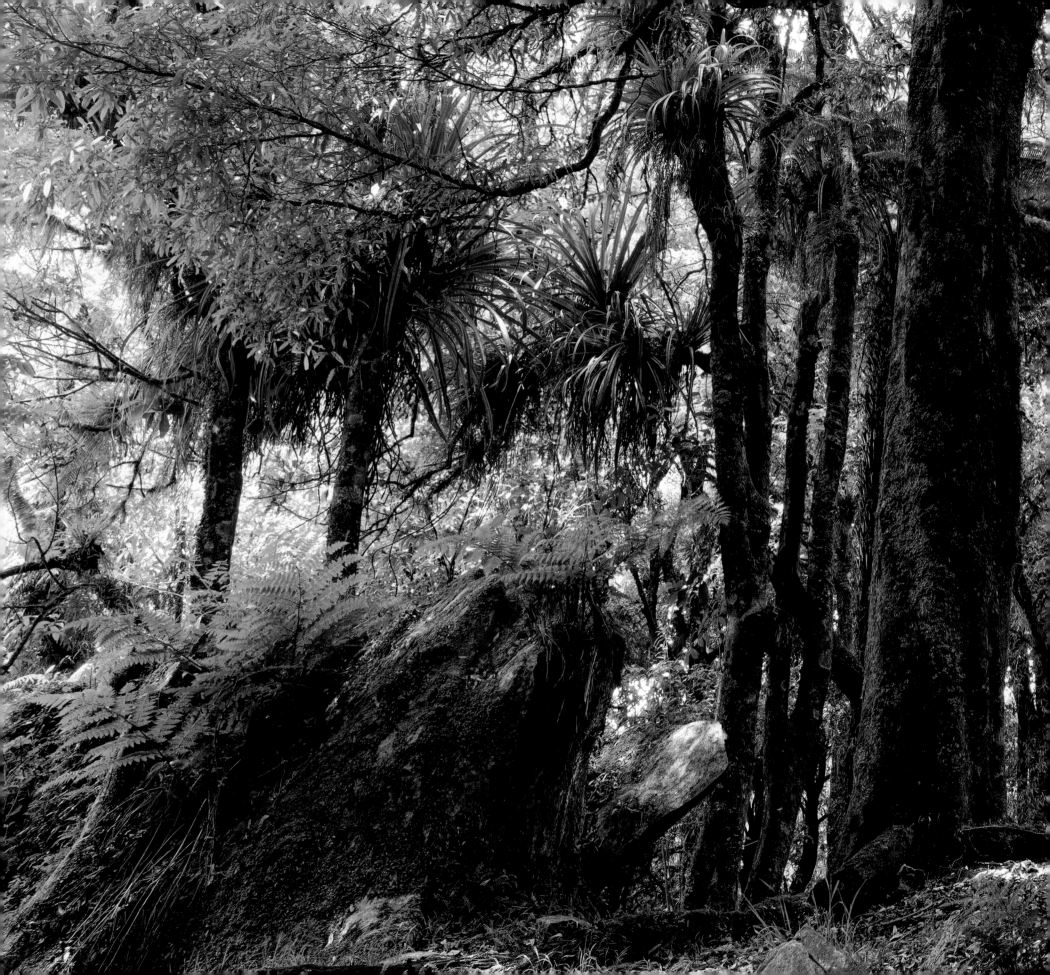

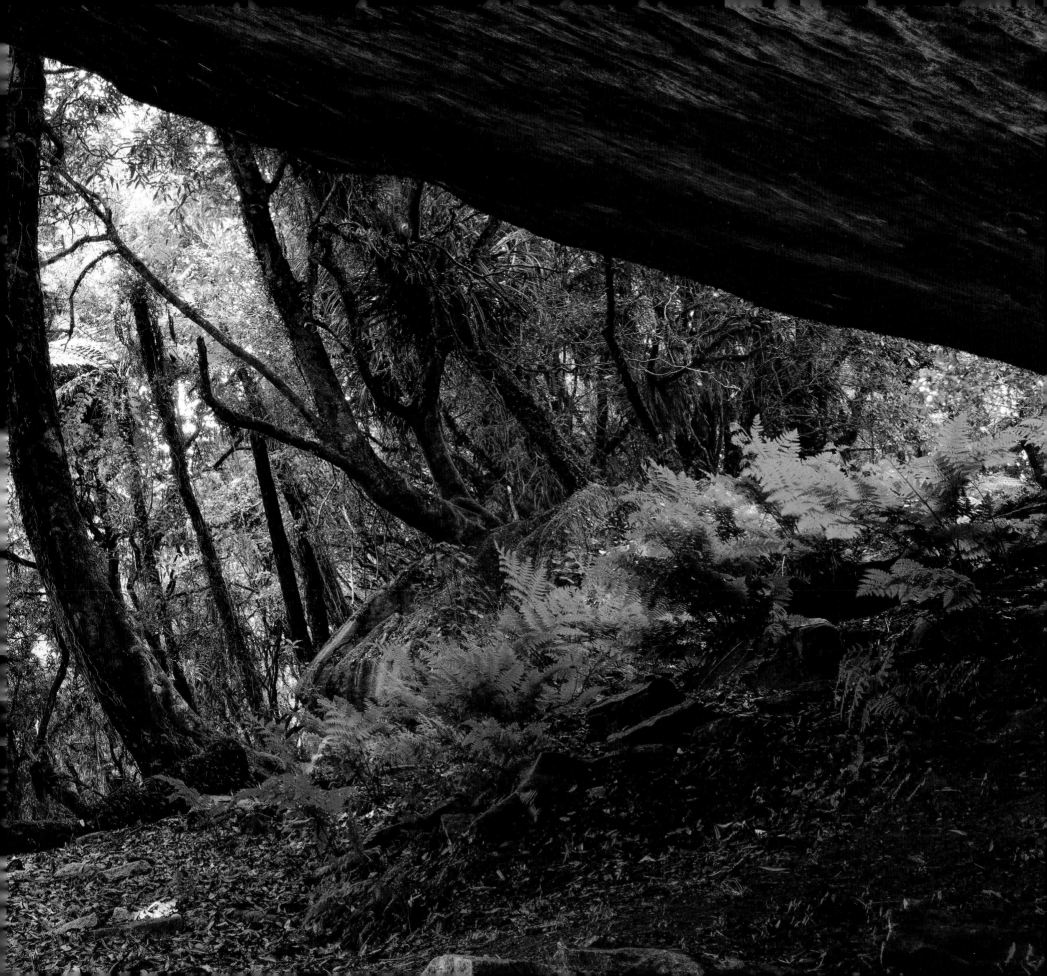

RANGITIKEI RIVER GORGE

The *River Anduin* in *The Fellowship of the Ring* incorporated four different rivers, the Rangitikei near Taihape appearing first. Drive south from Taihape and turn left at Ohotu. A bungy jump, flying fox and swing are nearby, so follow the 'Mokai Gravity Canyon' signs through heartland New Zealand. At the bungy site, park your car and cross the one-way traffic bridge. An amazing scene is revealed as the unspoilt river appears 80 metres below, flowing through a gorge of enormous proportions.

At its confluence with the Rangitikei, the Moawhango River was also used to portray the *Anduin*. As you return to the main road, cross via the next one-way bridge. Park at the far end and walk back for another spectacular view.

To make your own trip down the *Anduin*, drive south 18 km to Mangaweka. Beneath the distinctive DC-3 café is the headquarters of Mangaweka Adventure Company. River safety specialists for filming in this area, they offer a full-day eco tour entitled 'Grand Canyons of the Rangitikei'. Sit back and enjoy the scenery as you drift downstream past the exact site.

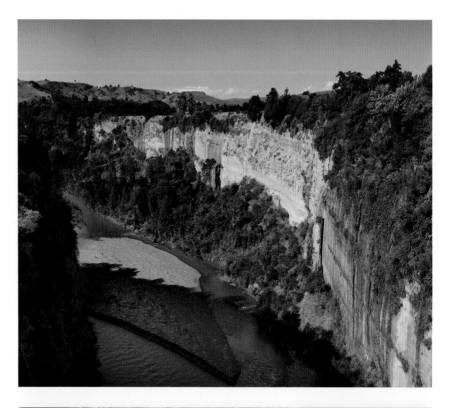

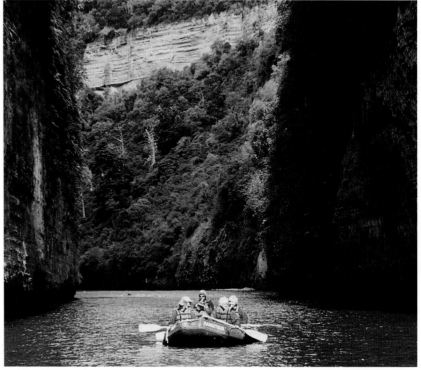

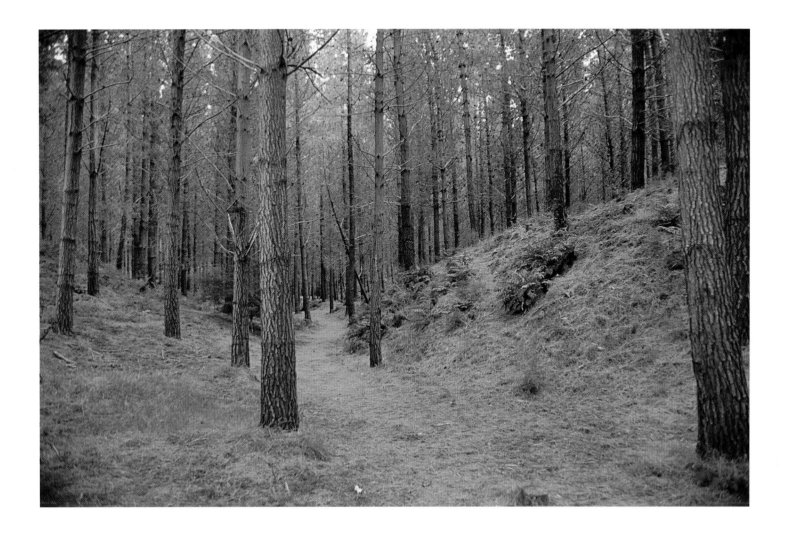

WAITARERE FOREST

Waitarere Forest is south of Foxton on the Kapiti Coast. Coming from the north, after passing Poroutawhao watch for the turning to Waitarere Beach on your right, a typical beach village. As you enter Waitarere, a small unnamed side road on the right allows entry to a parking area on the edge of the forest. Further vehicle access is not permitted, but you can walk on any of a number of well-formed tracks.

The plantation forest has since been felled and replanted. It used to stretch for some kilometres both north and south of Waitarere and is very different to native bush, with most of the trails also suitable for mountain bikes. Filming took place here for a number of scenes, including *Osgiliath Wood*, where *Frodo*, *Sam* and *Sméagol* walked after leaving *Faramir*, *Arwen* walking through the trees, and *Gandalf* and *Pippin* riding to *Minas Tirith*.

OTAKI AND OTAKI GORGE

Otaki is rich in sunshine and history, with a property situated on the Otaki Gorge Road used to portray the young hobbits' journey to the border of the *Shire*. The turn-off to the gorge is on the left, just south of Otaki, after crossing the Otaki River. Initially sealed, it soon becomes a narrow unpaved road, so care should be taken, especially for drivers not used to these conditions. Although the specific locations are not accessible to the public, the short 19 km drive is remarkable, providing a useful insight into why New Zealand was the perfect place to depict *Middle-earth*. Leaving rolling farm country, the road narrows and plunges into rimu and rata bush, revealing glimpses of the river as it flows through the gorge. The scenery is reminiscent of Tolkien's description of the outer reaches of the *Shire*, and at the end of the road there are a number of excellent picnic spots.

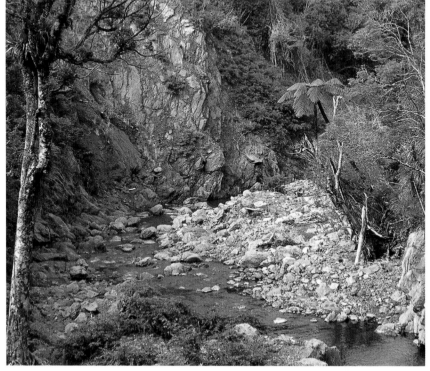

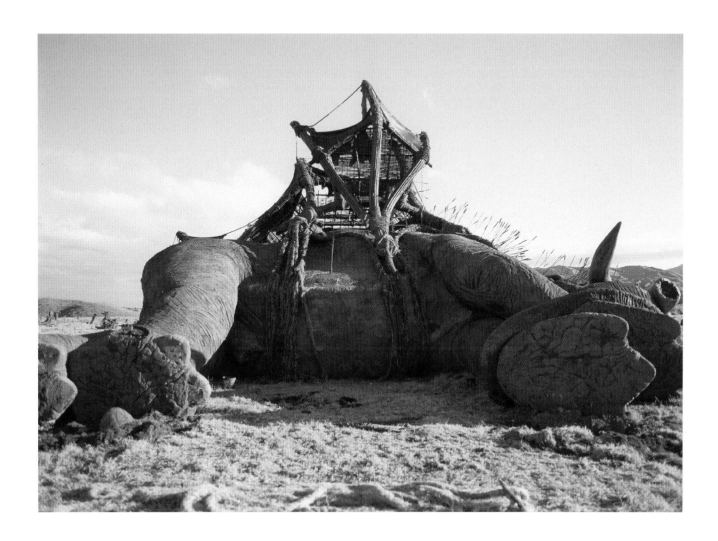

PARAPARAUMU

The ability to film different locations for the same scene and then combine them seamlessly is part of the film-maker's wizardry — and the epic *Battle of the Pelennor Fields* is a perfect example. Although wide shots for the battle were filmed in the middle of the South Island near Twizel (see page 201), many of the close-ups were filmed at Queen Elizabeth Park near Paraparaumu.

Heading to Wellington from Otaki, you can drive into the park at MacKays Crossing, which is just south of Paraparaumu. Much of the filming was undertaken with a blue-screen background, so there is nothing very recognisable — however, the downed *Nazgûl* and *Mûmakil* were both filmed here. A walk in the park or along the nearby beach is a pleasant diversion, and the Marines Memorial nearby commemorates the US Marines based here during the Second World War.

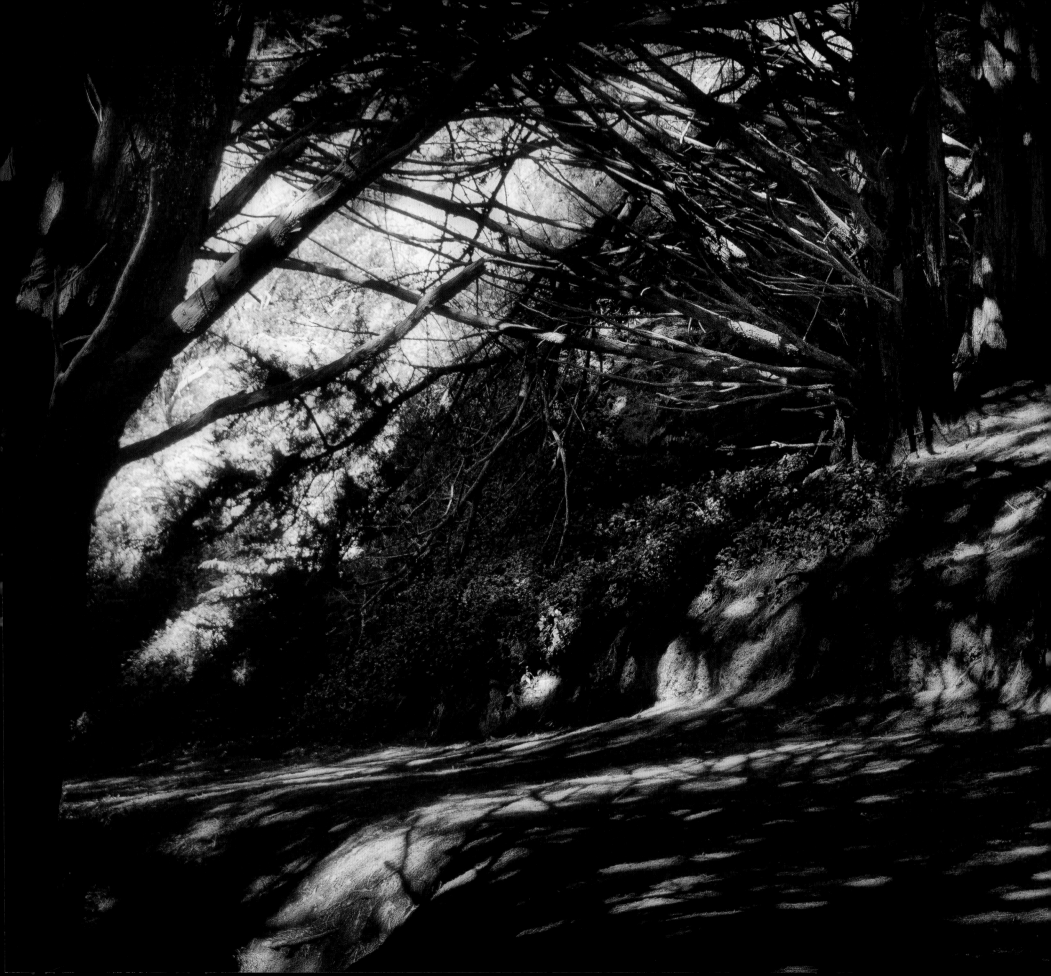

MT VICTORIA

While on paper the centre of a metropolitan area may seem to be an unlikely location for the rural *Shire*, Mt Victoria's role in *The Fellowship of the Ring* movie is a direct result of the foresight of Wellington's town planners. With a superb view from the summit — stretching from Cook Strait in the south to the city of Wellington in the north — Mt Victoria is part of an encircling green belt. Its forests and landscape provided the perfect location for the *Outer Shire*, along with good accessibility for the cast and crew, something that wasn't always easy to achieve. It also marked the commencement of shooting on 11 October 1999, and the beginning of a journey that would take the cast and crew throughout the country.

To reach the location on Mt Victoria, turn on to Alexandra Road and travel 1.3 km until you reach a car park on your left. The best way to visit the locations is to take the right-hand track along the edge of the trees downhill until you meet a track that crosses left to right. Take the track to the left and the first location you will see is the steep bank on your left where the hobbits slid down to discover a feast of mushrooms. Just a few metres further is where *Frodo* stood listening fearfully for the approaching *Nazgûl*. On your right is a hollowed-out area with a small overhanging ledge. Here a large manufactured tree was transplanted to provide a more realistic root system for the hobbits to hide under. It was here the frightened hobbits hid to escape the *Nazgûl*, with the worms and spiders escaping from the ground in revulsion at his evilness.

A little further on there is a track leading down to your right, with another steep track leading again to the right. The tree that can be seen down this slope was where *Frodo* and *Sam* had breakfast in the *Woody End*, with *Frodo* lying in

the crook of the tree smoking his pipe. Return up this track and turn to the right. Here is where the lane with overhanging trees was filmed, with the added smoke and shimmering digital effects.

Continue up the path and then veer to the right. It was here that the terrified hobbits ran to the ferry with the *Nazgûl* in hot pursuit, racing downhill through the trees. Looking back up the slope, you can see the top ridge where a scene showing the *Nazgûl* highlighted against a blue mist was filmed. Climb up here to return to the car park.

The path winds down through the woods towards the city and on a warm summer's day, the scent of pine needles and the tall trees standing against a blue sky create an idyllic and surprisingly peaceful spot.

A visit to the *Rohirrim* encampment of *Dunharrow* can also be achieved while visiting Mt Victoria. Although wide shots were taken in the South Island, close-ups were filmed here and at nearby Lyall Bay. Travel down Kent Terrace (past the Embassy Theatre) to the Basin Reserve. Turn immediately left (before the road tunnel) and drive to the top of Ellice Street. This disused quarry was remodelled into *Dunharrow* with *Rohirrim* tents and a path laid through the middle — and was where *Dernhelm* approached *Merry* prior to their epic ride to the aid of the *Gondorians*.

Additional scenes were shot at Lyall Bay, which is situated immediately beside the airport facing Cook Strait. Drive around Lyall Bay on the Island Bay Road and park beside the sea in the area known as Dorrie Leslie Park. The cliff face in the fenced-off area was utilised as *Dunharrow*. Further along at Red Rocks is where *Frodo*, *Sam* and *Gollum* cowered at the *Black Gate*.

WETA CAVE

The Weta Cave Workshop Tour is a movie-based visitor experience in the heart of Miramar, Wellington. A 45-minute guided tour from the famous Weta Cave provides a unique behind-the-scenes glimpse into the workings of Weta Workshop. The story of the creative process is told by members of the multi-talented crew from the workshop floor using the props, models and weapons they helped make for the movies. Through a number of windows opened into the heart of Weta Workshop, you can see the work being done inside one of the world's leading concept design and physical effects manufacturing operations.

The Weta Cave Shop — a cavern of creativity in its own right — boasts a range of limited edition sculptures handcrafted by the artists at Weta, unique Weta-designed clothing, jewellery and books, mugs and other collectibles. Showing every 20 minutes is their exclusive behind-the-scenes film, which features interviews with Weta Workshop co-founders Peter Jackson, Richard Taylor, Tania Rodger and Jamie Selkirk.

Enjoy an exclusive insight into the creativity and imagination that goes into crafting the props and physical effects of Weta Workshop. No visit to Wellington is complete without a peek into the Weta Cave.

FERNSIDE

Fernside provides an opportunity to drift back to the peace and tranquillity of a bygone era. Created by Ella and Charles Elgar in 1924 to entertain the rich and influential, Fernside is a gracious home with large rooms including a library, and dining and drawing rooms. Accommodation is available in one of four original en-suite bedrooms, and rooms are available for private functions.

It's no wonder the gardens of Fernside were chosen to portray *Lothlórien*. In the style of English garden designer Gertrude Jekyll, they feature a number of 'garden rooms' with their own distinctive plantings. The man-made lake was used to portray the departure from *Lothlórien* as well as scenes depicting *Sméagol* and *Déagol* fishing near the *Gladden Fields*.

The wooded walks are beautiful, especially in the autumn — to walk under the golden trees with fallen leaves underfoot is an absolute delight. Fernside is not open to casual visitors but you can either visit with Flat Earth on their Extended Location Tour or stay the night at the gatehouse, a holiday cottage situated on the property.

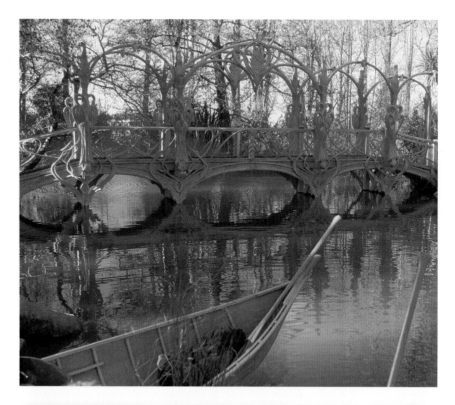

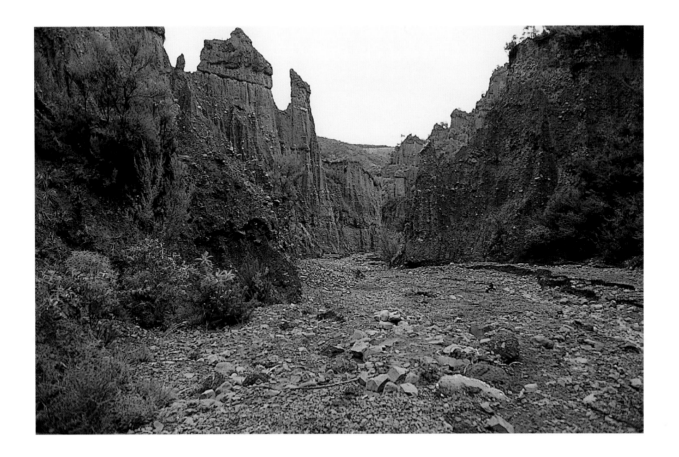

THE PUTANGIRUA PINNACLES

The Putangirua Pinnacles, an unusual geographical landscape, is accessible by car on the Wairarapa south coast. If you stay overnight in the small town of Martinborough you'll be surrounded by vineyards and olive trees, its Victorian buildings home to some great restaurants. There's also the opportunity to spend a night in the historic Martinborough Hotel, where Cate Blanchett and other cast members stayed while filming at nearby Fernside.

The drive to Putangirua takes about 45 minutes heading south on Pirinoa Road, then turning left towards Cape Palliser. After reaching the rugged coast it's a short drive to the Department of Conservation (DOC) car park and the Putangirua Pinnacles Campsite here for those with a tent and time to relive *Aragorn*'s epic journey.

One of the most spectacular ways to reach the Pinnacles (and the best way to the filming locations) is up the Putangirua streambed. Although not hard, the return trip can take two to three hours. The 'badlands erosion' was formed over time as the streambed exposed layers of gravel to rain and floods. Some rocks remain more resistant, forming pinnacles or 'hoodoos' — and within the shadows of these eerie columns *Legolas* tells the story of the *Army of the Dead* in *The Return of the King*.

KAITOKE REGIONAL PARK

Kaitoke Regional Park nestles in the foothills of the Tararua Range, 12 km north of Upper Hutt. With 2800 hectares of mature native forest, it's popular for picnics, swimming and walking, with more than 100,000 visitors a year. Turn off State Highway 2 and travel down Waterworks Road to the Pakuratahi Forks car park. Four walks begin near here, with many pleasant picnic spots along the rivers and bush fringes. Camping is available on the grassy flats at Kaitoke, with toilets and coin-operated barbecues. The beautiful clear pools on the Hutt and Pakuratahi rivers are ideal for swimming.

The position of *Rivendell* is signposted from the entrance to the park and at the location there is an interpretative display showing the construction and final result. Although most exterior shots were digitally rendered, a large set was built at Kaitoke, including the bedroom where *Frodo* recovered from his knife attack. The impressive site included scaffolding out into the river itself along with a man-made river and waterfalls to suit the film-makers' exacting requirements. Over 30 people worked from November 1999 to March 2000, with filming between April and May 2000 when more than 300 crew were on site. The temperate rainforest and river made this beautiful area an ideal representation of *Rivendell*.

HARCOURT PARK

To travel from *Rivendell* to *Isengard* was a journey of many weeks with countless leagues of wild country to cross — but in Upper Hutt it takes less than 15 minutes. Harcourt Park was used for three different *Isengard* scenes and is situated on Akatarawa Road; a right turn off State Highway 2 if returning from Kaitoke. Accommodation is available next door at the Harcourt Holiday Park.

An elevated section of the park was transformed into the gardens of *Isengard* where *Gandalf* and *Saruman* met after the rediscovery of the ring at *Hobbiton*. It is located across a green lawn and up a small rise with a park bench at the top, and you can look down and see another two sites, although nothing remains today. During filming, the lawn was removed and a gravel pathway formed complete with a chain-link fence on each side. Sound familiar? It was the entrance road into *Isengard*. Once the scenes were completed it was removed and the lawn replanted.

During the transformation of *Saruman*'s lair, trees needed to be filmed being cut down to fuel his furnaces, a number of times and from different angles. Two trees were cut and transported (roots and all) over 200 km, with each section numbered. Two holes were dug and iron poles driven into the ground, and the trees reassembled by bolting the branches together before they were 'planted' attached to the iron poles. Effectively hinged, they could be 'cut' down, brought back up and 'cut' down again. As the trees didn't have enough leaves, a team spent two weeks wiring on plastic ones.

The results were spectacular. Filmed in the rain, the trees toppled on command and some spectacular footage was obtained and mixed digitally to portray the infamous makeover of *Isengard*. The trees have since been removed.

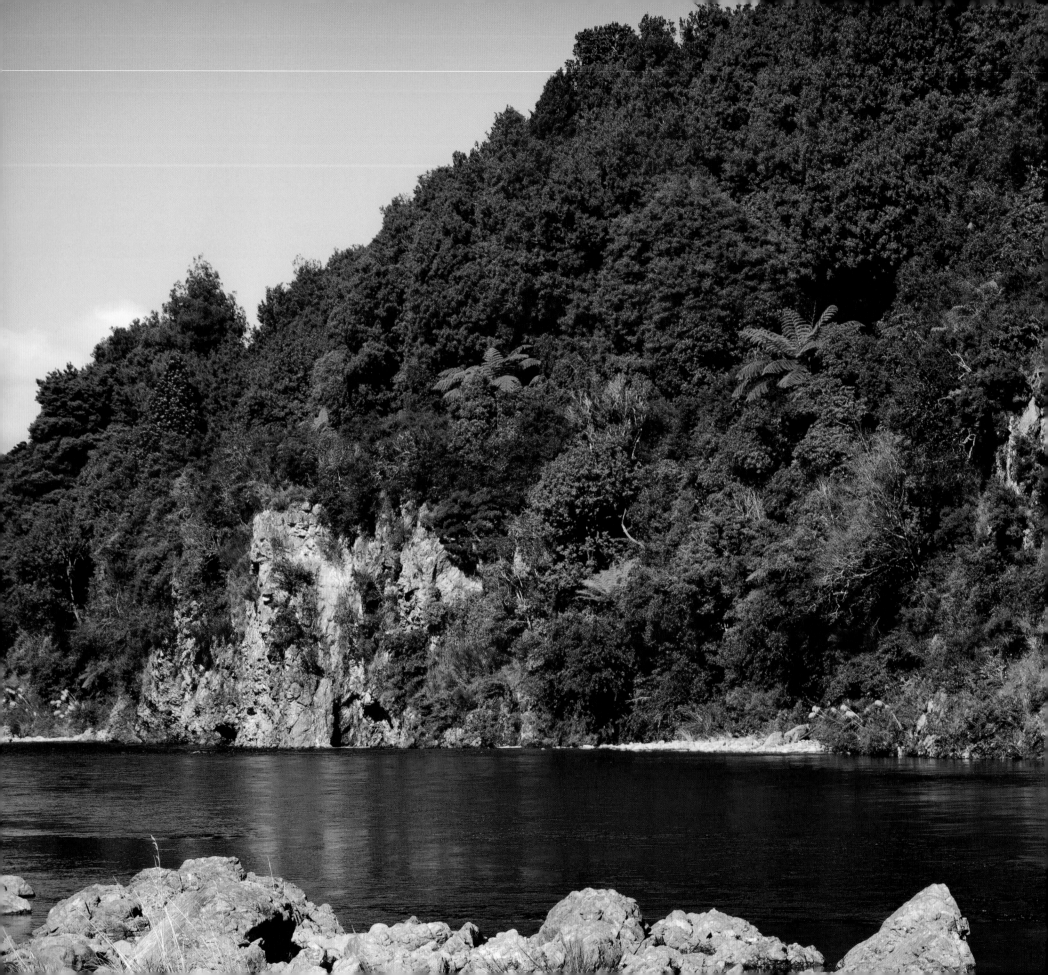

HUTT RIVER

The Hutt River flows from its source in the southern Tararua Range through bush, farmland and city before entering the sea at Petone, and was an important transport link for both Maori and European settlers. Remnants of original vegetation remain on its banks in many places and its natural beauty provided an ideal site for filming the *River Anduin*, close to the Wellington studios.

Principal filming took place between Moonshine and Totara Park, although further smaller scenes were shot at Kaitoke in the north. The river can be accessed off State Highway 2 — after crossing the Moonshine Bridge (heading north) watch for the access road on your left just past Poets Park. Here the *Fellowship*'s small Elven boats were launched into the river, and a number of close shots of the travellers came from here.

Another great way to follow the river is to walk all or part of the 24 km Hutt River Trail, starting at Petone in the south. An access point at the Moonshine Bridge allows a short stroll along the bank to Totara Park, making a pleasant diversion — civilisation seems very far away.

The scene where *Aragorn* was washed ashore after his encounter with the wargs in *Rohan* was filmed on another portion of the Hutt River. To reach it, turn left off the main highway (State Highway 2) approximately 2 km north of Upper Hutt on to Topaz Street. At the next roundabout turn right into Gemstone Drive and a little way down on the right there is public access via a small driveway to the river.

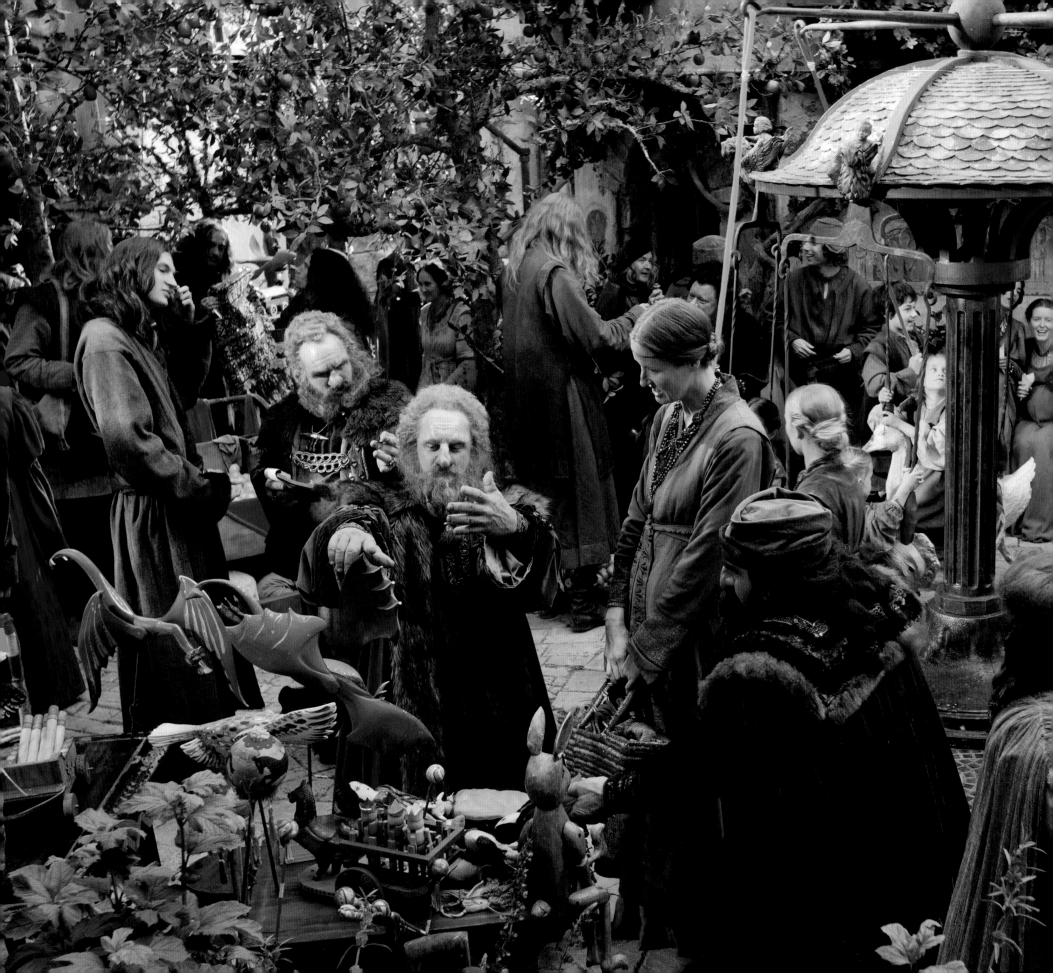

DALE — THE SET

The township of *Dale* was built into the slopes of Mt Crawford in Wellington. Totally removed after the completion of filming, nothing now remains of this beautiful set. *Dale* was situated on the *River Running* between the *Lonely Mountain* and the *Long Lake*. A fine city, it traded food and other supplies with the dwarves of the *Lonely Mountain* in return for craft, and especially toys. In the year 2770 of the *Third Age*, the dragon *Smaug* destroyed the city and killed most of its residents, including *Girion*, the last *Lord of Dale*.

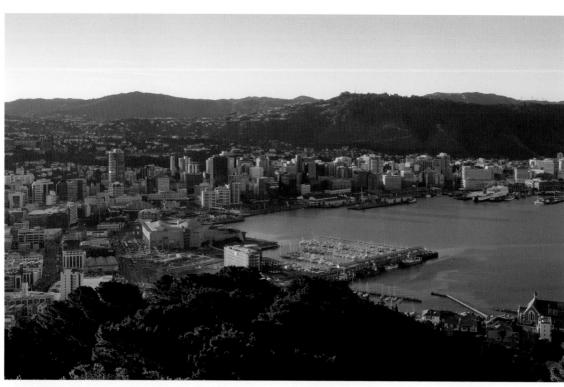

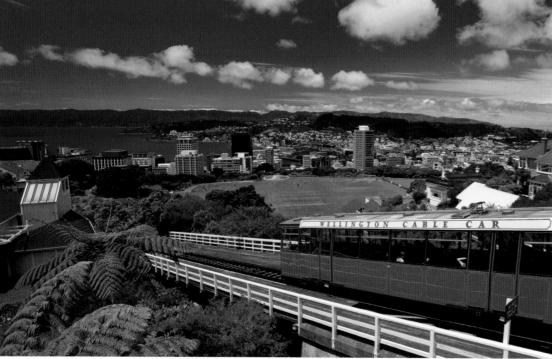

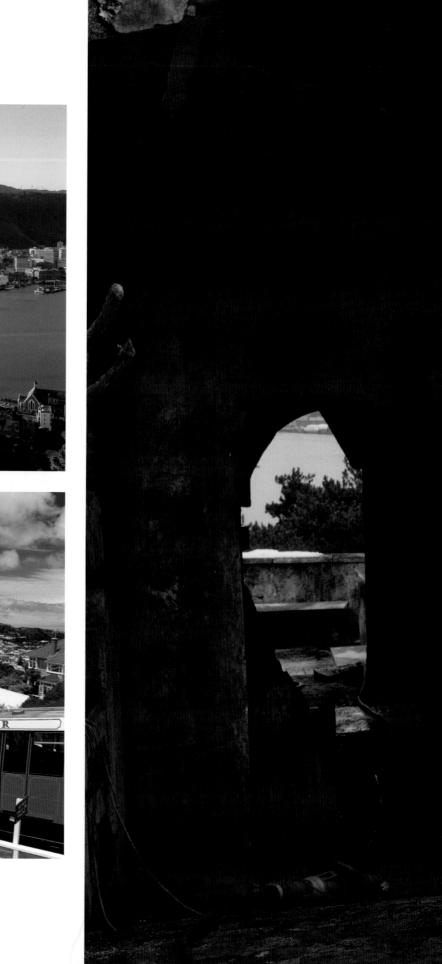

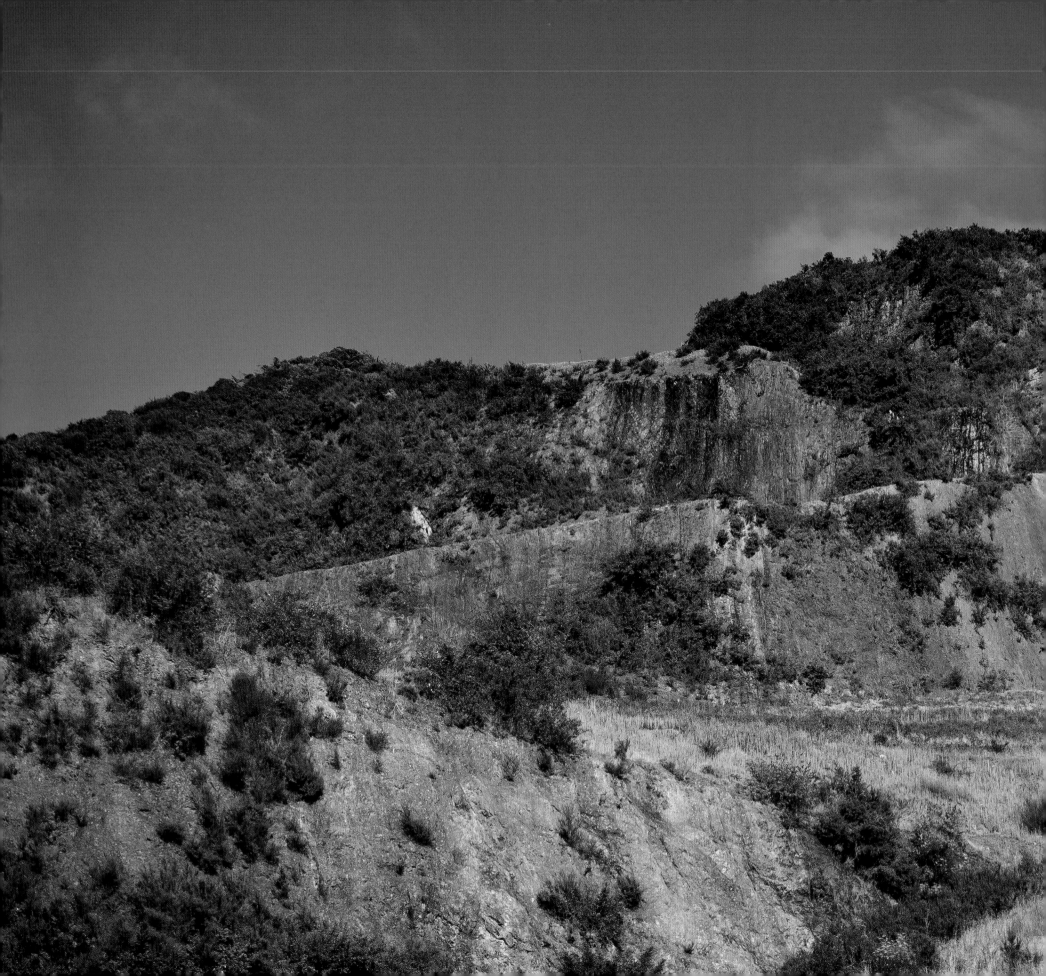

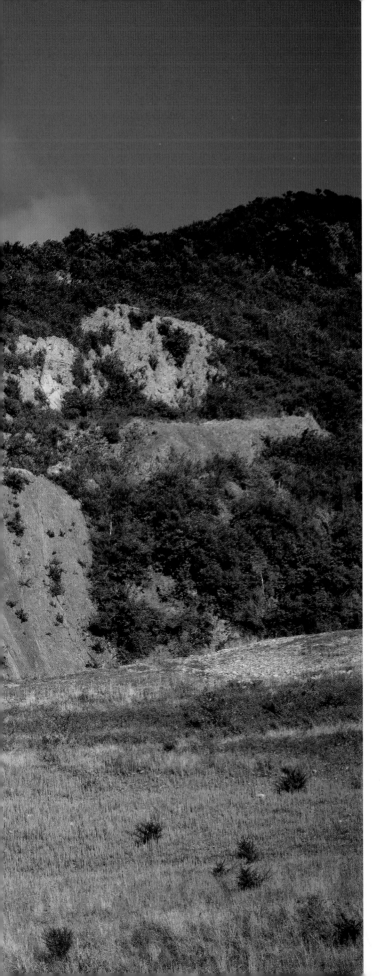

HELM'S DEEP — THE SET

The set has been totally removed but for the curious, travel out on the Western Hutt Road to Haywards Hill Road. The quarry is at the bottom of this hill and is closed to the public.

The fortress of *Helm's Deep* was located in the northern *White Mountains* at the head of the *Deeping Comb*. Although built by *Gondor*, it was later occupied by the men of *Rohan* and became a refuge during times of war. *The Tower of the Hornburg*, *Helm's Gate*, the *Deeping Wall* and *Deeping Tower* were major fortifications guarding the *Aglarond*, a series of caverns reaching back into the hills. Also known as the *Glittering Caves*, these became a place of hiding during the *Battle of Helm's Deep*.

MINAS TIRITH — THE SET

Also constructed at the quarry off Haywards Hill Road was the city of *Minas Tirith*. Nothing now remains and the quarry is fully operational again.

Built upon the foundations of the *Helm's Deep* set, parts of *Minas Tirith* were constructed as full-scale sets where close-up action with actors was required. Some of these were later rebuilt at the Stone Street Studios when pick-ups were filmed just prior to the release of *The Lord of the Rings: The Return of the King*.

In addition, the whole city was created as a very large, highly detailed 'bigature' by Weta Workshop, which also included the city and surrounding *Pelennor Fields* and *Mount Mindolluin*.

The scenes here were some of the last to be filmed and included three different units shooting simultaneously.

BREE — THE SET

Bree was filmed at Fort Dorset, in the suburb of Seatoun, an old army base that has since been demolished and replaced by houses. Nothing remains of the set but those wishing to obtain a view of the base can go to the end of Burnham Street and take a stroll along the beach to the south.

The township of *Bree* was located near the intersection of the *East* and *North*

*Road*s in central *Eriador*. It was a hamlet of both hobbits and men, and the *Prancing Pony Inn* was the centre of community life for both the local populace and travellers who frequented the tavern each night to gossip and share stories. A two-day ride from *Hobbiton*, it became the overnight refuge for the four hobbits as they fled their homeland.

SOUTH ISLAND

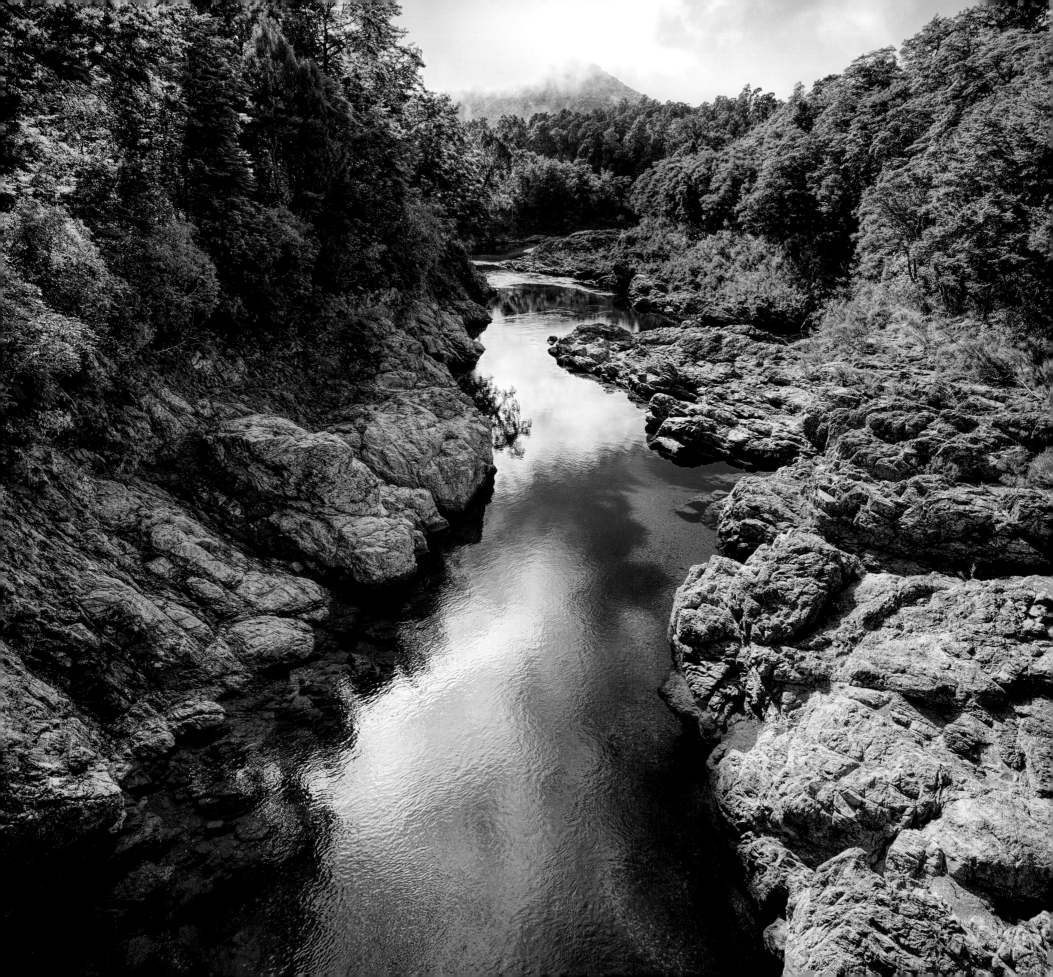

PELORUS BRIDGE

The short drive from Havelock to Pelorus Bridge follows the Pelorus River. As you approach the bridge, the road dives into a river-flat forest, with towering beech, rimu and kahikatea, where 13 dwarves and one bedraggled hobbit washed ashore after their capture by *King Thranduil* and subsequently escaped down the *Forest River*. With crystal-clear water contrasting with dark-green trees, you could be in *Mirkwood Forest*. Walk onto the bridge and look downriver to the trees and water, before descending via the path beside the bridge on your left, where the orcs tried to stop the wild barrel ride. Filming came to a rapid conclusion when the river rose to a dangerous level within a few hours. For those with a tent, the Pelorus Bridge Campground is superb, with great facilities and a beautiful outlook — the river where the dwarves were washed ashore and climbed out of their barrels flows past the campground. Advance preparations included stunt crews planning how the actors could float safely down the river, while scaffolding allowed cast and crew easy access. Large plastic pools augmented the small waterfall — releasing floods of water on cue.

There are a number of walks, such as the 30-minute Totara Walk and the 45-minute Circle Walk. Both are easy and flat, through ancient forest with glimpses of the river — a striking and accessible location.

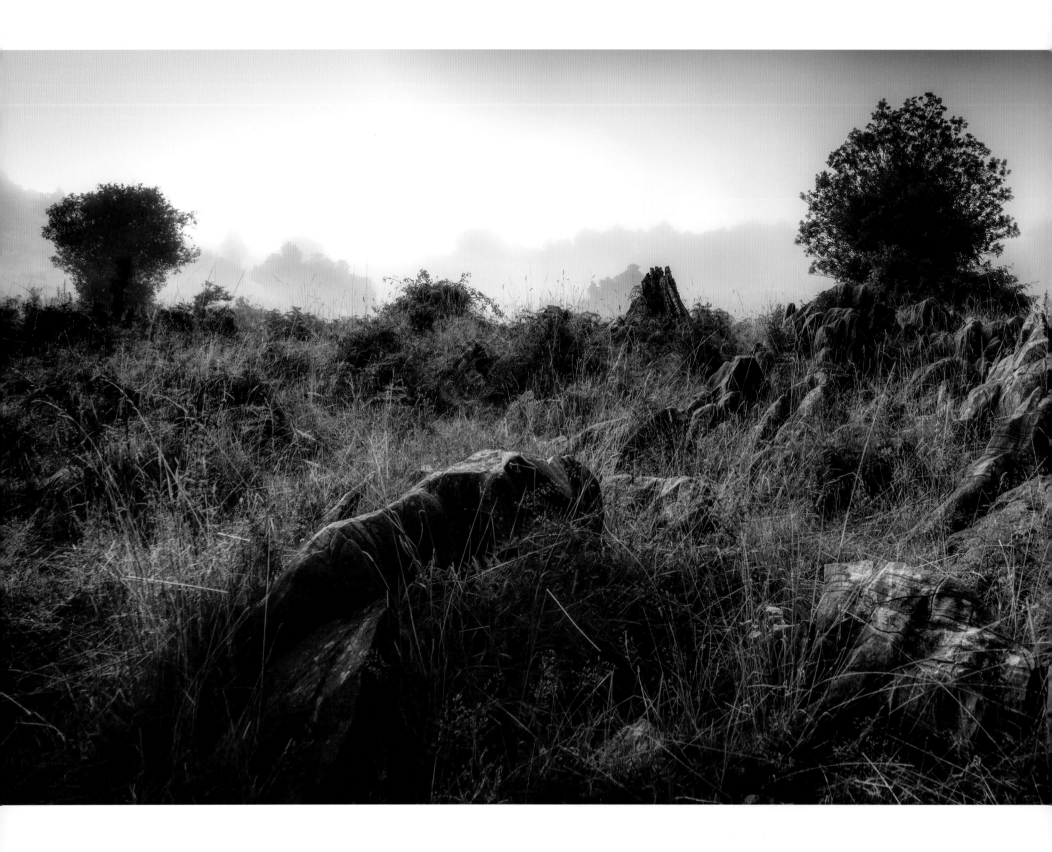

TAKAKA HILL

The two-hour drive to this location is one of unspoilt beaches, striking mountain landscapes and dramatic holes in the earth. After passing through rich orchard areas, stop at Mapua for great coffee and the freshest, tastiest smoked fish. Pass through Motueka and pause at the golden sand beach of Kaiteriteri, where holidaymakers sunbathe and swim in clear blue water.

At the 792-metre summit of Takaka Hill are rocky marble outcrops, the only place outside of Italy where such formations exist. Takaka marble can be seen in many public buildings throughout New Zealand. The summit also offers great views of Golden and Tasman bays before winding down to Takaka, and entry to Abel Tasman National Park.

At Ngarua Caves, a scene in *The Hobbit: The Battle of the Five Armies* was filmed showing the return to *Hobbiton*. Travel the unpaved Canaan Road nearby for a journey through ghostly trees amid outcrops of weather-worn marble. Park after the cattle stop 8 km from the main road. Just ahead on your right is where the catering marquee was situated and a little further on past another stand of trees is where *Aragorn* led the hobbits into the wilds after leaving *Bree*. A further scene filmed here showed the hobbits leaving the *Shire* as well as the edges of *Fangorn Forest* and the *Party*'s departure from the *Shire* in *The Hobbit: An Unexpected Journey*.

There's also a two-hour return walk to Harwoods Hole, a 176-metre-deep, 15-metre-wide *tomo* (sinkhole) in the limestone rock. The twelfth largest in the world and the largest in the southern hemisphere, it's very popular with potholers. Warning: keep to the marked paths, as a number of unmarked sinkholes rival the best in *Moria*.

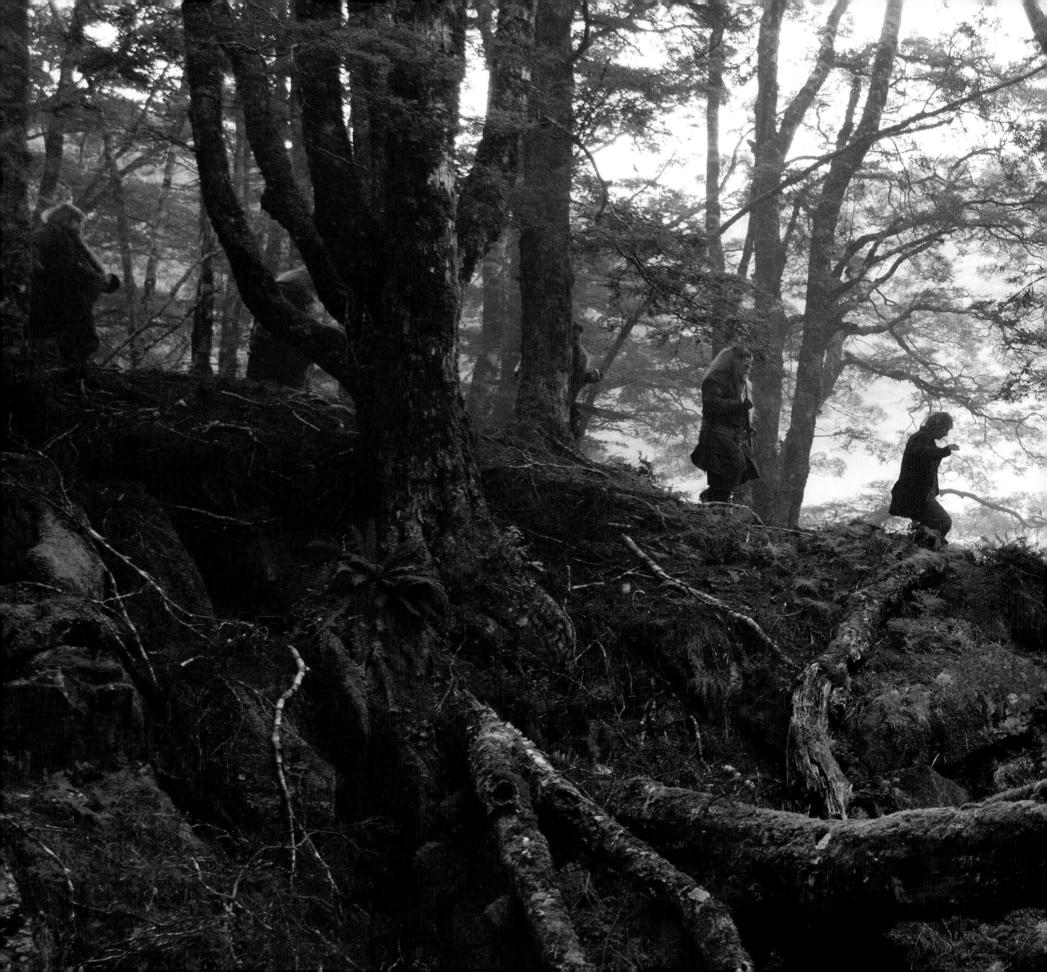

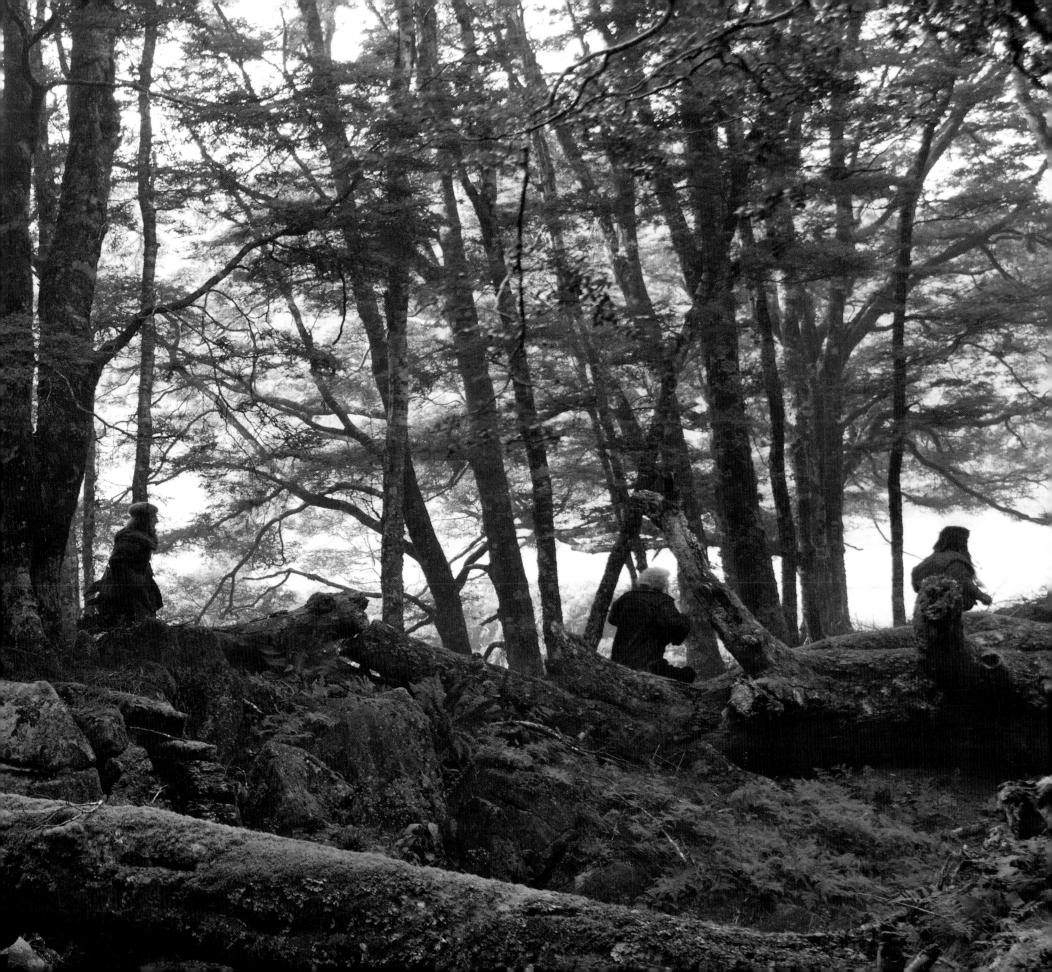

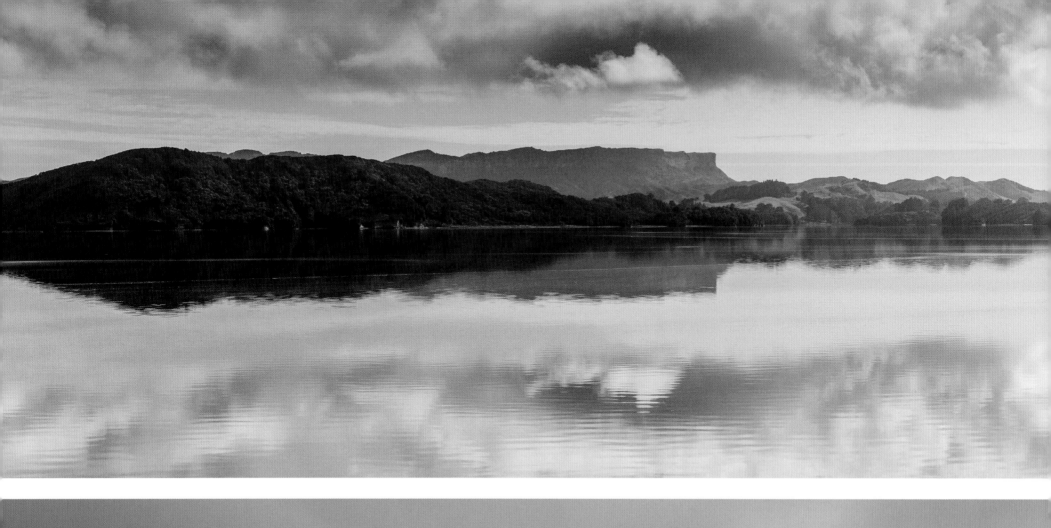
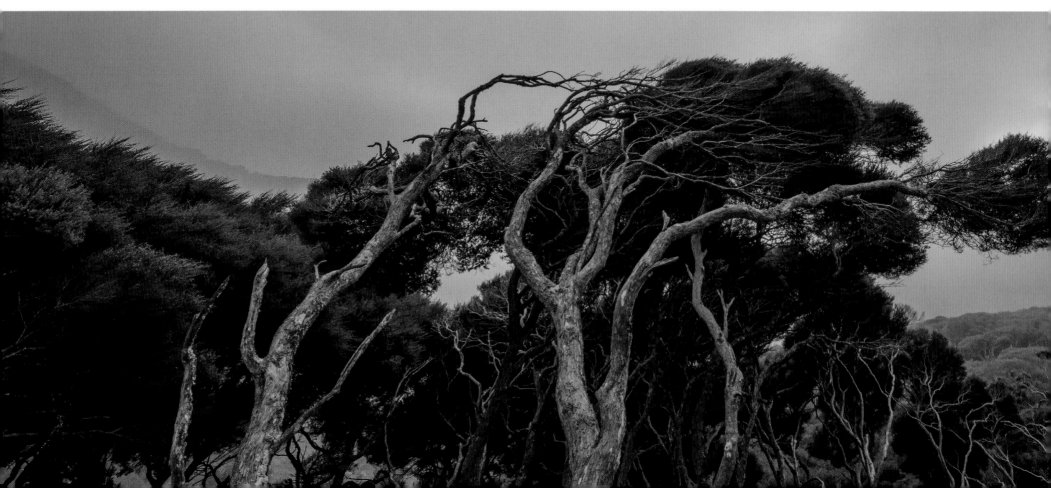

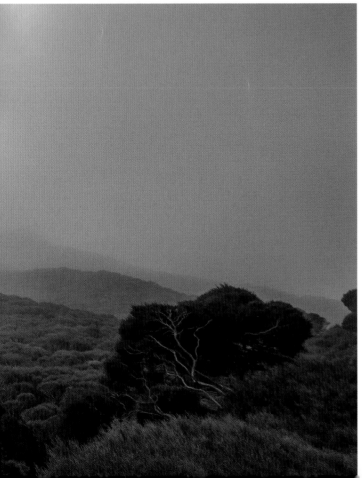

KAIHOKA LAKES

As the *Party* leave the *Shire* and travel through the wilderness, *Bilbo* heads towards his first adventure — meeting the trolls in the *Trollshaws*. The main location for this scene was filmed at Piopio in the North Island, but there's a glimpse of a wild land as the *Party* descend around a rocky outcrop. This small but important scene was filmed near Kaihoka Lakes and while it appears only briefly in the movie, a visit to the location and surrounding area is highly recommended.

Depart Collingwood towards Farewell Spit and at Pakawau turn left onto Pakawau Bush Road. After 5.2 km turn right into Kaihoka Lakes Road. Despite the valley's proximity to the sea, the mountains and rocky outcrops keep it hidden. Millennia of wind and rain have removed the soft outer layers, and the amazing shapes of the peaks are a photographic gem. The location used in the film is not accessible, but the journey to a locked farm gate is well worth it.

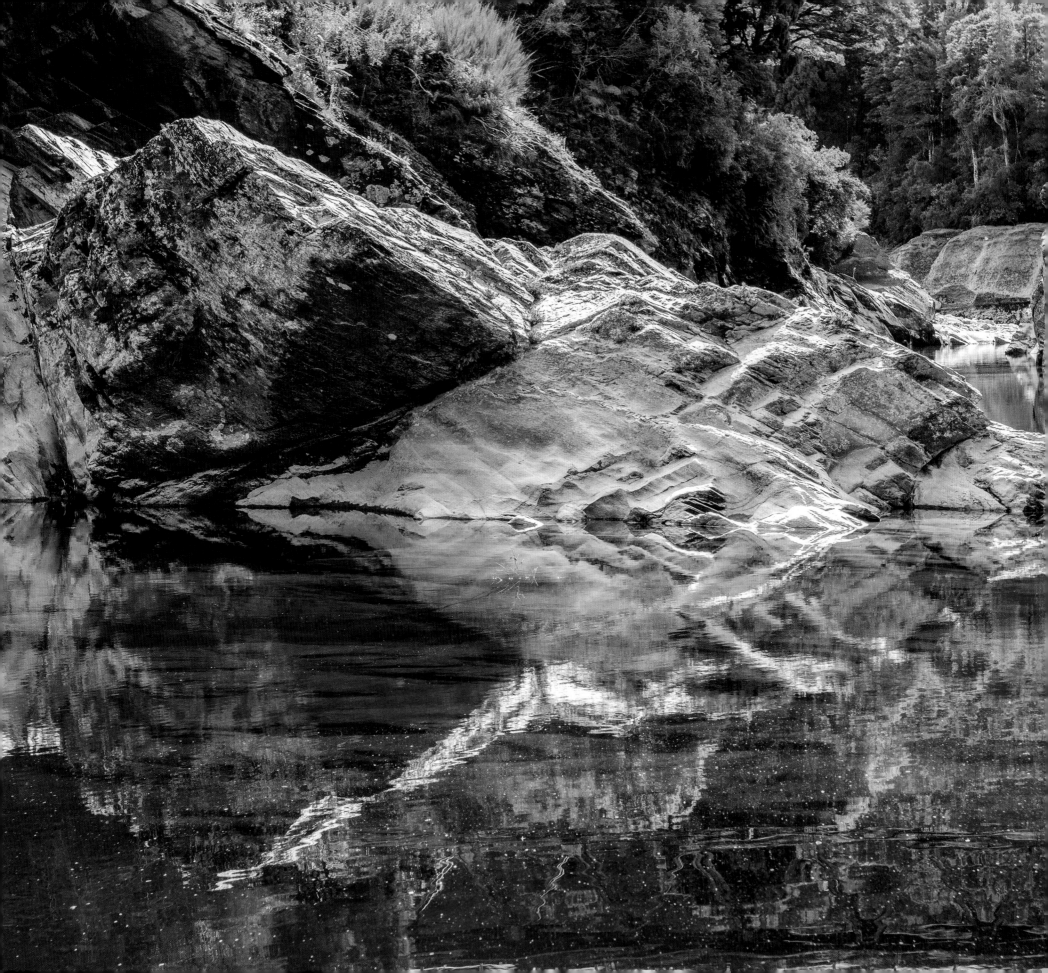

AORERE RIVER — SALISBURY FALLS

Despite the challenges of remote locations, in each movie the cast appear in the extraordinary places Tolkien imagined. One of these is Salisbury Falls. Follow the road marked 'Heaphy Track' off the main Takaka–Collingwood Highway for 18 km. There's an absolute treasure 5 km before the falls. The road to Salisbury Falls is just past the historic Langford Store, in Bainham, which has stood for over 100 years. Look inside the tiny store, where the shelves are delightfully cluttered, and buy a postcard, use the local post box or have a coffee.

The view crossing the bridge is as spectacular as it is surprising — an unexpected river carves through the landscape, surrounded by granite guardians. The falls are a five-minute walk away. Despite the distance between Aratiatia in the North Island and the Pelorus and Salisbury falls in the South Island, similar geographical formations allowed the film-makers to seamlessly meld the *River Running* from the *Elven King's Gate* to the *Long Lake*.

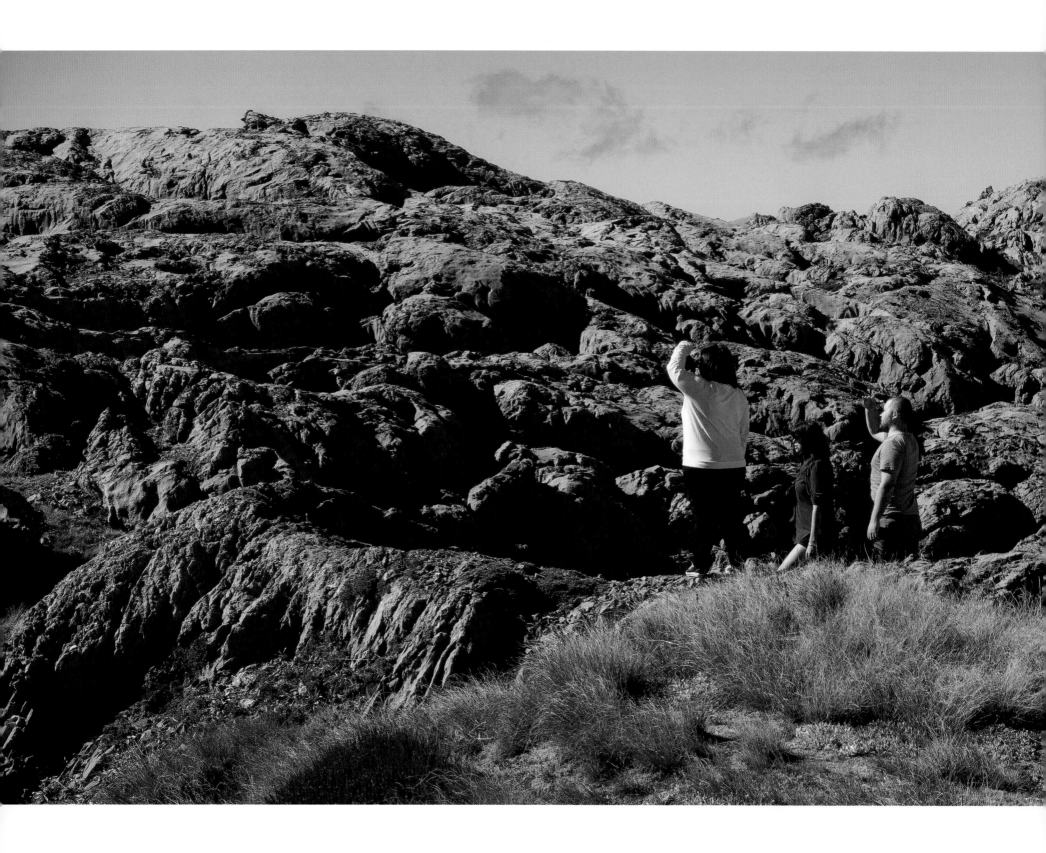

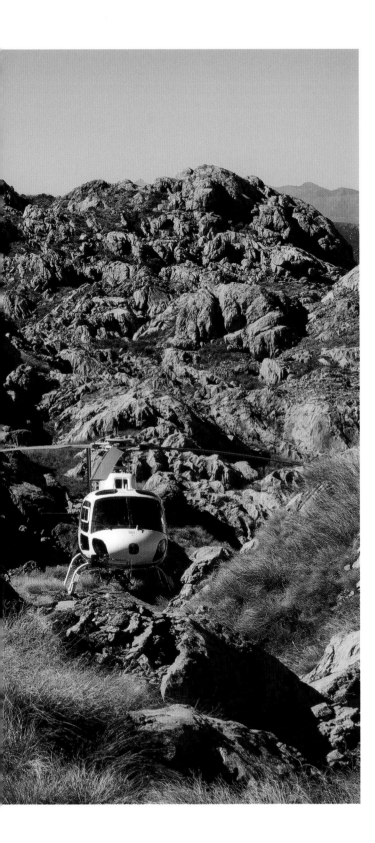

MT OWEN

The 1800-metre peak of Mt Owen is near Murchison, at the southern end of Kahurangi National Park, which contains some of the oldest rocks in New Zealand, with many geological features linking the area with the ancient continent of Gondwanaland. Mt Owen appeared in *The Lord of the Rings: The Fellowship of the Ring* depicting the eastern exit from the *Mines of Moria*.

As you cross the eastern slopes of Mt Owen, a landscape of glaciated marble karst appears, and then as you move closer, the scale of the rocks is revealed. The seemingly flat features are split with crevasses and interspersed with deep sinkholes — like the face of a wrinkled troll — displaying the awesome power of nature. As water fell on the soft limestone over millions of years, a vast underground drainage network evolved, resulting in New Zealand's largest cave system.

When you visit this location, you begin to appreciate what a huge undertaking it was to film here. Totally exposed to the elements, crew and actors were transported in and out by helicopter for 10 days — with spectacular results.

To portray the depleted *Fellowship* escaping from the horrors of *Moria*, wooden steps were built on the site and the eastern doors added digitally. It's a tribute to the location scouts that one of the most emotively charged scenes in *The Fellowship of the Ring* was geographically enhanced by the bleached moonscape of Mt Owen.

While it's possible to tramp to this site, it's not recommended for anyone other than experienced mountaineers, so sit back, relax and enjoy a magic helicopter ride.

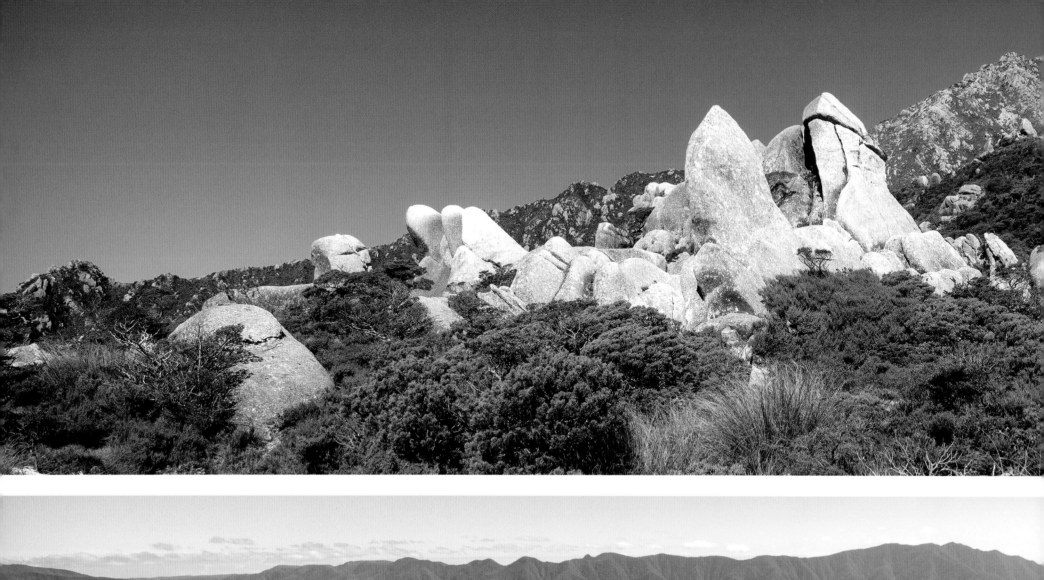
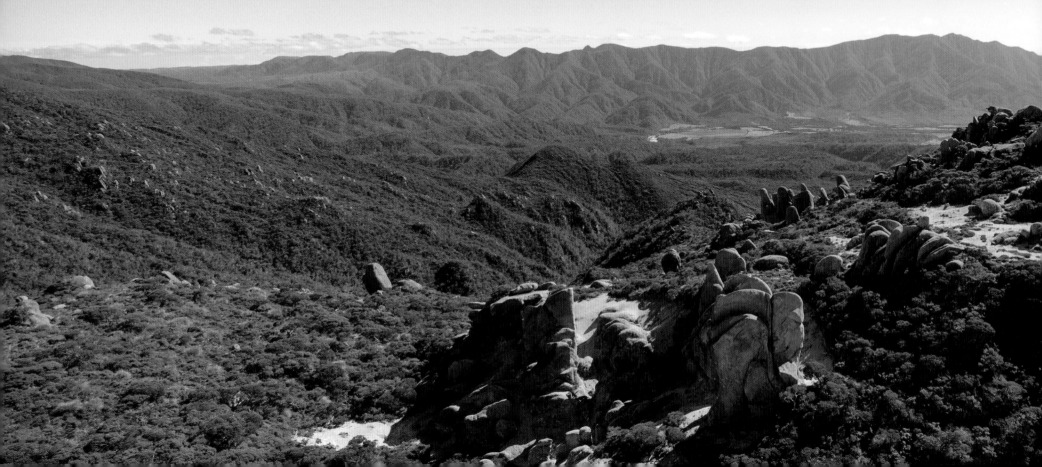

MT OLYMPUS

One of the most spectacular landscapes in *The Fellowship of the Ring*, in Kahurangi National Park, on the side of Mt Olympus, would not have appeared at all were it not for the local knowledge of Reid Helicopters' pilot, Bill Reid. While filming was under way at Takaka, Bill described a place he thought would be ideal to show some of the rough country south of *Rivendell*. Several months later, when snow made filming at another location impossible, this became where the *Fellowship* hide from *Saruman*'s *crebain* (black crows from *Dunland*).

The location is remote and spectacular, and so isolated that the only way for the average traveller to reach it is by helicopter. Reid Helicopters provided considerable logistical support to the crew while they filmed in the region and transported the cast and crew from base camp to the cliff-top sites. Reid Helicopters offers a number of scenic flights, including a special *Lord of the Rings* location tour over the *Chetwood Forest*, Mt Olympus and Mt Owen.

Mt Olympus is appropriately named. The rocky outcrops sprout from the side of the mountain as if the gods themselves cast them there in some form of demented game. Over time, water erosion has revealed twisted, cracked and unbelievable columnar shapes. At times, the valley below is covered in cloud, and the stark pillars point to the sky in an accusing manner, adding to the mystical effect.

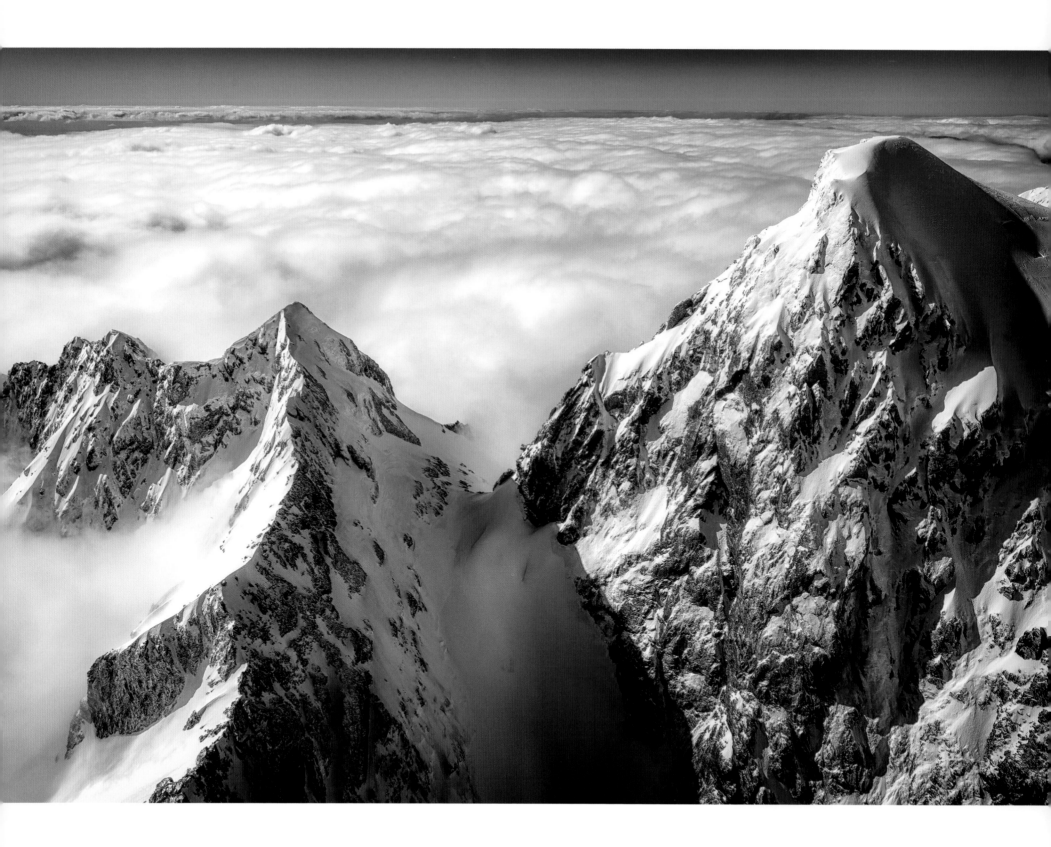

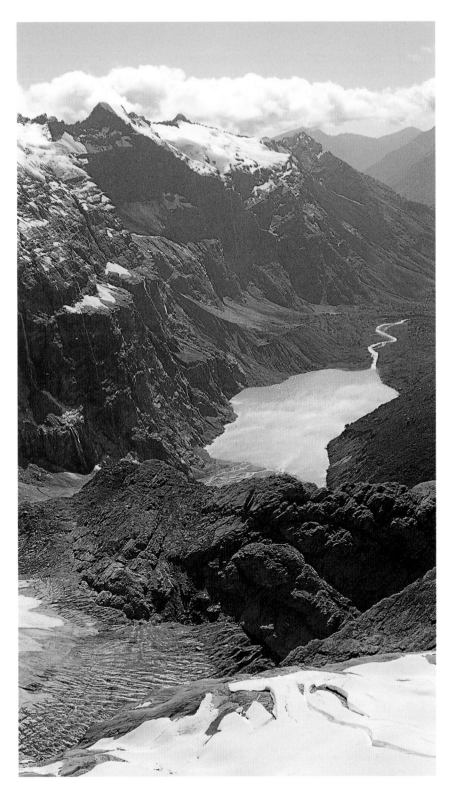

THE SOUTHERN ALPS

The Southern Alps form the backbone of the South Island. Stretching for over 550 km from Blenheim in the north to Fiordland in the south, they contain all of the peaks over 3000 metres in the country.

Sandwiched between the Australian and Pacific tectonic plates, there is continual movement both vertically and horizontally, but erosion caused by high rainfall and other factors keep the mountains at a fairly stable height.

The Alps have a considerable effect on South Island weather, with the predominant westerly winds buffeting the mountains creating two distinct climates. Westerly fronts cause significant rainfall on the West Coast, but as they rise over the Alps and drop their moisture, heating creates a hot, dry föhn wind in Canterbury and Otago, commonly called 'The Nor'wester'. The results are particularly noticeable crossing the Main Divide — the western side of the Alps is luxuriant bush and the east, brown grass.

The Alps were an obvious choice to portray the *Misty Mountains*. As well as a number of generic locations, four specific sites were used in the first trilogy.

The northwestern slopes of Mt Earnslaw near Glenorchy portrayed *Caradhras* as the *Fellowship* attempted to cross the *Misty Mountains*; the Rangitata region was used to portray the area where *Frodo* dropped the *One Ring* to be picked up by *Boromir*; Mt Aspiring near Wanaka was used in the spectacular opening sequence of *The Two Towers* to represent the high peaks around *Moria*; and the East Matukituki was used to show the *Fellowship* marching in single file through the snow.

PUNAKAIKI

The West Coast of the South Island is spectacular — the Southern Alps fall steeply to the wild Tasman Sea, with glorious rainforest between. To fully appreciate it, enter via the Buller Gorge in the north, travel the coast and exit through Haast Pass (or vice versa).

A location used in *The Hobbit: The Desolation of Smaug* lies near a unique geological formation — the Pancake Rocks, at Punakaiki. These formed 30 million years ago, from minute fragments of dead marine creatures and plants. Immense water pressure solidified these into hard and soft layers — and seismic action lifted them to where rain, wind and seawater sculpted intriguing shapes. At high tide waves surge through blow holes, and the round trip from the visitor centre is an easy 15 minutes.

The Paparoa Ranges, a backdrop to Punakaiki, were used in the barrel ride. While water sequences were filmed at Pelorus Bridge, Aratiatia Rapids and the Stone Street Studios, higher peaks were needed as a vertical counterpoint. Glacier Southern Lakes Helicopters pilot Alfie Speight flew and filmed through river valleys, and dramatic cliffs were seamlessly joined into the action. Bullock Creek Track, a 12 km narrow unformed road with a turning point at the end, takes you through unspoilt bush with glimpses of the cliffs (the road is closed in wet weather). Alternatively, the Pororari Track follows a spectacular limestone gorge, with huge rocks in deep river pools, and beautiful forest. A gentle 15-minute stroll from the car park brings you to a seat and lookout, with superb views.

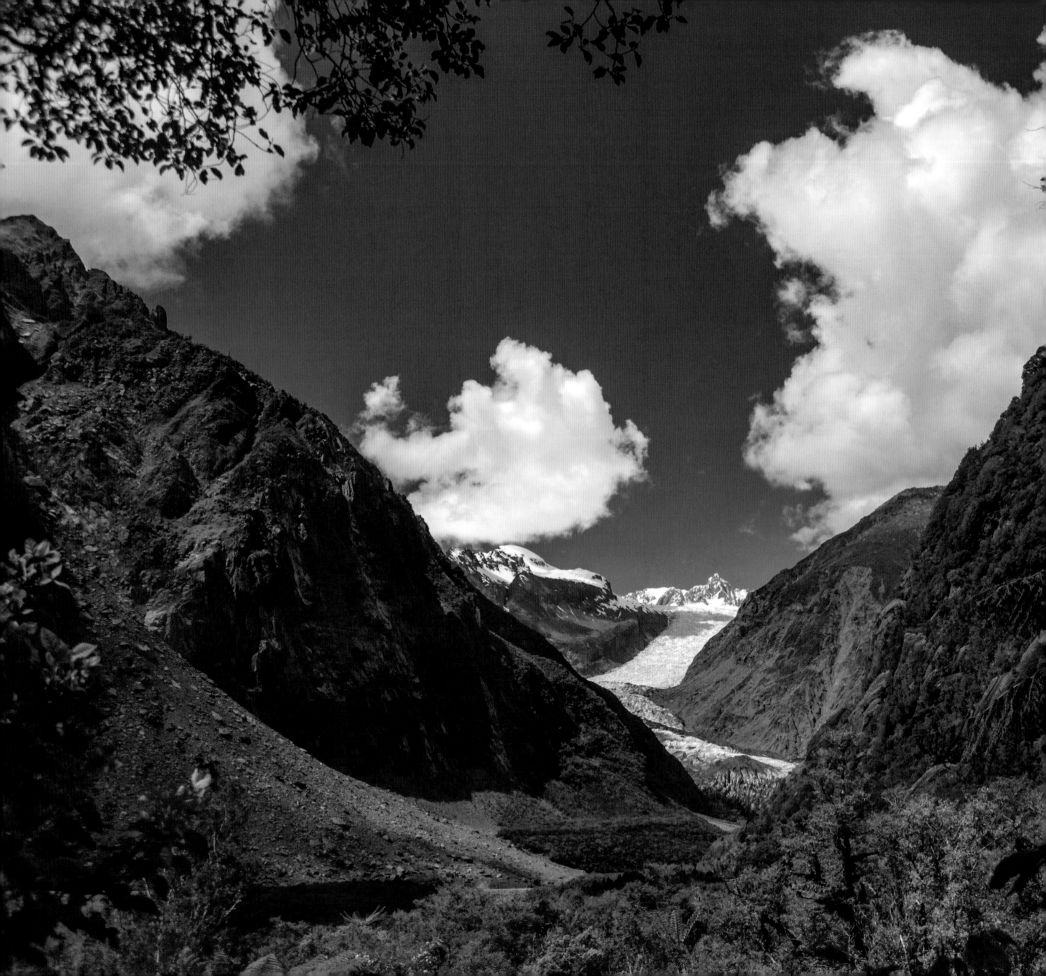

FRANZ JOSEF GLACIER

When Peter Jackson needed a location to portray the *Lighting of the Beacons*, he chose a mountain-top near Queenstown. Unfortunately, filming in the middle of a Central Otago summer coincided with a total fire ban. Searching the West Coast he was shown photos of Mt Gunn, which proved better than the mountain he had originally picked.

A drive up the access road takes you through the bush for wonderful views of the base of Franz Josef Glacier. It is an unusual sight — the glacier plunges down almost to the bush-line, and glaciers this low are rarely seen outside arctic regions.

The best view of Mt Gunn is by helicopter. Local company Alpine Adventures did all the flying for this scene and the pilots know the area well. Based at Franz Josef and Fox glaciers, Alpine Adventures offers tours over the location as well as scenic flights, including a landing on the glaciers.

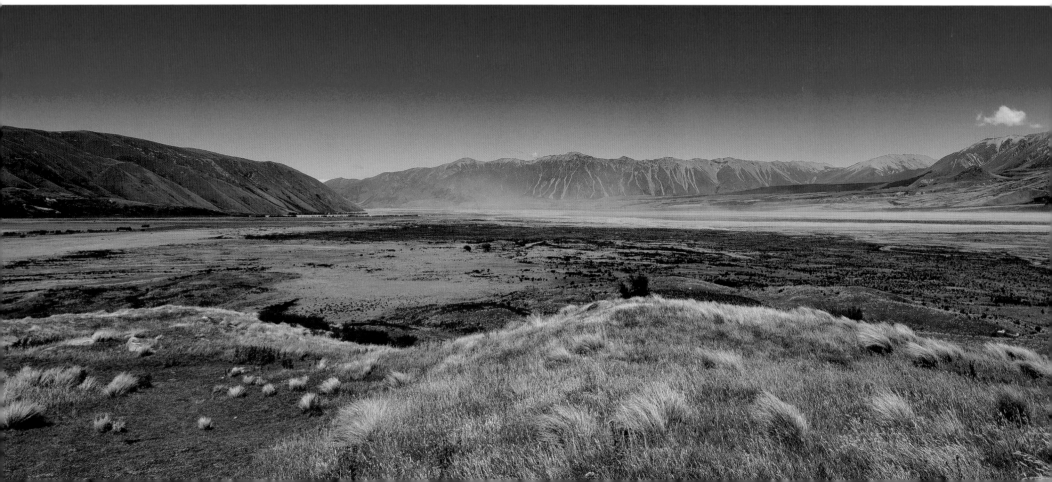

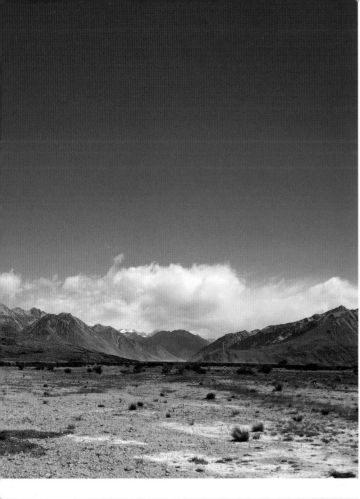

MT SUNDAY

Born high in the Southern Alps, the Rangitata River forms an alluvial shingle fan, with an associated valley virtually surrounded by mountains. Within this basin, the terminal moraine of ancient glaciers has created rocky outcrops. One of these, Mt Sunday, was used to create *Edoras* in Tolkien's realm of *Rohan*, the land of fabled horses and valiant warriors. One of the more elaborate sets, *Edoras* took 11 months to complete.

As one descends into the Rangitata Valley, Mt Sunday can be seen straight ahead, surrounded by brown tussock. There is no access to the mountain itself and the best views are on the unpaved road as it passes the entrance to Mt Potts Station.

A high-country station, Mt Potts is home to hardy merino sheep. Mostly summer hill country, its 2700 hectares stretch from an altitude of 500 metres to 2300 metres. Accommodation in an alpine lodge or cottages on the station provides an opportunity to experience high-country life, with home-cooked meals after a day of tramping, fishing or just quietly reading a book.

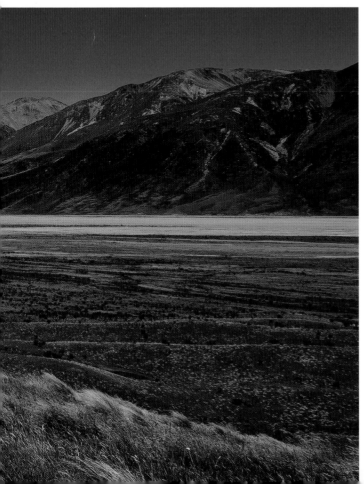

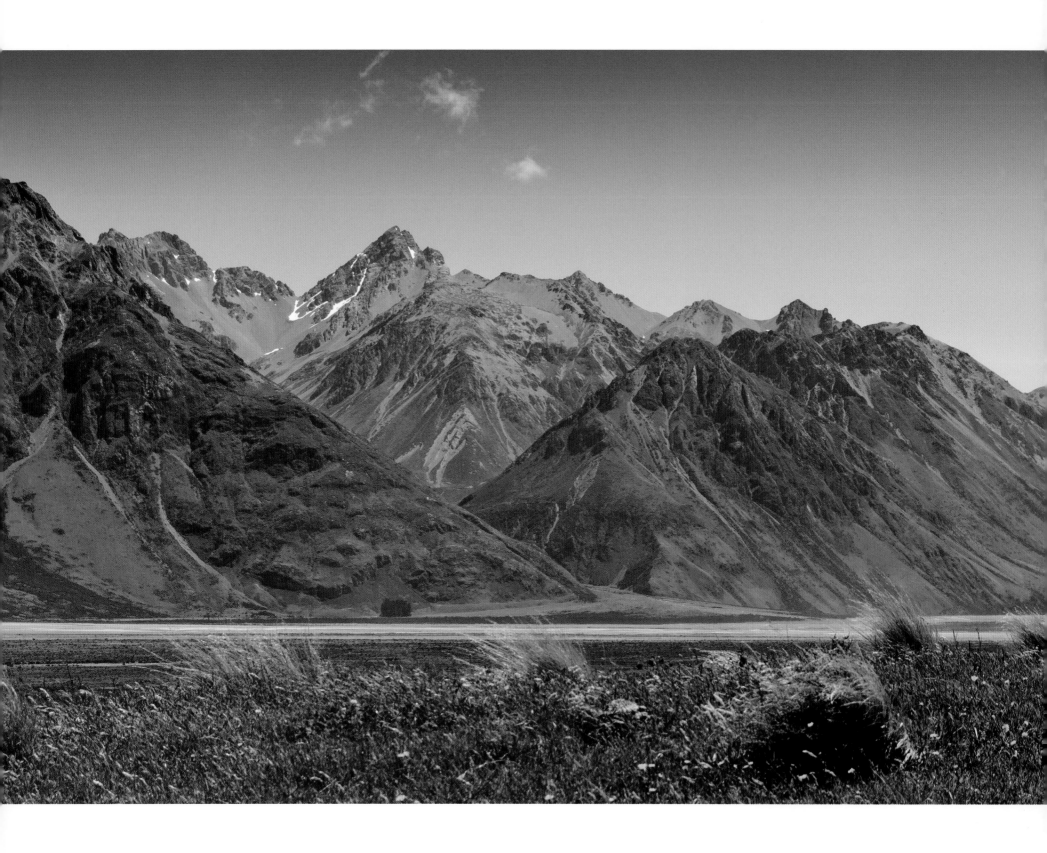

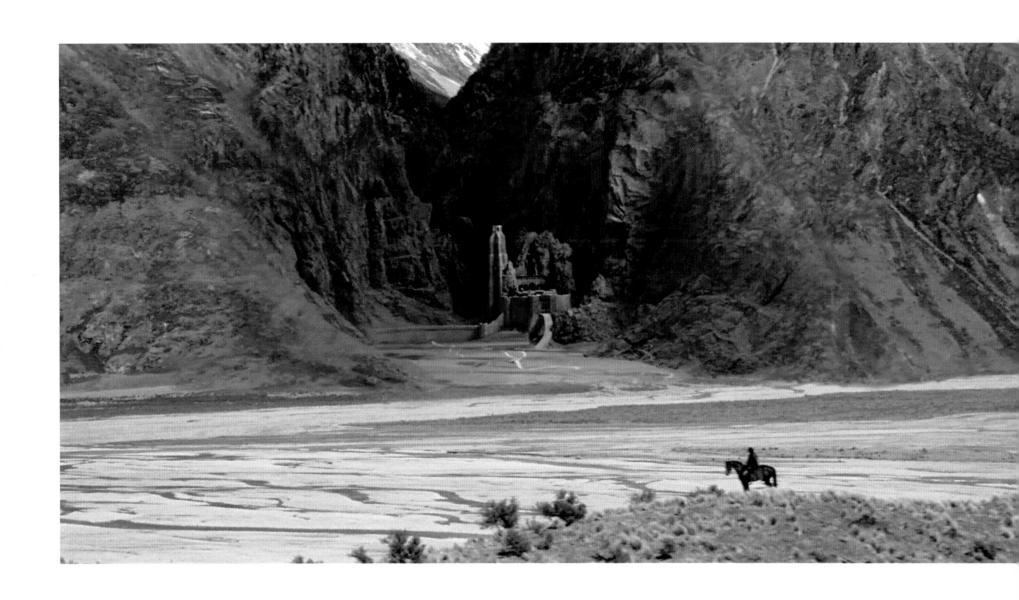

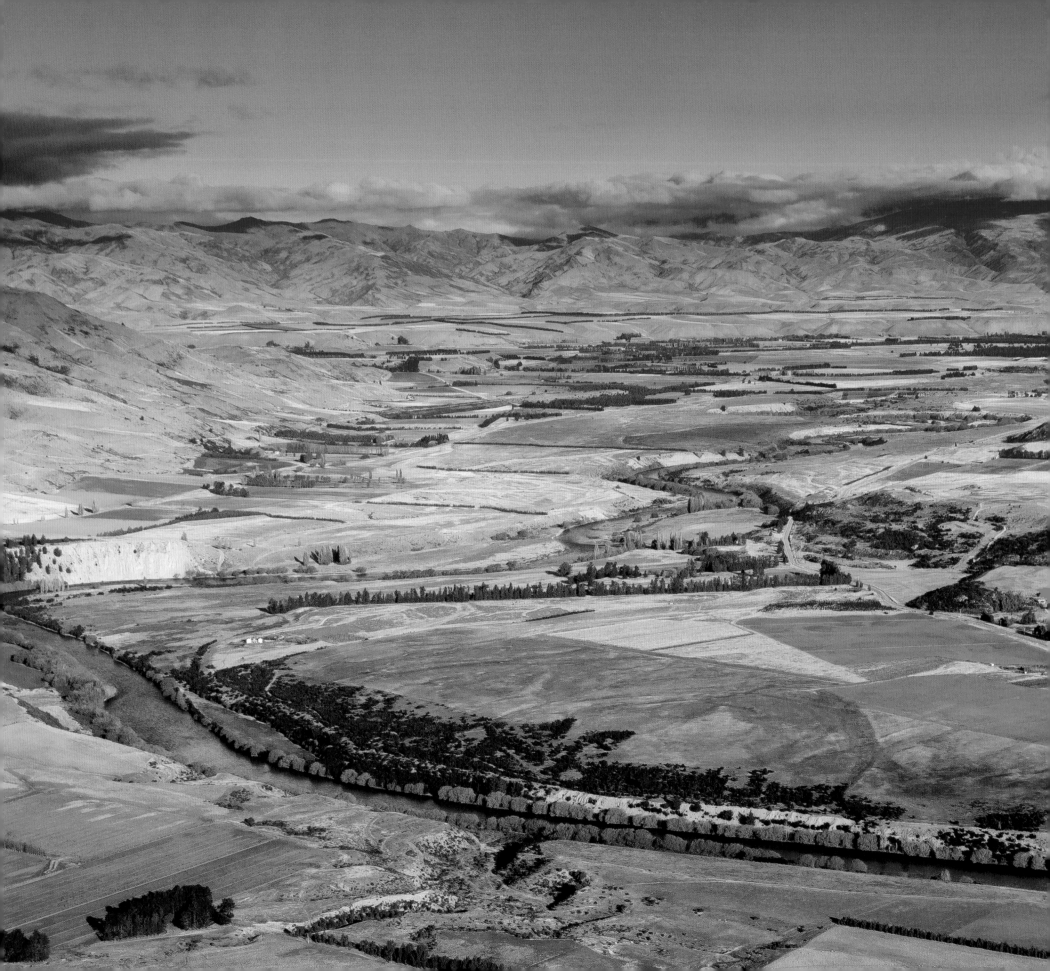

TARRAS

Tarras is a small farming village at the southern end of the Lindis Pass. An area of stark beauty, it is particularly photogenic as the setting sun turns the hills into distinct shades of brown.

The Tarras Country Store contains a souvenir shop, bookshop and café, and offers wine tasting; and the area provides an opportunity to stay on a merino sheep farm. The *Great East Road*, where scenes from *The Fellowship of the Ring* were filmed on private land, is a 10-minute drive from Tarras, although many of the pines have been replaced with vines. Travel south towards Cromwell for approximately 6 km then turn right onto Maori Point Road (unsealed). The area used as the *Great East Road* and to portray the *Flight to the Ford* is a further 2 km, with filming on both sides of the road.

Continuing along Maori Point Road, there are excellent views of the Southern Alps, with the Clutha River, New Zealand's largest river, to the left. The Clutha's Maori name is Mata-au, which means 'surface current'. Named after the Clyde River in Scotland (Clutha is Gaelic for Clyde), it was a rich source of gold, with 150 dredges in 1900.

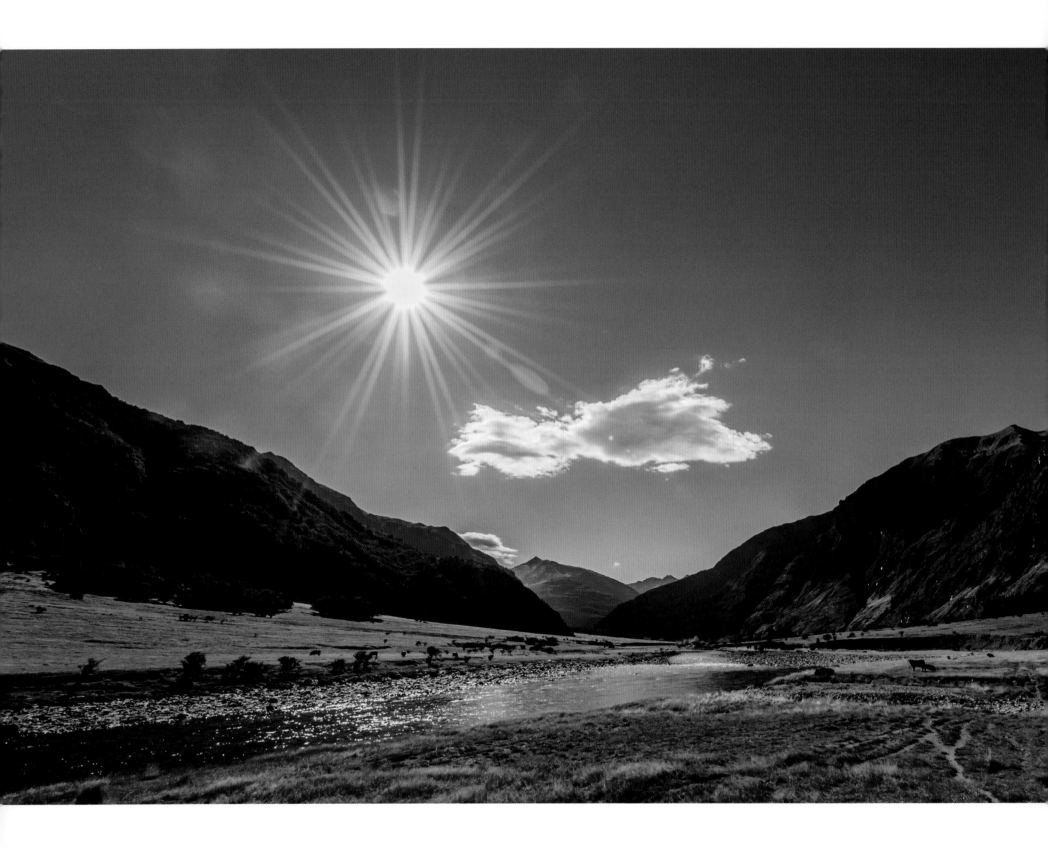

THE MATUKITUKI VALLEY

An hour's drive west from Lake Wanaka, the Matukituki Valley Road crosses river flats until you're encircled by the Southern Alps. Initially sealed, the road becomes gravel, with a couple of fords — normally not difficult, though river levels change dramatically in heavy rain. At the end of the road is a parking area, with a number of alpine tramps, including Mt Aspiring (3033 metres). With no food available here, I suggest you bring a picnic.

At Glendhu Bay, a sheltered cove where Lake Wanaka washes onto a sandy shore, look across the lake to Mt Aspiring, often called 'The Matterhorn of the South'. As you leave Lake Wanaka and drive around steep buttresses, the Treble Cone ski field appears directly in front — the top of this peak appears in *The Hobbit: An Unexpected Journey*.

Not far past the turn-off to the ski field the road becomes gravel, as the scenery becomes better and bigger. With the glacier-fed Matukituki to your right and snow-capped peaks on your left, there are views of a location from *The Hobbit: The Desolation of Smaug*. Here the *Company* left *Beorn's house* en route to *Mirkwood* — and you're now in Te Wahipounamu (The Place of Greenstone), South West New Zealand World Heritage Area, covering 2.6 million hectares and an area of world significance.

As the road branches left towards the head of the valley, you arrive at Raspberry Creek car park. Many of the tracks are for experienced mountaineers but for those with average fitness, try the Rob Roy Glacier track. Covering 10 km and taking three to four hours, this follows the river before climbing through a gorge and into ancient beech forest. The track gradually climbs above the forest floor, with spectacular views.

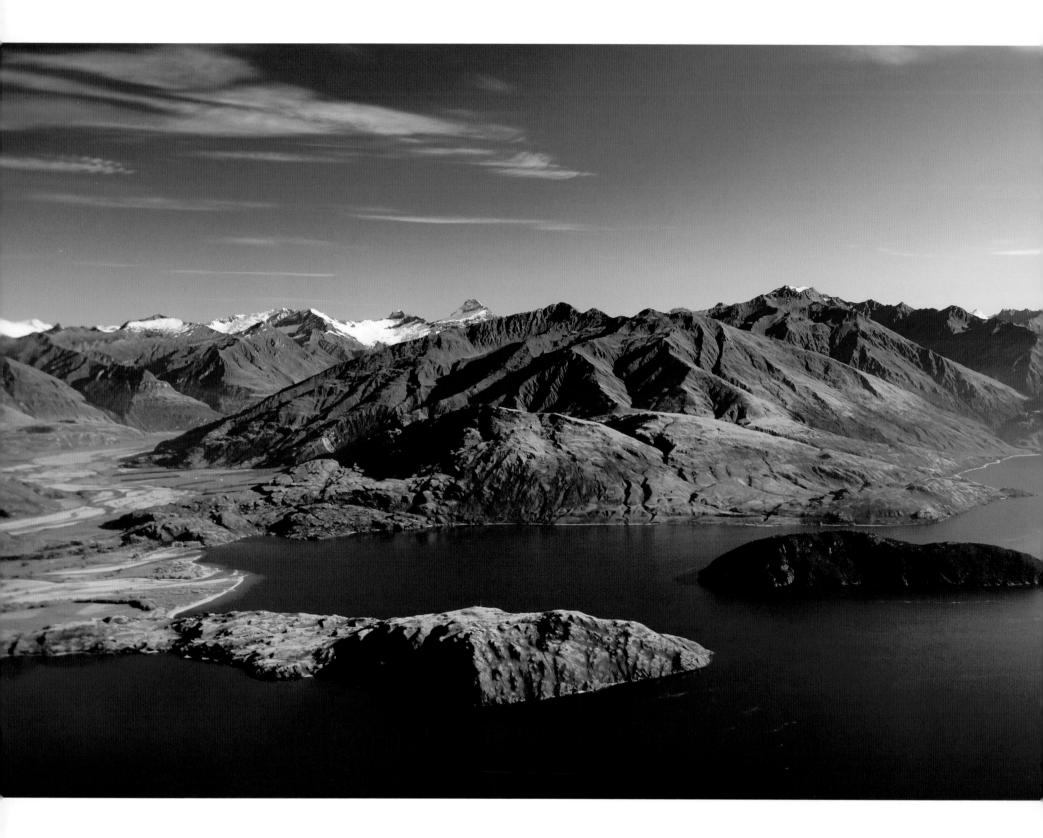

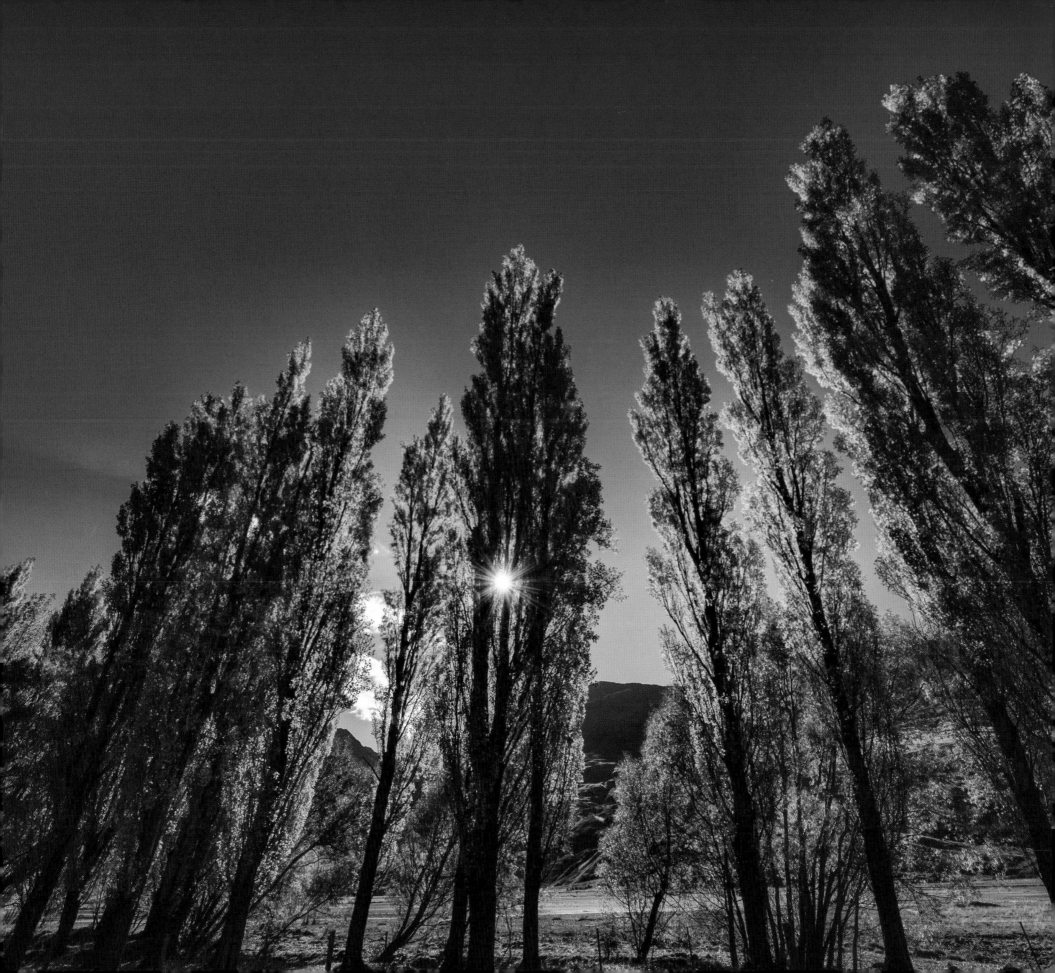

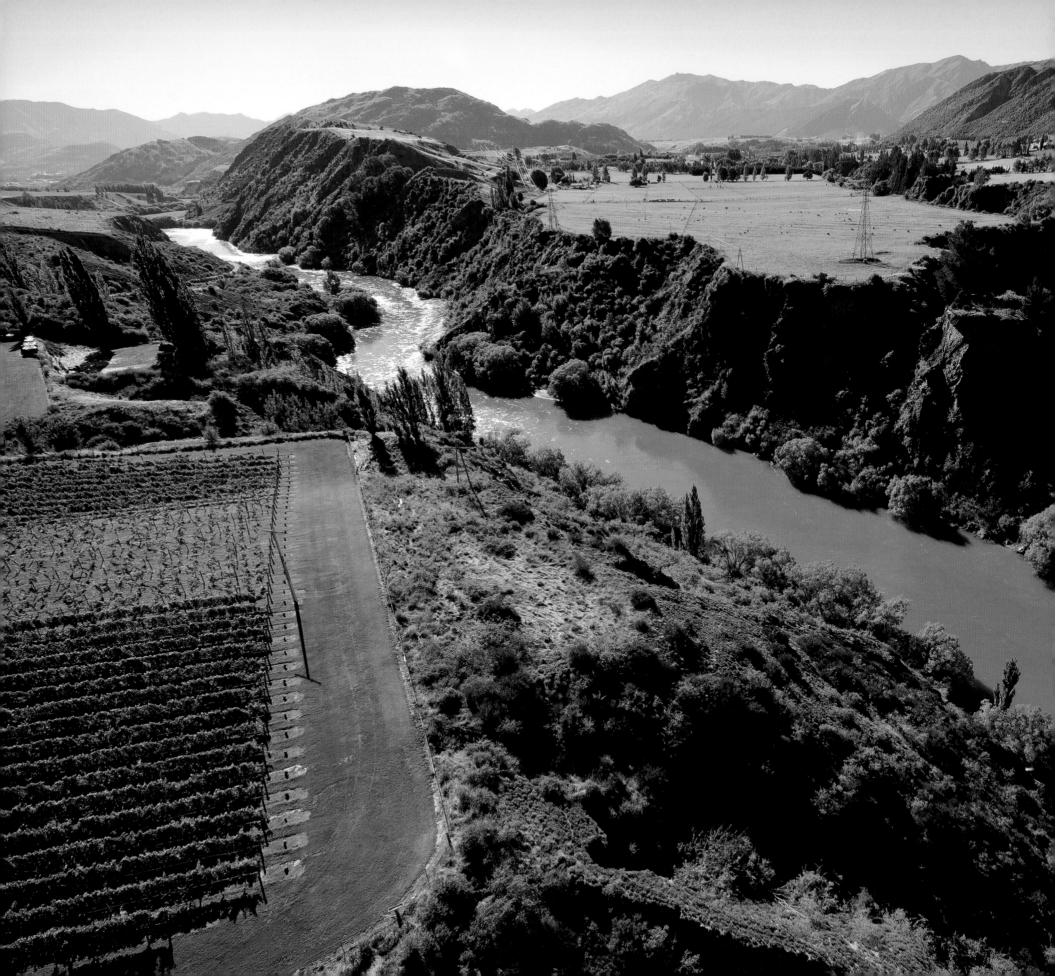

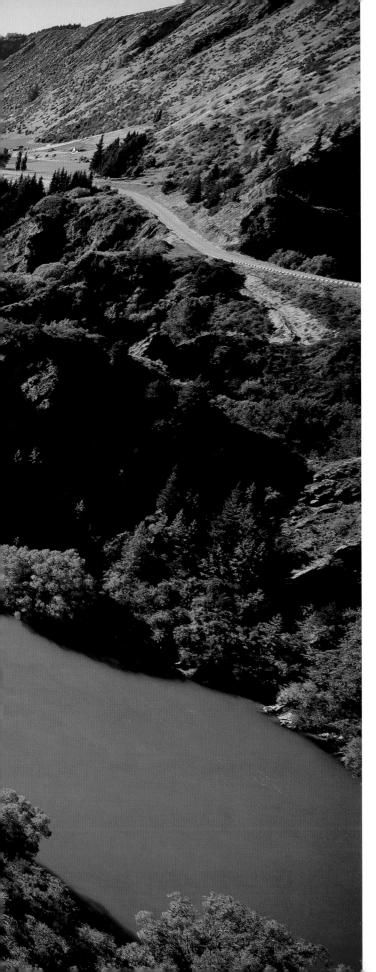

KAWARAU RIVER

Immediately opposite AJ Hackett's bungy jump is the road to Chard Farm Vineyard and a spectacular view of the *Anduin* and *Argonath* (*Sindarin 'Pillars of the Kings'*). Although the *Pillars* were computer-generated, the area is instantly recognisable.

At latitude 45° south, Central Otago perches on the southern edge of the grape-growing world. Established in 1987, Chard Farm was one of the first commercial vineyards in the Southern Lakes District and the area is now a significant wine producer, with four sub-regions. Altitude and climate impart distinct characteristics to New Zealand's highest vineyard above sea-level and the furthest vineyard from the sea. Warm, dry summers, cool autumns and cold winters, with relatively low humidity and a wide diurnal temperature range, help seal in flavours and acids in white wines and encourages colour development in Pinot Noir. Cellar door sales at Chard Farm are available seven days from 10 a.m. to 5 p.m. — winery tours are by appointment only.

A further 2 km towards Cromwell is Gibbston Valley Wines, with daily tours, a popular restaurant, an adjacent cheese factory and a unique and innovative wine cave dug 76 metres into the Central Otago schist.

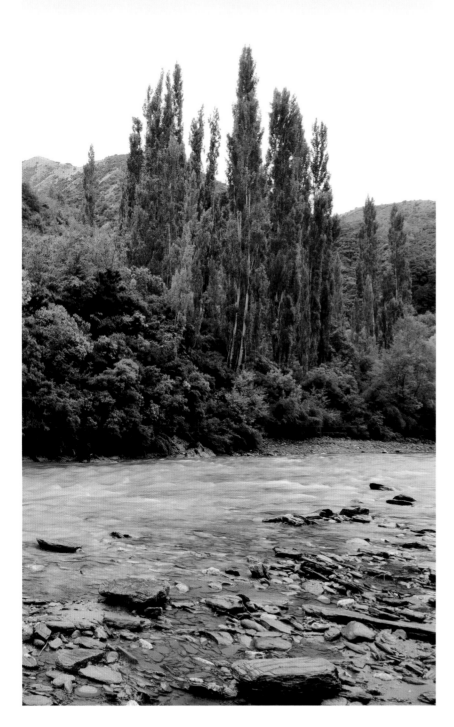

ARROWTOWN

In 1862 William Fox discovered gold, and over 7000 Europeans and Chinese flooded to the area. The goldfield had its share of lawlessness, and the excellent Lakes District Centennial Museum on the narrow one-way main street provides information about the characters who lived here. Restored Chinese miners' cottages can be viewed a short walk from the main street.

Autumn is wonderful: the tree-lined main street is a carpet of red and gold, as smoke creates a hazy atmosphere in shafts of sunlight. Larches on the nearby hills are golden pools of colour and the air is clear and crisp. Many of Arrowtown's shops and galleries feature local artists, so take your time and don't forget your camera. Nearby Millbrook Resort, with a world championship golf course, features luxurious restaurants and accommodation.

The Ford is minutes from the centre of Arrowtown. Park behind the main street and walk to the riverbank, then wade upstream 200 metres to the exact spot — the river is normally ankle deep — where the *Nazgûl* charged as *Arwen* ferried *Frodo* across the river on *Asfaloth*. The path they took is on your left.

Arwen's flood was filmed at Skippers Canyon, with locals lining the riverbank to watch proceedings.

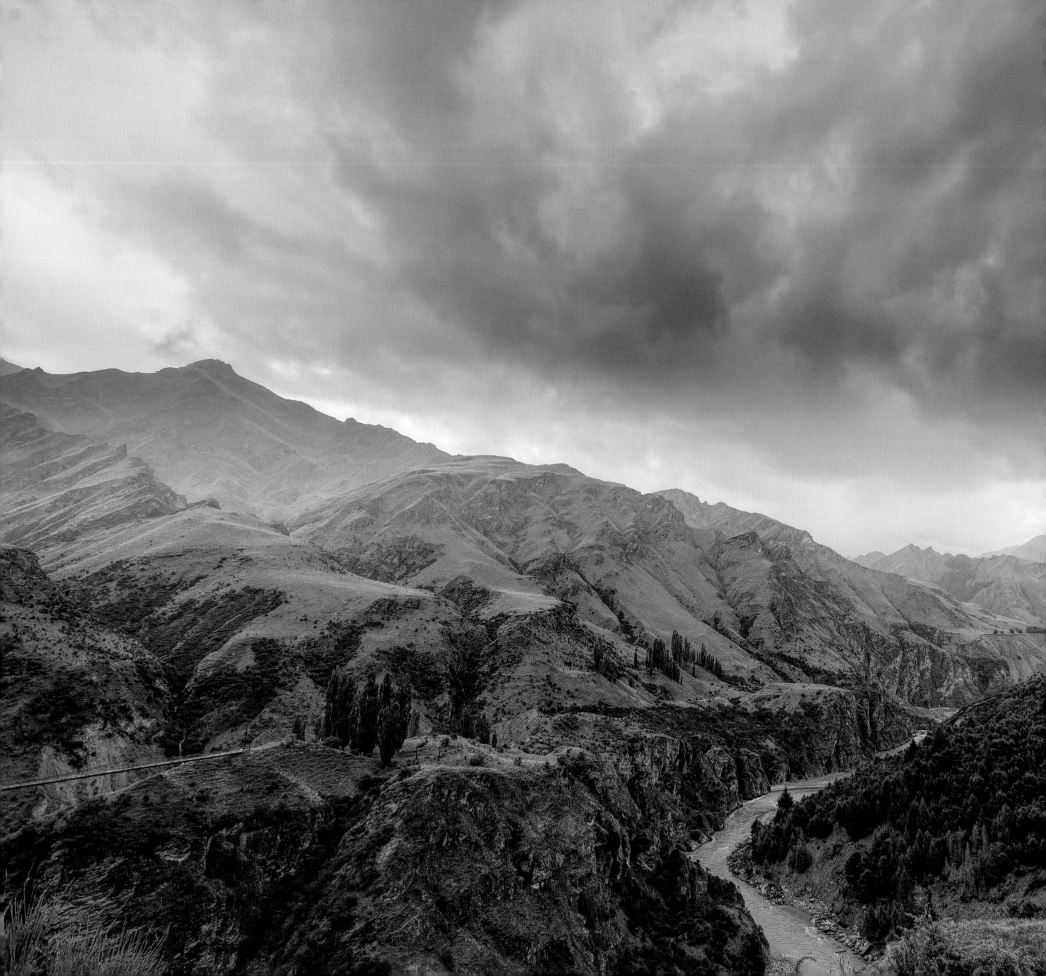

SKIPPERS CANYON

Returning to Queenstown, you'll see the Coronet Peak ski area on your right. Each winter international visitors enjoy spectacular skiing and snowboarding, with five ski fields within 90 minutes of Queenstown. Coronet Peak Road provides access to Skippers Canyon, where you can travel into the canyon with Nomad Safaris, which provides specialist four-wheel-drive *Lord of the Rings* tours. Closed to rental cars, Skippers Road is tortuous, especially for drivers unfamiliar with these sorts of roads. In the canyon, the steep valley walls, winding road, stark brown hills and snow-covered peaks are beautiful, but of equal interest is the river. The part close to the original bridge (12 km into the gorge) portrayed the *Ford of Bruinen* in flood.

A little further towards Queenstown, you'll pass historic Gantleys Restaurant, a cast and crew favourite, opposite the Quality Resort Alpine Lodge, used as 'wet weather cover' for interior shots.

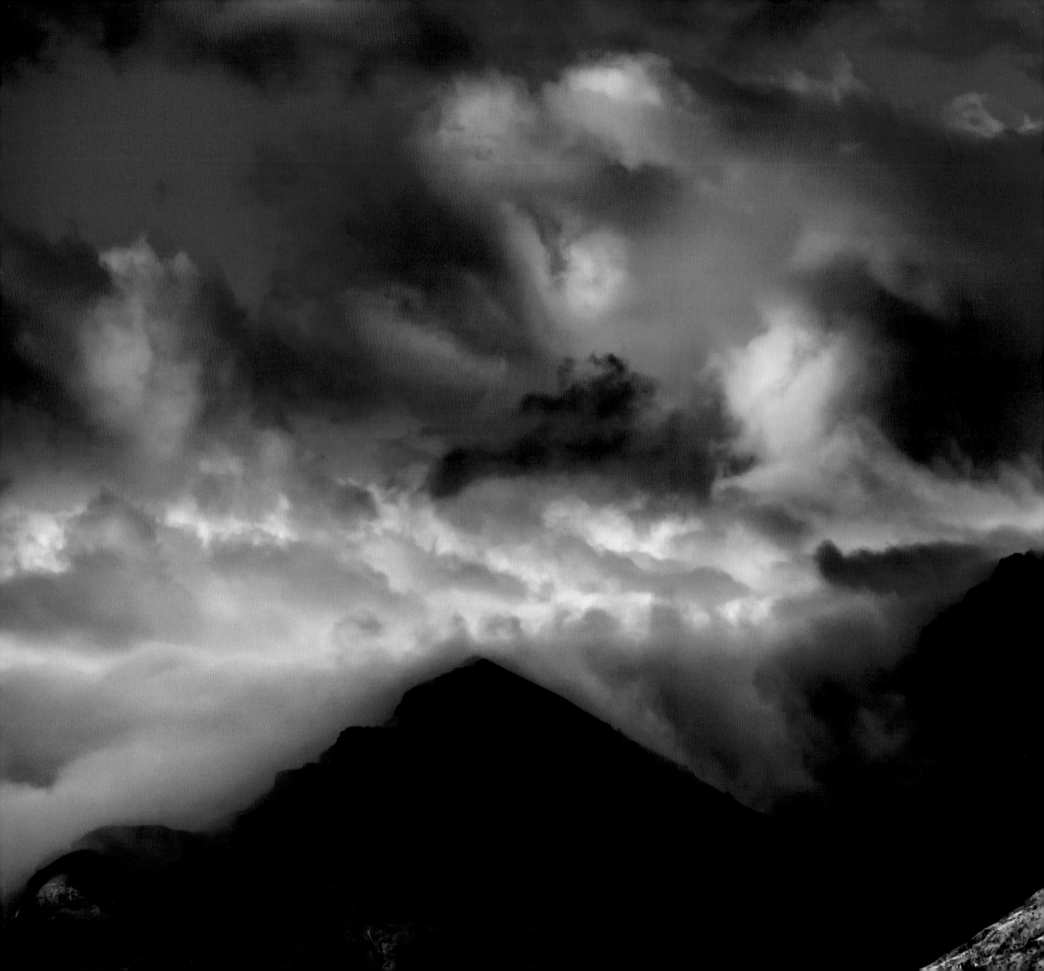

THE REMARKABLES

When a demoralised *Fellowship* flee the *Mines of Moria*, *Aragorn* leads them down the steep slopes of the *Dimrill Dale* towards *Lothlórien*. High in the Remarkables mountain range, this location can be reached by one of two routes.

Those with reasonable fitness can drive to the top of the Remarkables Ski Field, 20 km from Queenstown, where Lake Alta, an alpine tarn, is a further 20-minute hike up the hill.

The easier and more exciting option is a helicopter flight with Glacier Southern Lakes Helicopters, whose pilot Alfie Speight provided much of the aerial filming and transportation for both trilogies. Glacier Southern Lakes Helicopters offers *Lord of the Rings* flights ranging from a 30-minute excursion to Lake Alta, *Amon Hen* and the *Ford of Bruinen* through to a 90-minute extravaganza covering all local locations. Flying like *Gwaihir* around the Southern Alps is a very special climax to any tour of *Middle-earth* New Zealand.

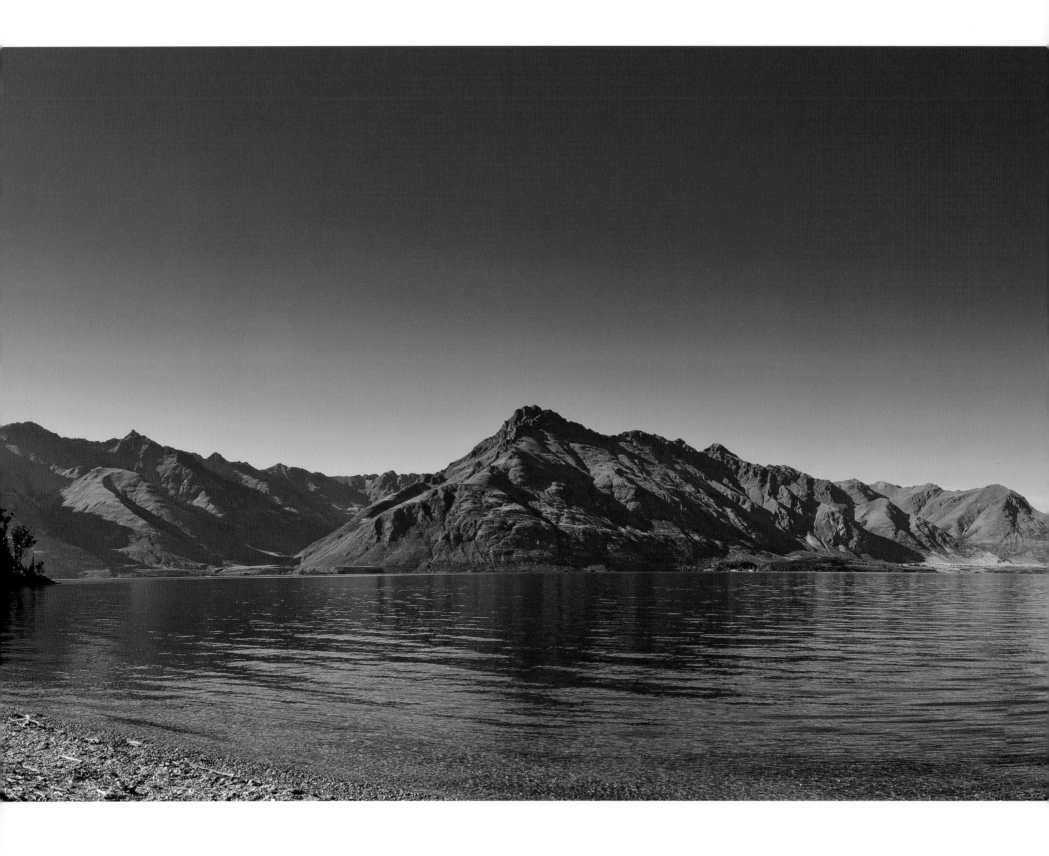

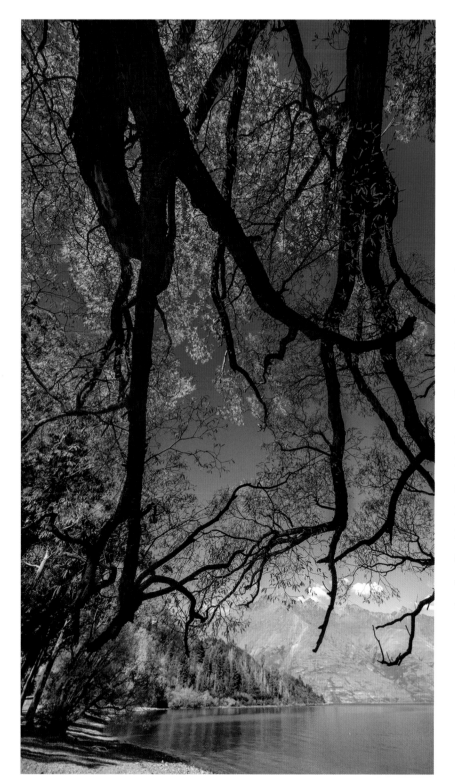

CLOSEBURN

The drive to Glenorchy follows the shores of Lake Wakatipu for 45 km. At times the road climbs around high bluffs with views of the lake and mountains, at others it passes secluded bays at lake level. Pine trees cover the lower mountains in places and there are some lovely walkways. Have your fishing rod handy, as brown and rainbow trout cruise close to the shore — Viggo Mortensen was spotted fly-fishing here — although remember to organise a fishing licence.

Closeburn is 8 km from Queenstown. While the location of *Amon Hen* is not accessible, a stop on the lakeshore after descending the hill to Closeburn Bay is suggested. The pine trees on the peninsula to your left was the area used for filming, with the use of multiple sites to portray one scene very apparent. Filming for the finale of *The Fellowship of the Ring* took place at Closeburn, Paradise and Mavora Lakes, with these three places skilfully interwoven. In summer, Closeburn is reminiscent of the scented forests of *Ithilien* and with dramatic views of lake and mountains bringing *Middle-earth* to mind, it's little wonder nearby Twelve Mile Delta was used to portray the *Ithilien Camp*.

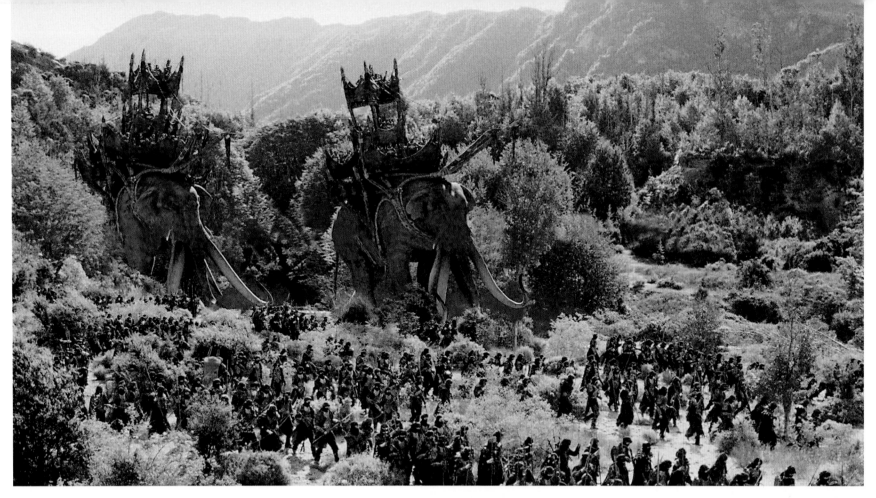
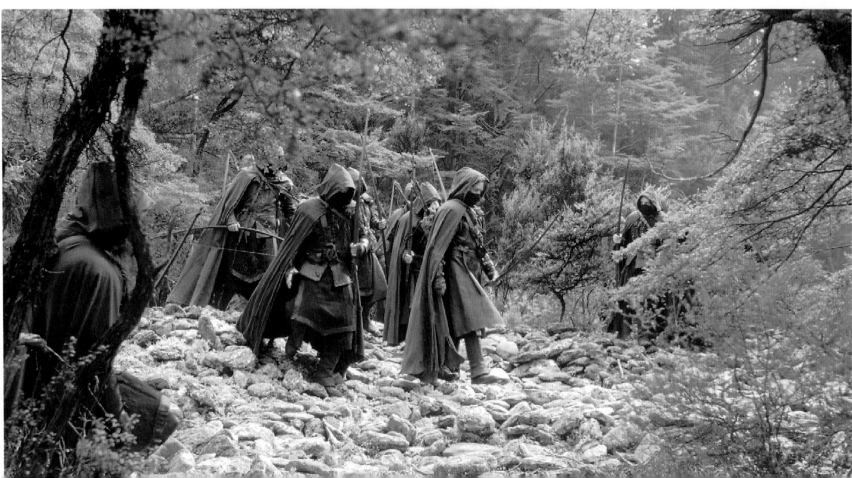

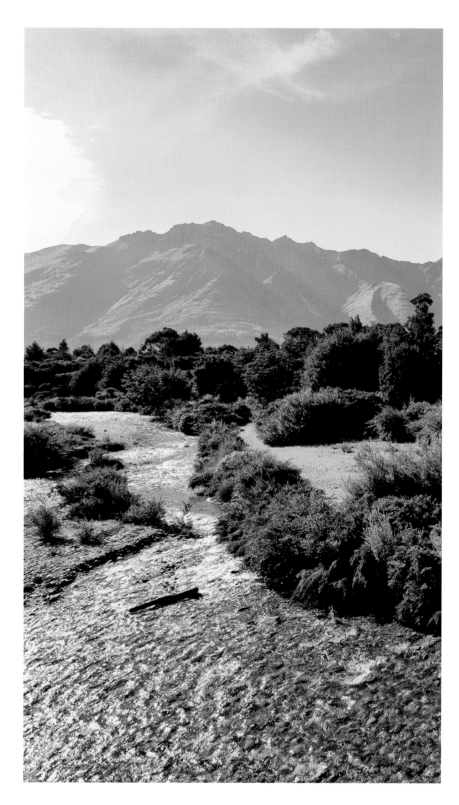

TWELVE MILE DELTA

Situated 4 km past Closeburn is Twelve Mile Delta, with a large camping area and a number of walks and mountain bike tracks to take you into *Ithilien*. Two areas were used here to portray *Ithilien*, where *Sam* saw his *Oliphants*. To reach this location, go down to the river and walk towards Lake Wakatipu. The bank on your right is where *Frodo*, *Sam* and *Sméagol* watched the battle between the *Men of Harad* and the *Rangers of Gondor*. To reach the cliff-top hiding space where *Sam* and *Sméagol* discussed the merits of cooking coneys with 'taters', return to the walking track at the western end of the river.

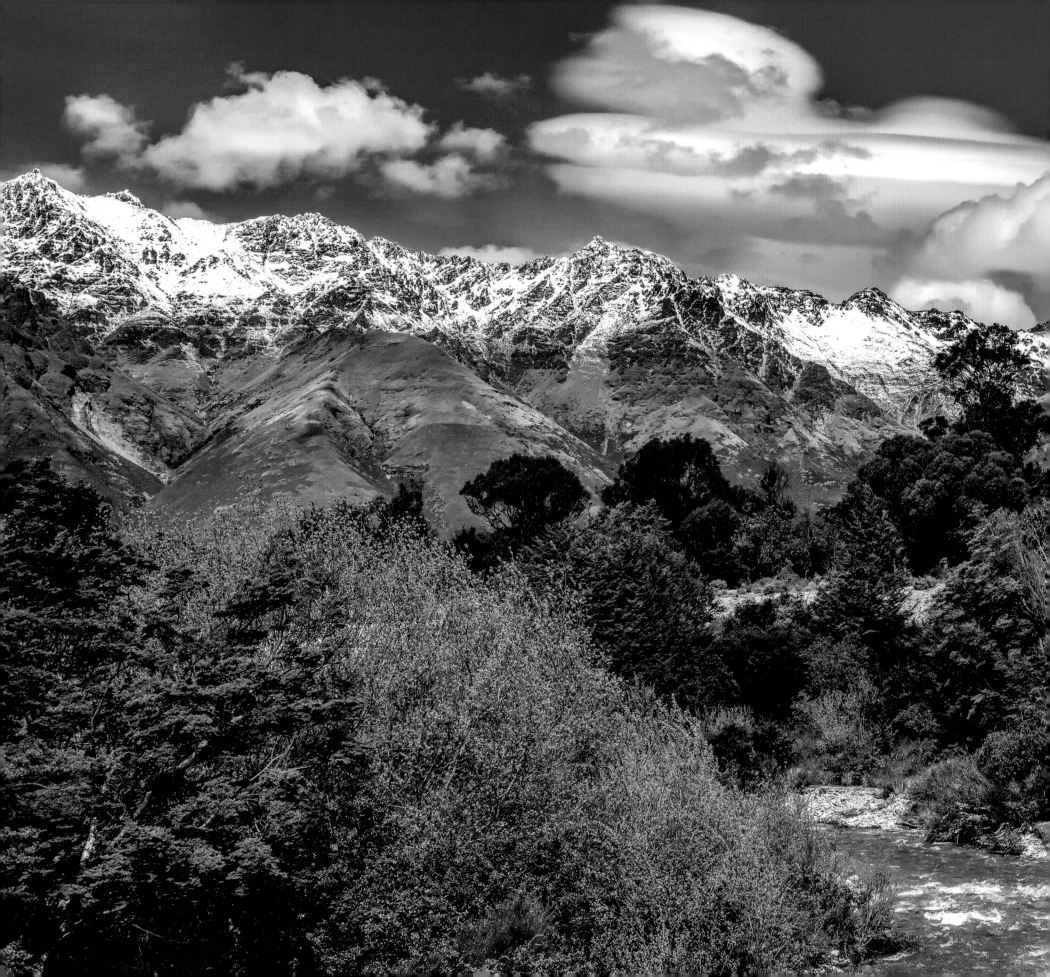

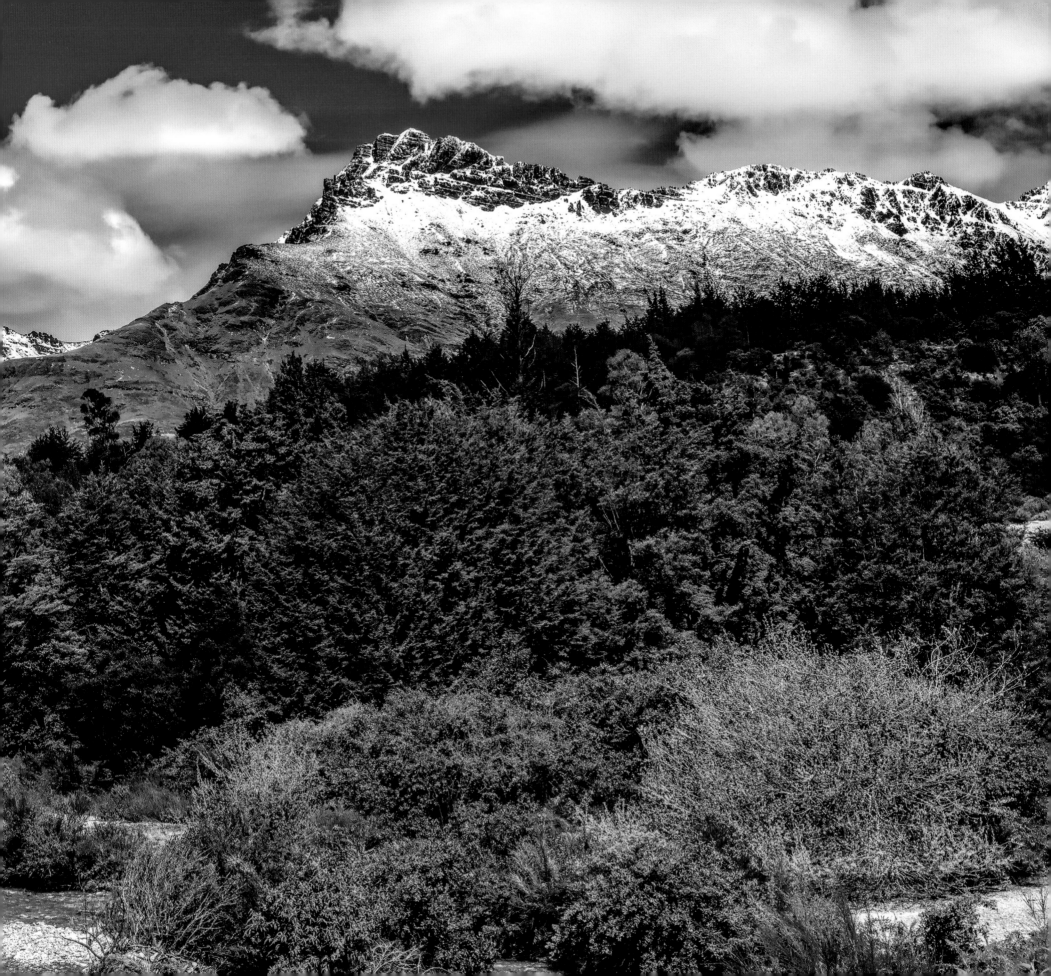

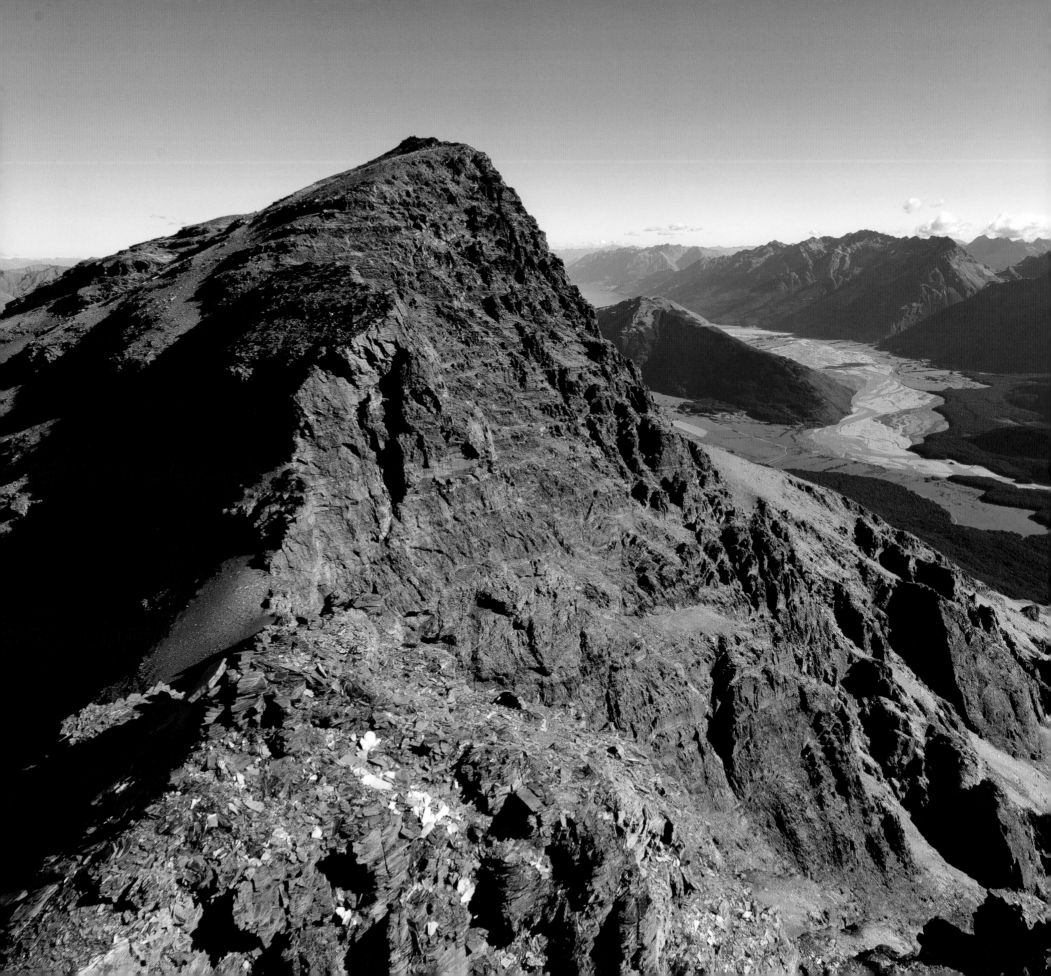

GLENORCHY

Glenorchy nestles at the northern end of Lake Wakatipu, with a spectacular backdrop of jagged snow-capped peaks. Maori passed through in their search for pounamu (jade or greenstone) but it wasn't until 1862 that settlers used the broad river flats for grazing. Some 3000 gold miners followed briefly, with yields proving less spectacular than in other regions. The 1890s brought tourism, and guesthouses were built for adventurous visitors from Queenstown. Today, Glenorchy has evolved into a centre for eco-tourism, and is a gateway to Mount Aspiring National Park, covering 355,543 hectares and part of Te Wahipounamu. A DOC information centre provides information on the many outstanding walks in the area including the Routeburn Track, and the Rees-Dart and Greenstone Caples tracks. Accommodation ranges from backpacker to luxury.

Leaving the village going north, take the road marked Paradise, and the river flats eventually give way to patches of beech forest. Dan's Paddock appears after 26 km. Up the slope on your right (where paddock and forest meet)

Gandalf rode to *Isengard*, and Mt Earnslaw, whose peak towers overhead, was part of the *Misty Mountains*. Travel another 2 km through beautiful forest and open paddocks — just after leaving a clearing to enter a glade, the edge of the forest was used to portray the *Fellowship* entering *Lothlórien*.

The location used for *Beorn's house* is on private property but there are two options to visit with an organised tour. The first is a jet-boat ride with Dart River Wilderness Jet. Operating daily from Glenorchy (with free transfers from Queenstown), this exciting excursion transports you deep into the heart of Mount Aspiring National Park. Pausing to view the location for *Beorn's house*, the journey continues further upriver, surrounded by the backdrop for the land between the *Misty Mountains* and *Mirkwood*.

Dart Stables has been operating horse treks into Paradise for many years, and with different treks available this is a great way to see a number of locations, including *Beorn's house*. Paced as a walk and suitable for beginners, it's the ride of a lifetime for film location visitors.

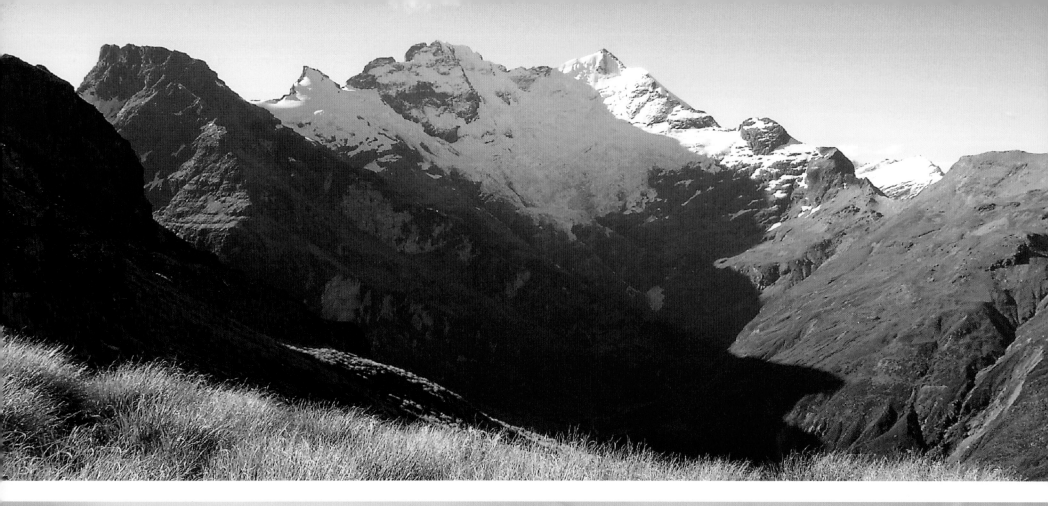
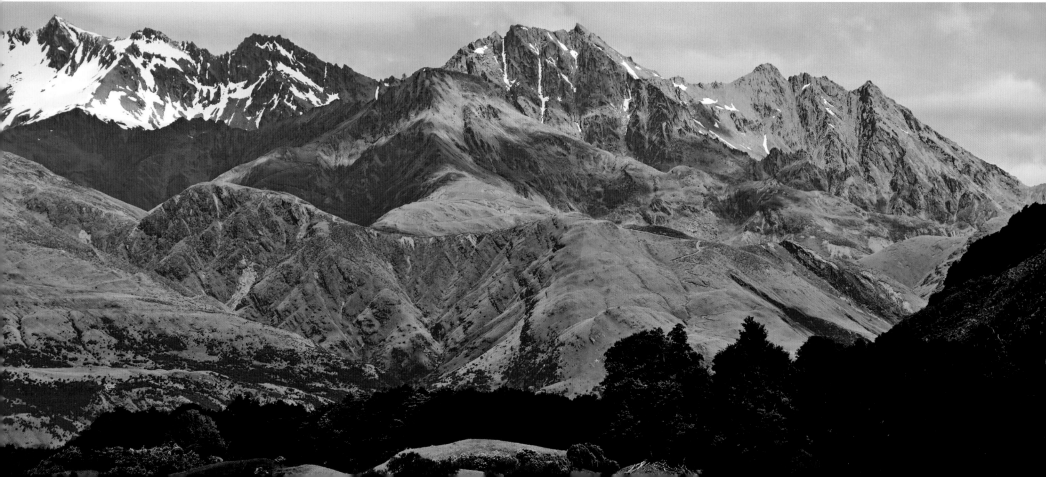

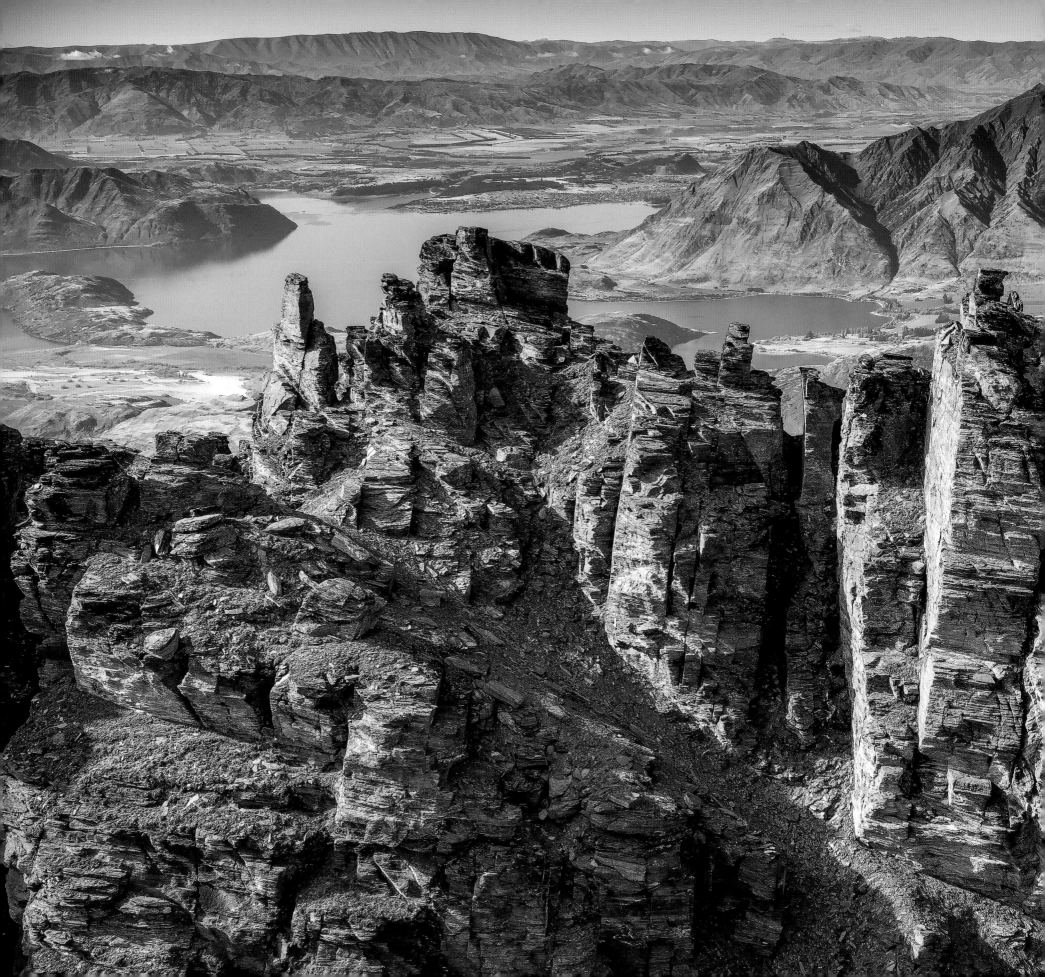

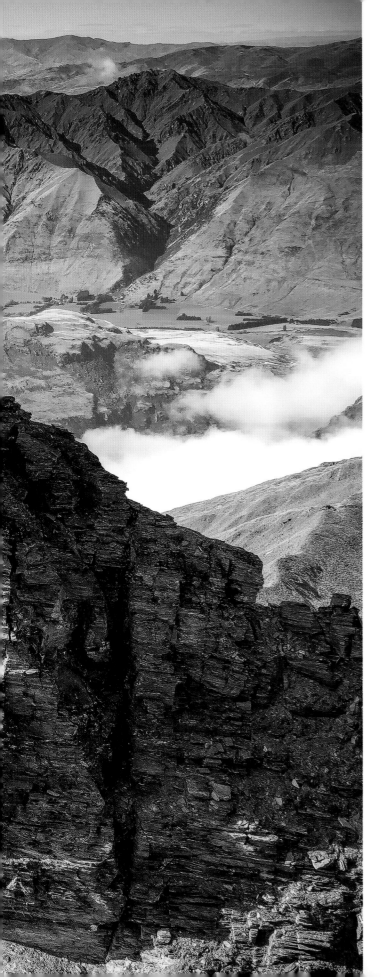

TREBLE CONE

The northern-facing slopes of Treble Cone ski field are nirvana to powder hounds during the winter months, when visitors come to enjoy the largest skiable area and the longest verticals available in the Southern Lakes. No wonder Olympic ski teams from around the world come here to practise before international competitions.

This location was filmed during the late spring of 2011 and depicts the *Company* trekking along a ridge crowned with high tors and precipitous drops, as they made their way towards the *Misty Mountains* pass.

The location is accessible in summer on a four-wheel-drive, heli-hike and walking adventure with Eco Tours Wanaka. To enjoy the view in winter, you need to be a capable skier or snowboarder. If snow sport isn't your forte, there are fantastic views from the base building, and it's worth the drive up on a crisp winter's day to sit in a café with mugs of steaming coffee or hot chocolate and a freshly baked muffin.

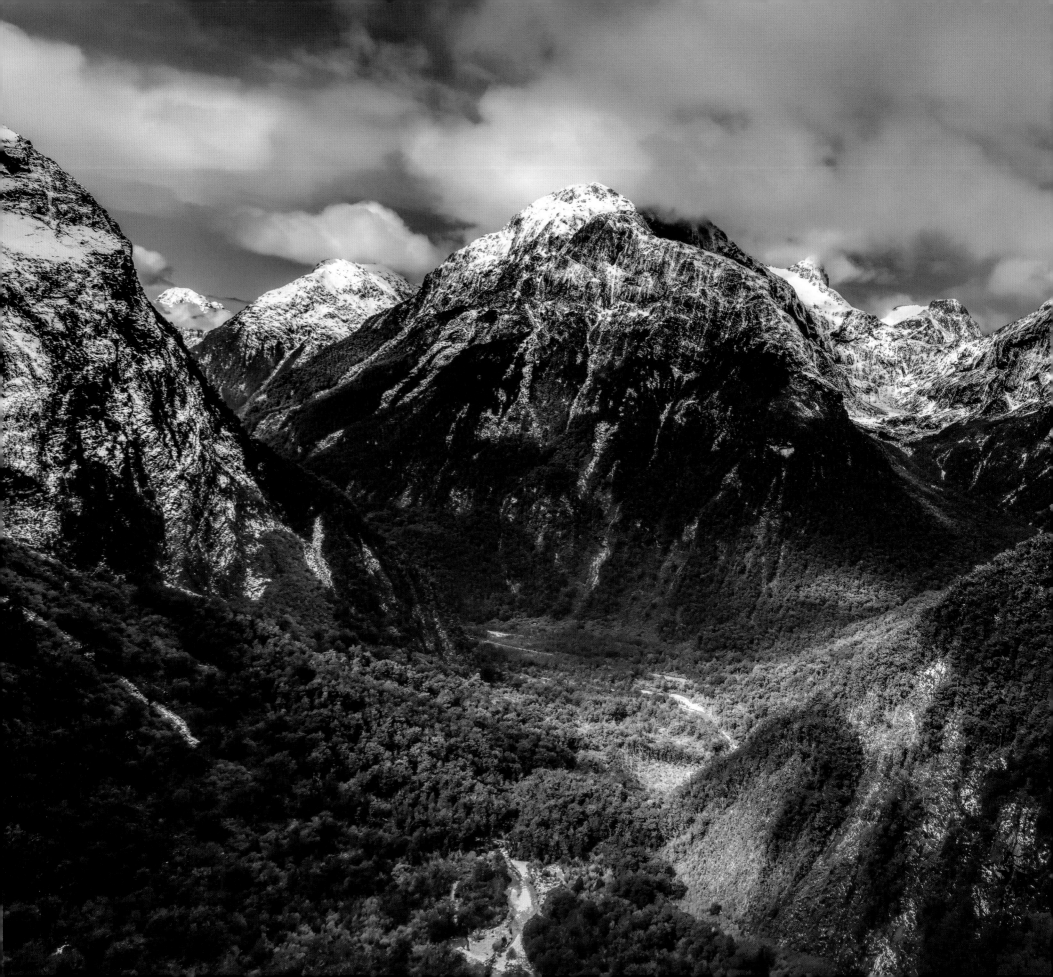

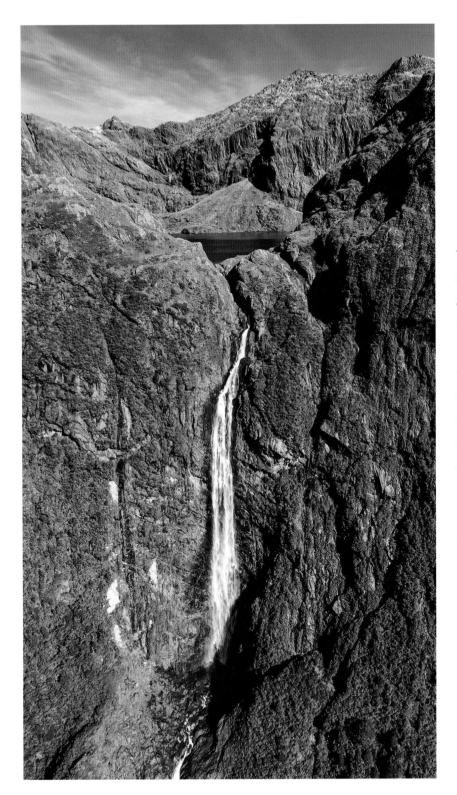

SUTHERLAND FALLS

The location of the *Eagles' Eyrie* is deep in the Southern Alps. As spectacular in real life as it appears in the film, it can only be reached by air. Situated near Sutherland Falls and the Mackinnon Pass, the base of this unnamed mountain (580 metres) is accessible two ways, both breathtaking.

The first requires a few days and a reasonable level of fitness, but means you experience the world's finest walk — the Milford Track. This 53.5 km hike, from the head of Lake Te Anau to Milford Sound, follows a Maori route for transporting greenstone. Established as a guided tour by Quintin McKinnon in the late 1800s, the Milford Track can be experienced as a freedom tramp or fully guided tour. Day three climbs to the highest point of the Mackinnon Pass, then ascends towards Quintin Hut and the bottom of the Sutherland Falls (580 metres), fed by Lake Quill. Helicopter pilot Alfie Speight flew film crew across the lake and down the falls with a 3D SpaceCam camera to record the dramatic journey to the *Eyrie*.

The location can also be experienced on the scenic flight to Milford Sound from Te Anau or Queenstown — travelling through the valley is like flying with the giant eagles.

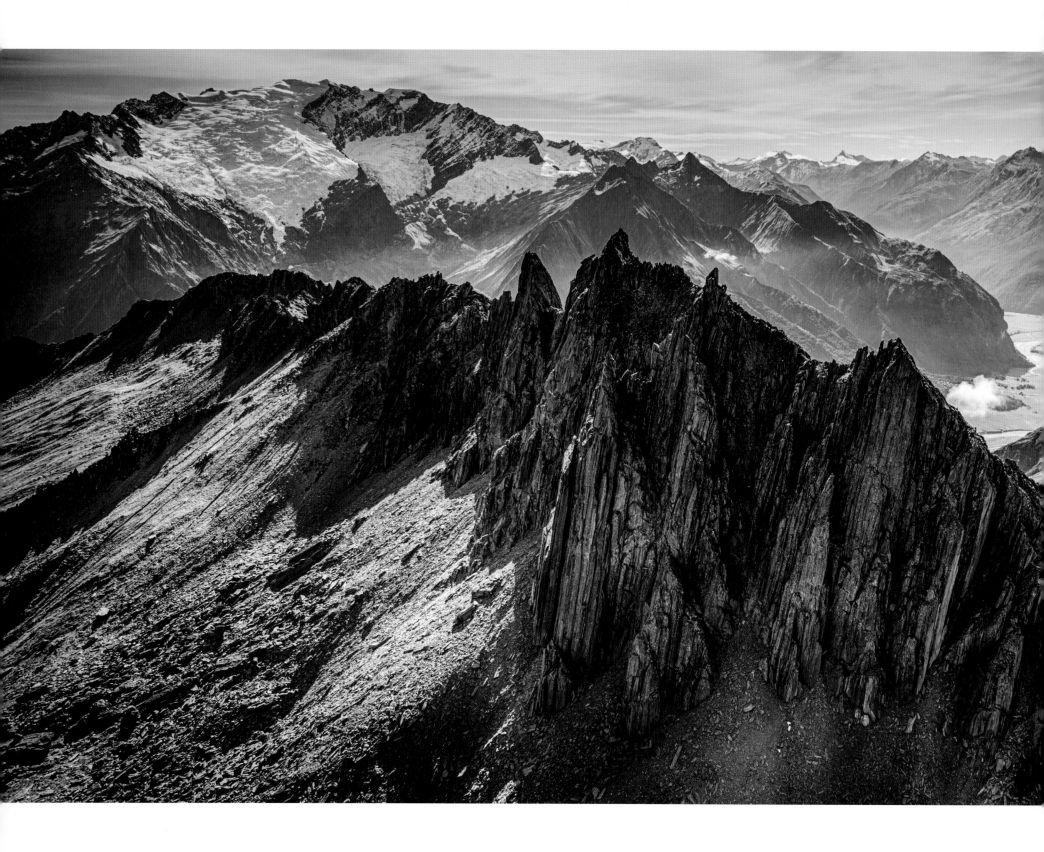

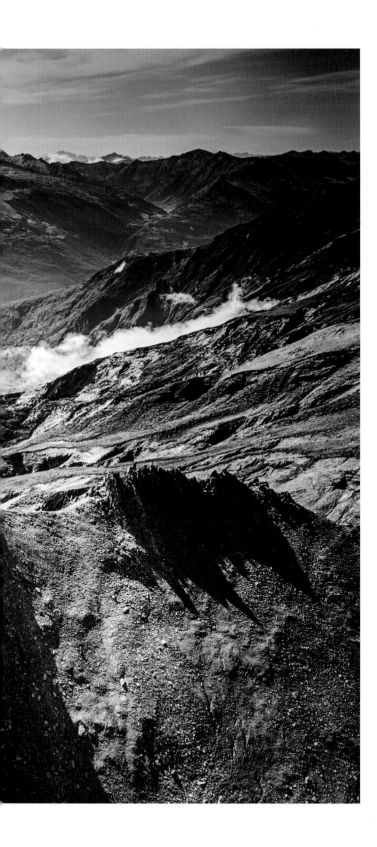

ORGAN PIPES

As the *Great Eagles* of the *Misty Mountains* rescue the *Company* from the clutches of *Azog* and his minions, they take them towards their *Eyrie* and are shown flying against a number of different backdrops, including the aptly named Organ Pipes. These are situated to the west of Treble Cone and south of the Mt Aspiring Hut road and track. Reaching over 1900 metres, this jagged teeth-like range was filmed in spring after the winter snows had melted, leaving the schist rock exposed.

This same range was seen in *The Hobbit: The Desolation of Smaug* when *Gandalf* climbed precariously towards the *High Fells* and the resting place of *The Nine*.

PASSBURN

The Passburn Valley and Saddle are situated west of the Greenstone Valley, a spectacular setting of golden tussock in a stream valley surrounded by high mountain peaks. In 2012 it was introduced in the first trailer for *The Hobbit: An Unexpected Journey* and seen in the film as the *Company* trek from *Rivendell* towards the *High Pass* over the *Misty Mountains*.

Cast and crew were taken into the area by helicopter. The scenes were filmed by SpaceCam from multiple angles to showcase the dramatic mountainous scenery of both New Zealand and *Middle-earth*.

This location is part of Te Araroa, The Long Pathway (see next page), but can also be seen when undertaking the *Hobbit* scenic flight with Glacier Southern Lakes Helicopters.

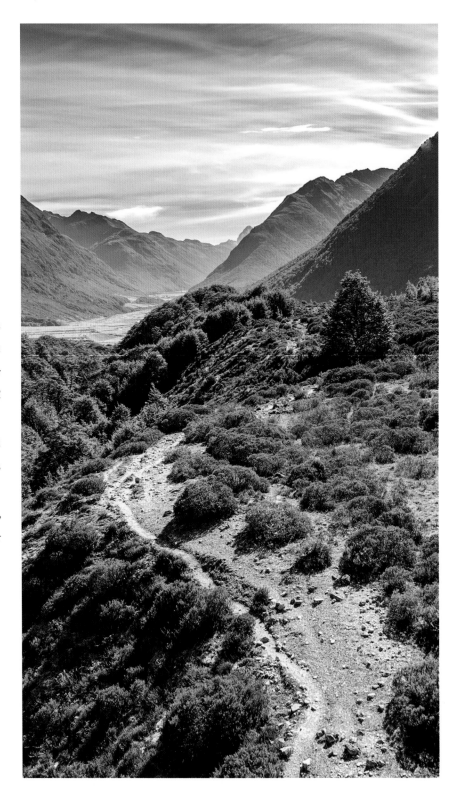

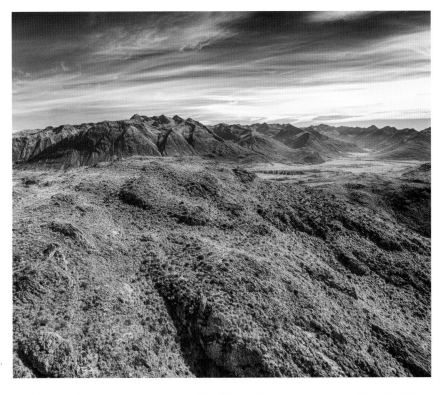

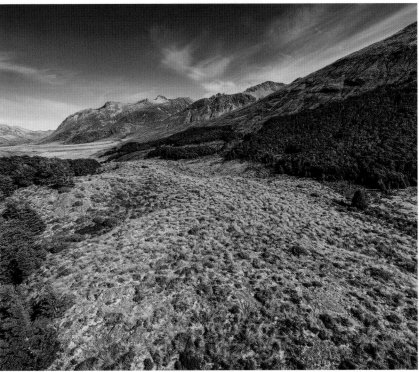

MARAROA SADDLE

The Mararoa Saddle is seen in the prologue of *The Hobbit: An Unexpected Journey* in a sequence where *Thorin* is leading the dwarven *Erebor* refugees through the wild lands after their escape from *Smaug*.

The actual location is accessible as part of Te Araroa, The Long Pathway, a 3000 km trail stretching from Cape Reinga in the north of New Zealand to Bluff in the south. Officially opened by the Governor General in 2011, Te Araroa is the result of many years of hard work by dedicated volunteers who have worked tirelessly to create one of the world's longest walking trails. The trail encompasses all of our diverse scenery and can be undertaken in small portions or its entirety, so a proud walker can rightfully claim to have walked from Cape Reinga to Bluff.

The section crossing this area is the Mavora Walkway, a 47 km four-day moderately difficult tramp from Greenstone (on the shores of Lake Wakatipu) to the Mavora Lakes camping area.

The location is also seen when flying with Glacier Southern Lakes Helicopters on its *Hobbit* scenic flight.

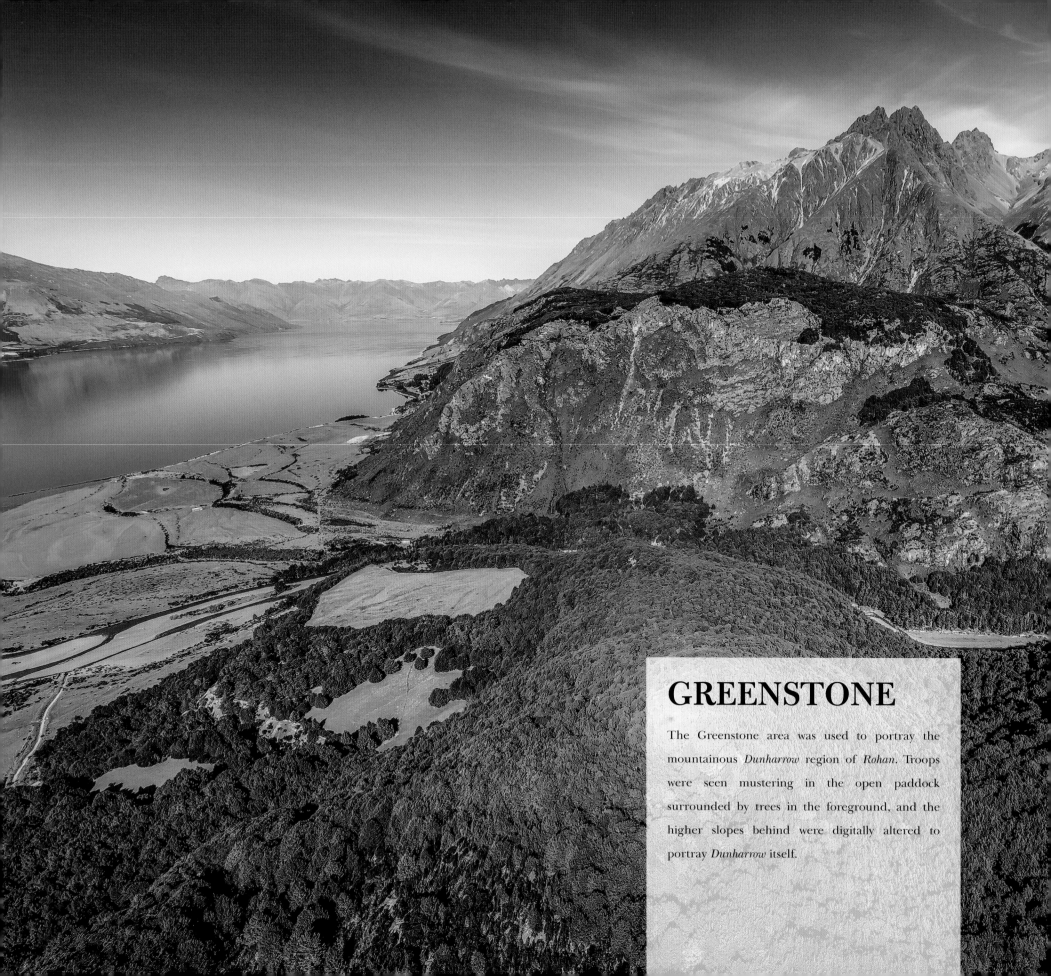

GREENSTONE

The Greenstone area was used to portray the mountainous *Dunharrow* region of *Rohan*. Troops were seen mustering in the open paddock surrounded by trees in the foreground, and the higher slopes behind were digitally altered to portray *Dunharrow* itself.

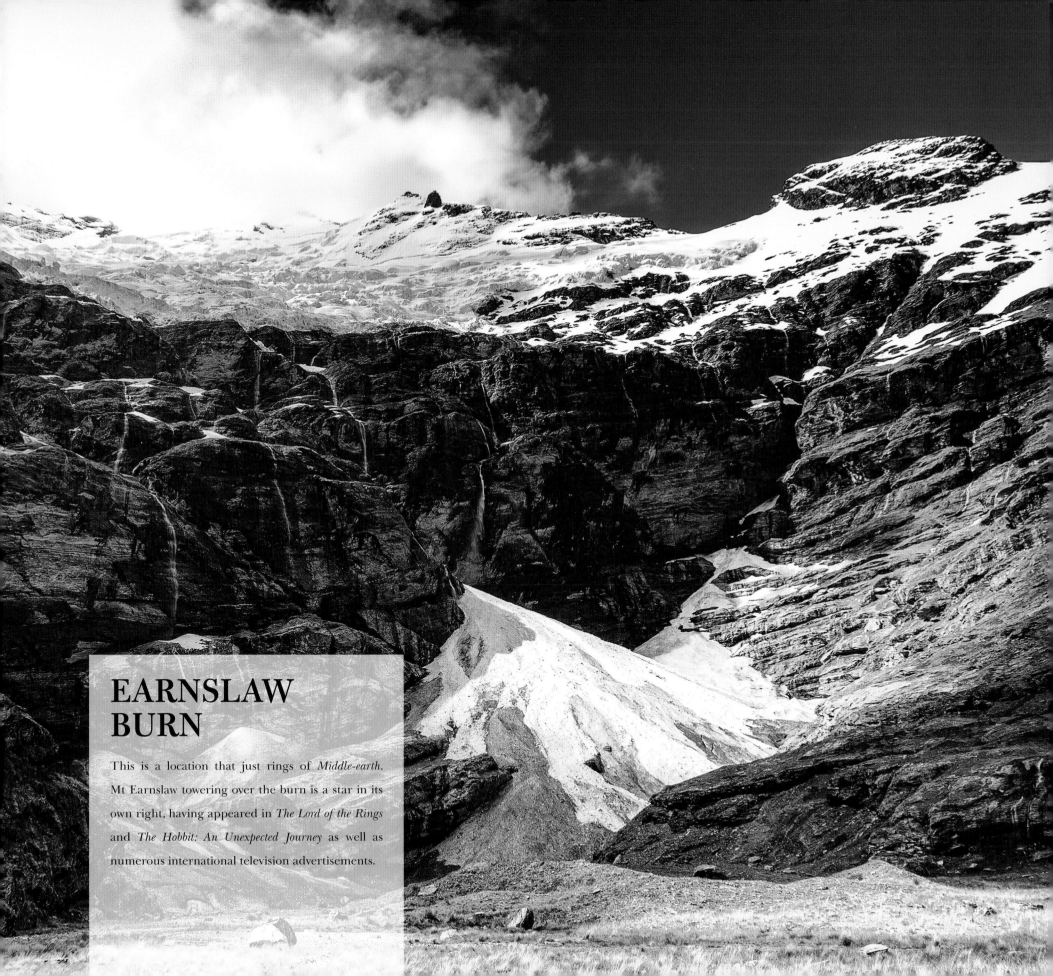

EARNSLAW BURN

This is a location that just rings of *Middle-earth*. Mt Earnslaw towering over the burn is a star in its own right, having appeared in *The Lord of the Rings* and *The Hobbit: An Unexpected Journey* as well as numerous international television advertisements.

NOKOMAI STRING BOG

A dramatic scene in the prologue of *The Hobbit: An Unexpected Journey* has *Thorin* leading the dwarven refugees in narrow file across a desolate landscape interspersed with swampy streams. Called the Nokomai String Bog, it is on private land and accessible only by helicopter, but you can combine a visit to this spot with a farm stay on one of the largest farms in the country.

Nokomai Station is one hour south of Queenstown and has a rich farming and gold-mining history. Staying in one of four comfortable cottages can be a very special time with a number of activities available. These include fly-fishing the world-famous Mataura River, mountain biking, walking and hiking or just lazing in a comfortable chair on the veranda with a good book. You can also visit the Nokomai String Bog with Nokomai Helicopters. A stay on this farm among some of the most spectacular scenery of Southland is a wonderful way to soak in the landscape of *Middle-earth* Aotearoa.

GLENARAY STATION

This rock face on Glenaray Station in Southland became the *High Fells* and featured (along with the Organ Pipes) as the remote mountainous area where *The Nine*, long thought removed from *Middle-earth*, were discovered by *Gandalf* and *Radagast*.

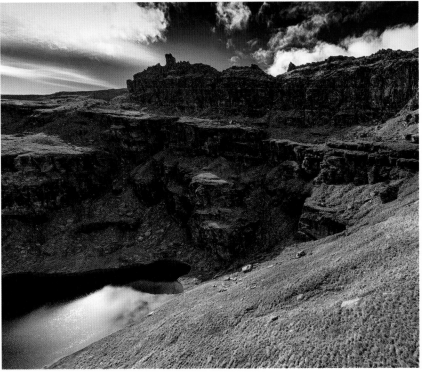

MAVORA LAKES

A visit to the Mavora Lakes guarantees an opportunity to relax. They are situated off the main Five Rivers – Te Anau highway: watch for the signposted road past Mossburn (there is also an access road closer to Te Anau).

From here, 45 minutes on an unpaved road takes you to *Fangorn Forest* and *Nen Hithoel*. After 35 km and just before the turn-off to Mavora Lakes, you'll see a stand of trees — the edge of *Fangorn Forest*. Step quietly and you may catch a glimpse of an *Ent* standing in the trees. During filming, over 160 people worked from the paddock on your right.

Climb the fence on your left and walk 250 metres northwest to where *Éomer* and the *Riders of Rohan* burnt the remains of dead orcs after their epic battle. The locality is just as you would imagine — a brown hillock with the edge of the deep forest just metres away.

MARAROA RIVER

The outlet of the Mararoa River by the swing bridge at South Mavora was used to portray the junction of the *Silverlode* and *Anduin* rivers as the *Fellowship* left *Lothlórien*. Tolkien's *Silverlode* was a fair river flowing from its source in *Nanduhirion* through *Lórien* into the great *River Anduin*. The pristine beauty of the Mararoa River as it leaves the South Mavora certainly brings his description vividly to mind, in a tranquil and profoundly beautiful location. Brown and rainbow trout are plentiful, and rare bush robins reside nearby while New Zealand falcons soar overhead.

If you don't want to camp, tourist operators in Queenstown and Te Anau offer four-wheel-drive day trips and Glacier Southern Lakes Helicopters offers flights over these locations. Nearby Mossburn offers farm-stay accommodation and, along with Te Anau (only 45 minutes by car), can be used as a base.

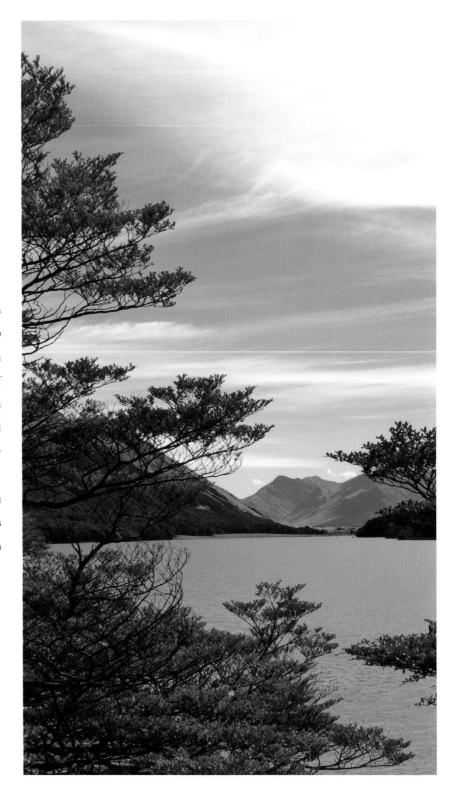

TAKARO ROAD

A wonderful bush location is situated on Takaro Road. Leaving Te Anau on the main Queenstown highway, turn left onto Kakapo Road just a few kilometres from town. Travel down this road for 9 km and turn left onto Takaro Road. After a further 6 km the unsealed road passes through a delightful bushy glade with an unnamed access road on the left.

Park in the little turning area. Filming took place on both sides of the road, with remote cameras strung from high wires to capture *Aragorn* moving through the trees. This lovely forest of red and silver beech seems untouched, while the floor is carpeted with intense-green moss. Beech trees are wind pollinated, producing small 'nuts', which grow in the shade of the parent tree. The half-light of the forest floor stunts the seedlings' growth, until a mature tree falls and light floods in. Once established, the trees can grow up to 30 metres tall and live more than 300 years.

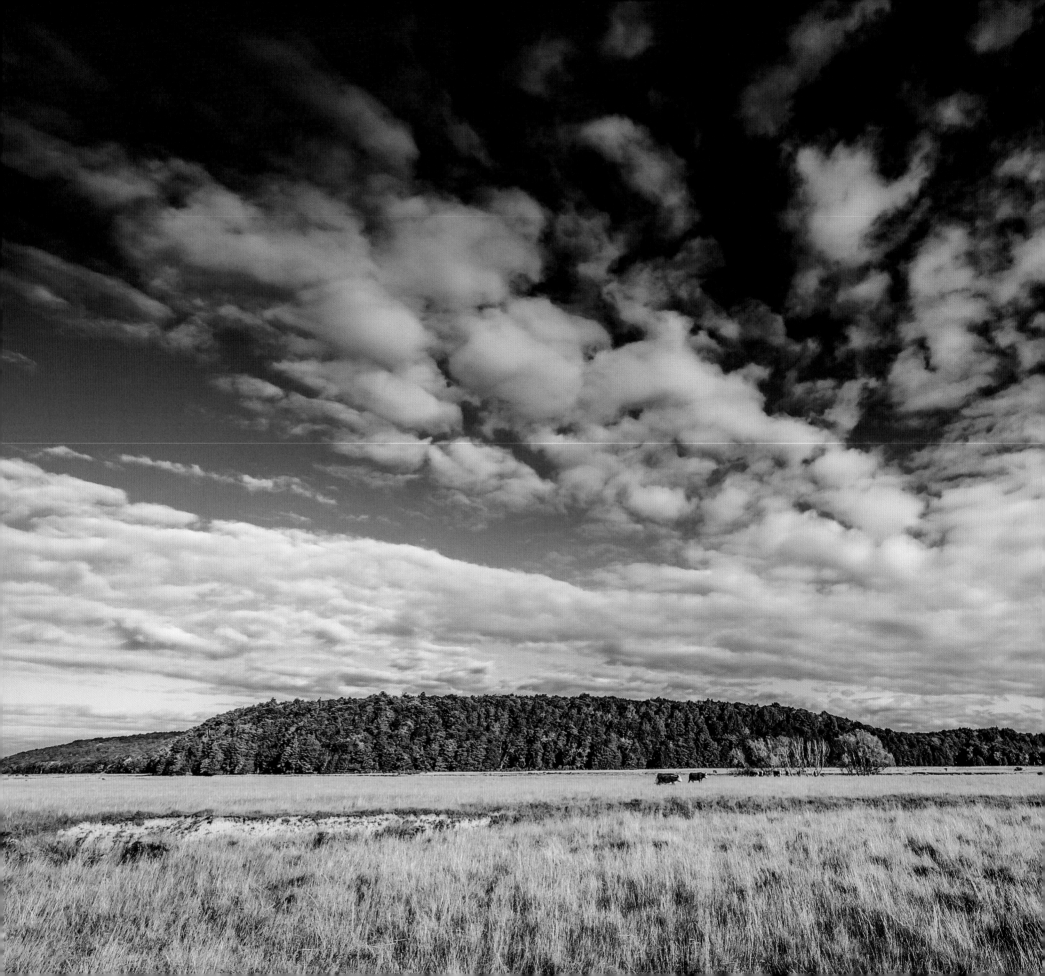

TAKARO LODGE

The landscapes adjacent to Takaro Lodge were used as middle grounds to create a composite shot of *Mirkwood Forest* reaching to the *Long Lake*. The actual location is part of the grounds surrounding the luxury Takaro Lodge Rejuvenation Retreat. Far away from the noise, pollution and stress of everyday life, this exclusive lodge has received many accolades for its accommodation and peacefulness.

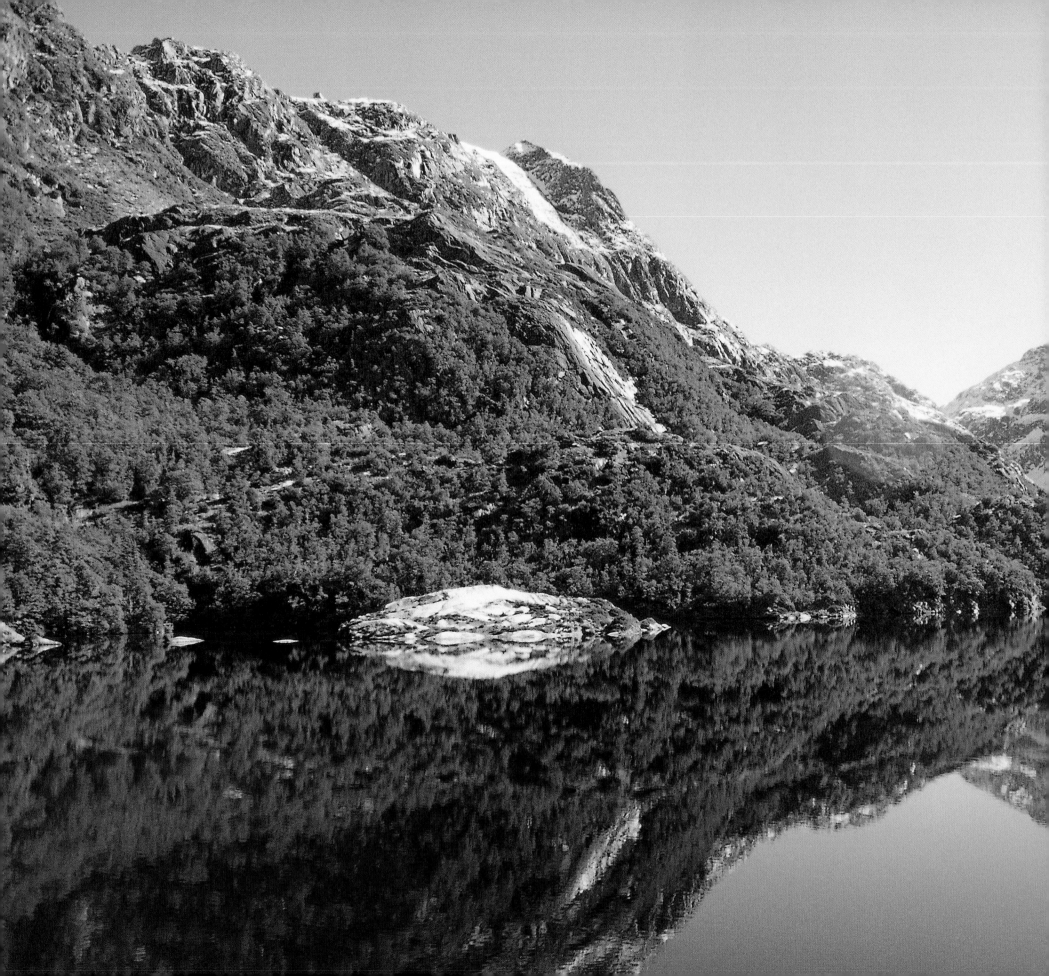

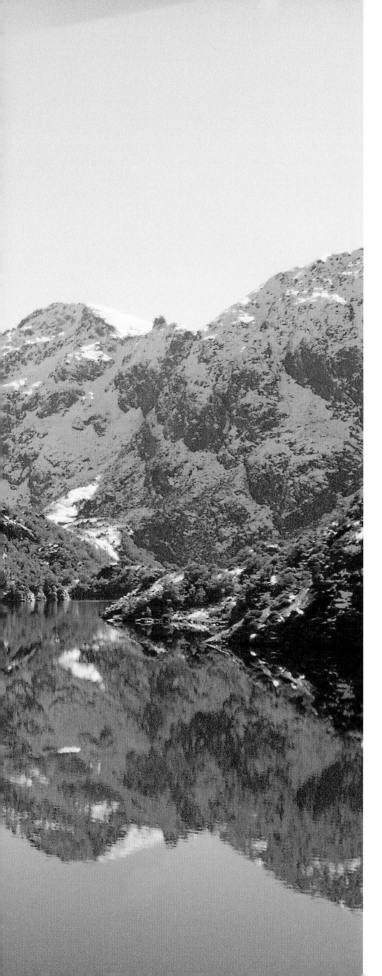

NORWEST LAKES

The helicopter is no stranger here, in the 1960s becoming the 'mount' for commercial deer hunters, who combed the area for venison. Commercial hunting gave way to farming and helicopters provide the perfect transportation to more remote locations.

As the *One Ring* heads south, a wild and rugged land opens in front of the *Fellowship* and, perched high in the Kepler Mountains, the Norwest Lakes are closely reminiscent of *Middle-earth*.

The opening sequence of the *Flight to the Ford*, which showed *Arwen* and *Frodo* in their desperate escape from the *Black Riders*, was also filmed near Te Anau, with the location only accessible on the longer Glacier Southern Lakes Helicopters tour.

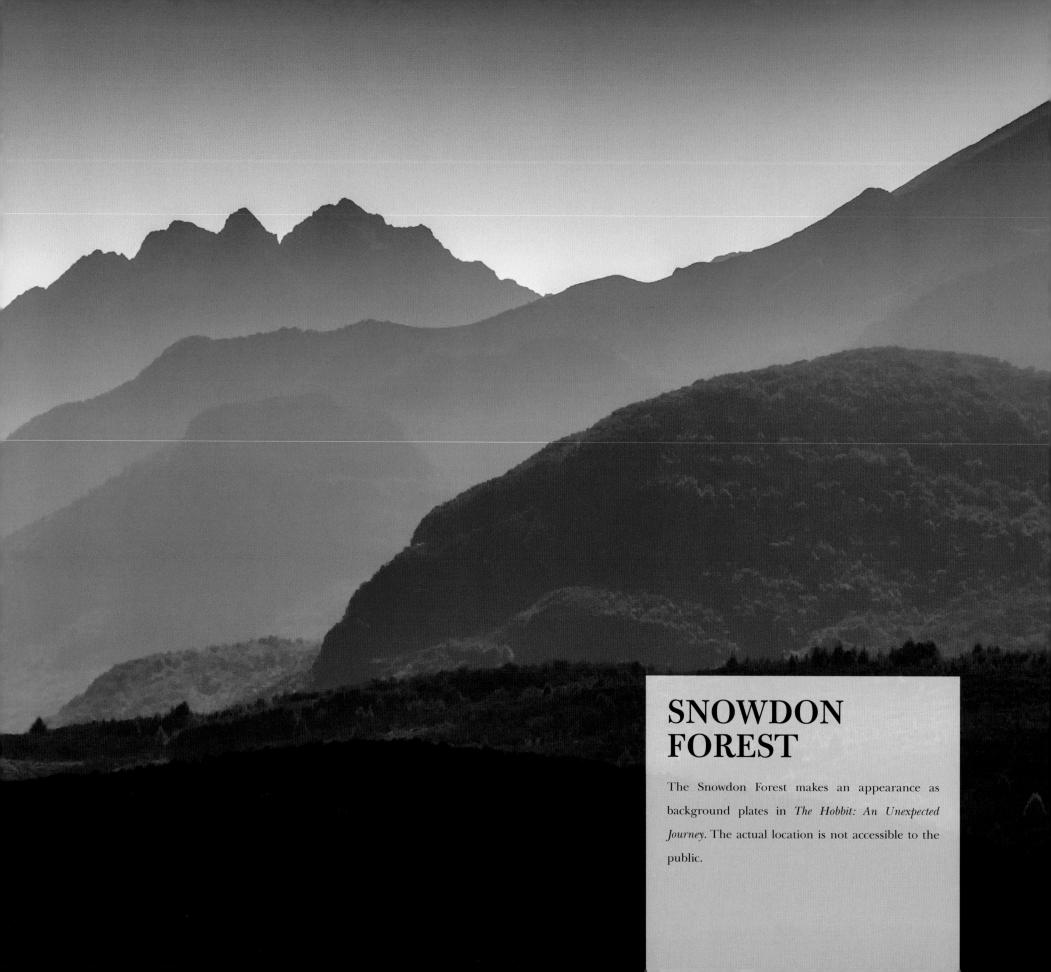

SNOWDON FOREST

The Snowdon Forest makes an appearance as background plates in *The Hobbit: An Unexpected Journey*. The actual location is not accessible to the public.

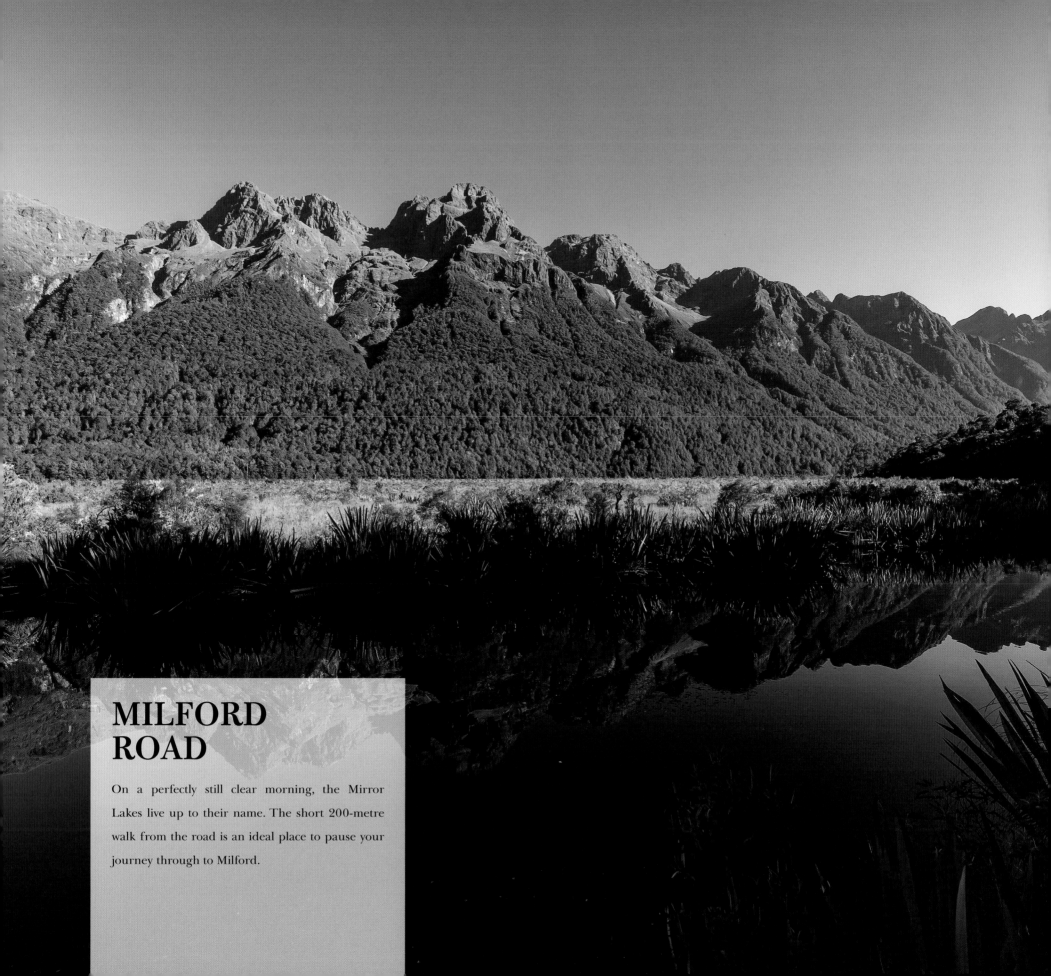

MILFORD
ROAD

On a perfectly still clear morning, the Mirror Lakes live up to their name. The short 200-metre walk from the road is an ideal place to pause your journey through to Milford.

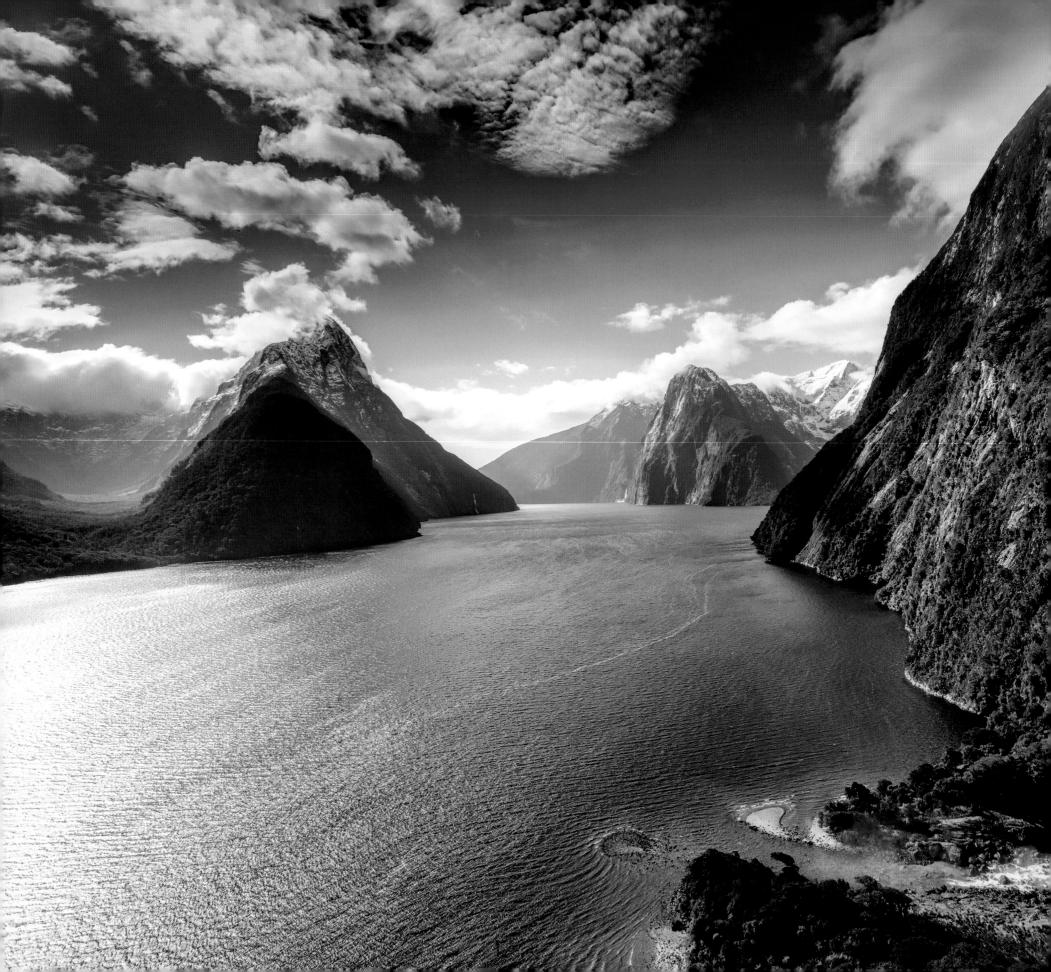

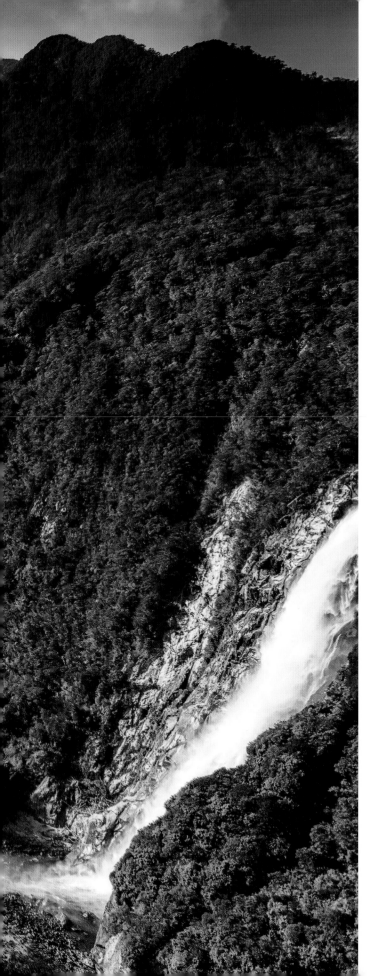

MILFORD SOUND

Arguably New Zealand's best-known tourist destination, Milford Sound is named after Milford Haven in Wales and is a typical fjord, with deep water almost completely enclosed by high cliff walls rising to 1200 metres. Mitre Peak (1692 metres) is one of the most photographed peaks in the country and the area has one of the world's highest rainfalls. Whatever the weather, this is a must-see on any tour of *Middle-earth* Aotearoa.

The road from Te Anau to Milford is a photographic journey, with breathtaking scenery. From the rolling hill country of Te Anau Downs Station, the road enters the Eglinton Valley where bush grows far up the mountains before yielding to precipitous rock faces, alpine tussock and snow. A fog often runs along the ranges, and this region was used to portray the *Misty Mountains* in *The Fellowship of the Ring*.

Pause at the Mirror Lakes and take a short walk — on a still day the Earl Mountains are reflected perfectly in the deep-blue water.

As the road climbs higher the Homer Tunnel appears, a very small dark hole in the cliff face. A car park at the Te Anau end is a great stopping place. Work began on the 1270-metre tunnel in 1935 and after various delays the tunnel was opened in 1954. The Homer Tunnel (1:10 gradient) runs through unlined granite to Cleddau Valley. Then it's a twisting downhill rush to sea level and Milford Sound. Keep a watch for the signposted walk to The Chasm, an essential stop. As you start this short bush walk, the awesome sound of roaring water surrounds you. Over thousands of years the river has carved its way through granite, creating a series of waterfalls, half hidden in stone, forcing the water through a narrow abyss. On a rainy day the sheer power is unbelievable.

At Milford Sound a boat trip to the sea entrance is highly recommended, giving a closer view of Mitre Peak, waterfalls and the Milford Road.

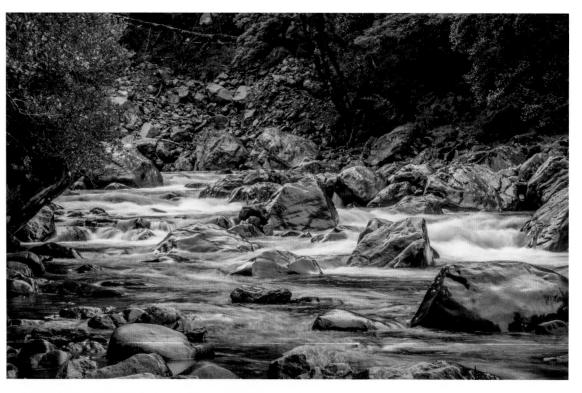

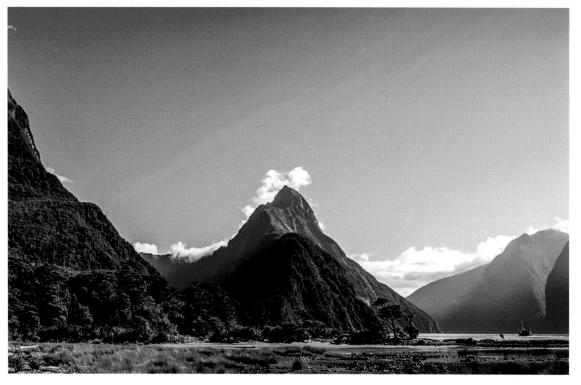

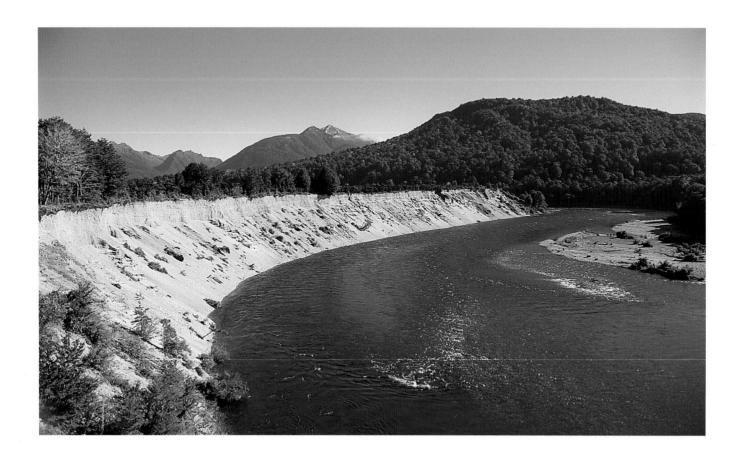

WAIAU RIVER AND KEPLER TRACK

Flowing from Lake Te Anau to Lake Manapouri, the Waiau River portrayed parts of the majestic *River Anduin*, and the first part of the *Fellowship*'s river journey to the *Brown Lands*, the desolate area between *Mirkwood* and the *Emyn Muil*, where long ago the *Entwives* made their gardens.

Sections of the river are accessible from the main Te Anau – Manapouri road and the entire waterway can be viewed on the longer of the Glacier Southern Lakes Helicopters tour options from Queenstown. Luxmore Jet also operates boat tours along the river.

A more energetic option, requiring a reasonable level of fitness, is the 67 km Kepler Track, from Te Anau. The full tramp takes three to four days and includes lake edges, beech forests, mountain-tops and a U-shaped glacial valley. If you have less time, take the main Te Anau – Manapouri highway, turning right at the DOC Rainbow Reach sign. As the unsealed road first veers left (and before it veers right again), turn right down the unmarked track to a magnificent view of the *River Anduin*. A further 2 km down the access road a swing bridge crosses the river to a shorter walk on the Kepler Track. Even a brief stroll takes you into native beech forest, with beautiful river views. The local DOC office in Te Anau has more information on the Kepler Track.

LAKE MANAPOURI AND DOUBTFUL SOUND

Situated 12 km from Te Anau, the island-studded Lake Manapouri (Lake of the Sorrowing Heart) is an area of unspoilt beauty amid the bush-covered Kepler Mountains.

While filming here, unpredictable weather delivered an unseasonable November snowfall — when it was over 20 centimetres deep, the cast and crew decided to move to the local hall.

One of the best ways to explore here is the full-day Doubtful Sound excursion with Fiordland Travel. After a cruise across the lake, the journey continues by bus over the Wilmot Pass (671 metres) and ends with a three-hour boat cruise to the sea. Doubtful Sound is home to a pod of about 60 bottlenose dolphins, and New Zealand fur seals can be seen basking on the rocks at the Nee Islets. Scattered around the sound is the rare and very shy Fiordland crested penguin.

The landscape has been sculpted over millions of years, and is cloaked in dense cool temperate rainforest, the 'sound of silence' one of its many charms. On the journey across Lake Manapouri, look up to the high mountain-tops on your right, by Freeman Burn. High in these alpine peaks are the Norwest Lakes — where the *Fellowship* headed south from *Rivendell*.

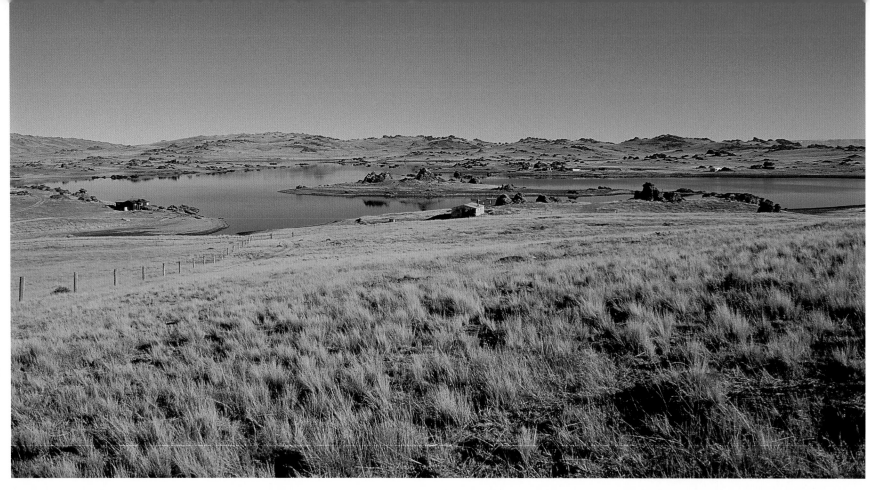

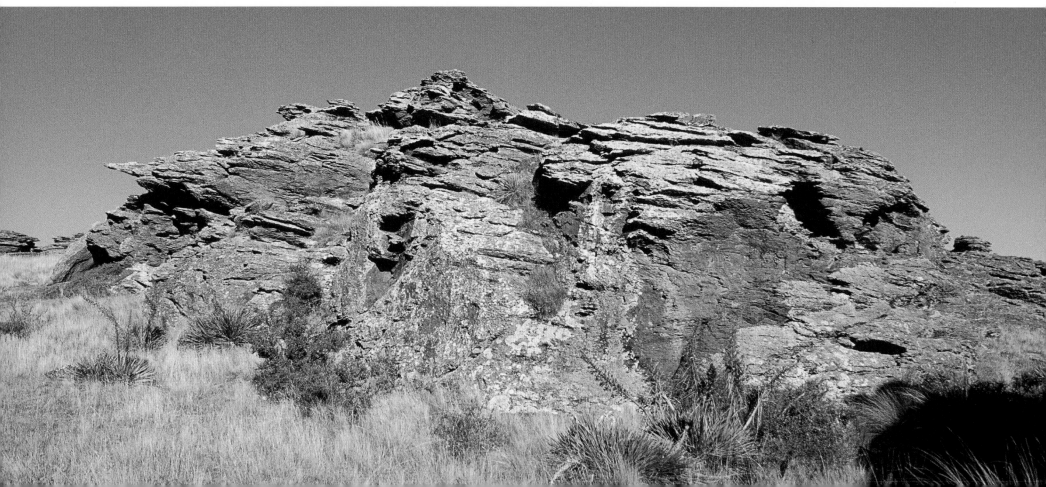

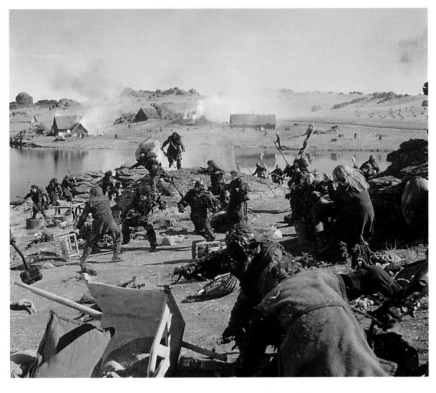

POOLBURN

The Poolburn Reservoir dam was completed in 1931, as a storage lake to irrigate the Ida Valley below. The land is rich and during the height of the gold rush, five hotels dispensed liquid warmth to miners toiling in the harsh environment. Today it's a popular recreational area, the reservoir richly stocked with brown trout.

On reaching the lake, there is an excellent view across to the location of the small village where *Morwen* sent her children to safety. No trace of the *Rohirrim* village remains but the area is immediately recognisable. A number of other sites were used in this locality to show the hobbits being rushed to *Saruman* and the epic chase by *Aragorn*, *Gimli* and *Legolas*.

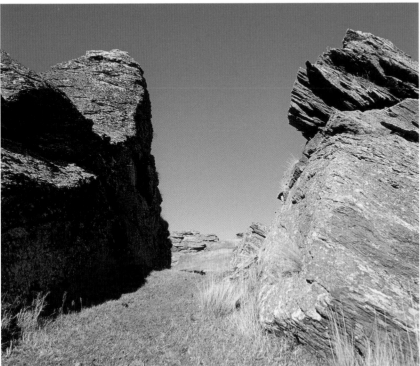

IDA VALLEY

The Poolburn Reservoir, high on the Rough Ridge Range in the Ida Valley, was the perfect choice for *Rohan* — rolling hills with distinctive rocky tors and expansive vistas suggest the *Riddermark*. The rough road from the valley floor is recommended for four-wheel-drive vehicles — the area is very exposed and the weather changes quickly.

Situated 40 minutes from Alexandra is Omakau, where the racecourse was used as the production office. Take a right turn into Ophir, where gold was discovered in 1863, before the road climbs across the Raggedy Range, with wonderful views from the summit. Descend to the valley floor, turn right at the Poolburn Hotel onto Moa Creek Road and continue to Webster Lane, then turn left into the unpaved road. The climb to Poolburn itself starts beside Bonspiel Station, where the landowners organise four-wheel-drive tours. With many of the locations on their property, they are ideal hosts to take you to *Rohan*, and offer accommodation in original Chinese miners' huts.

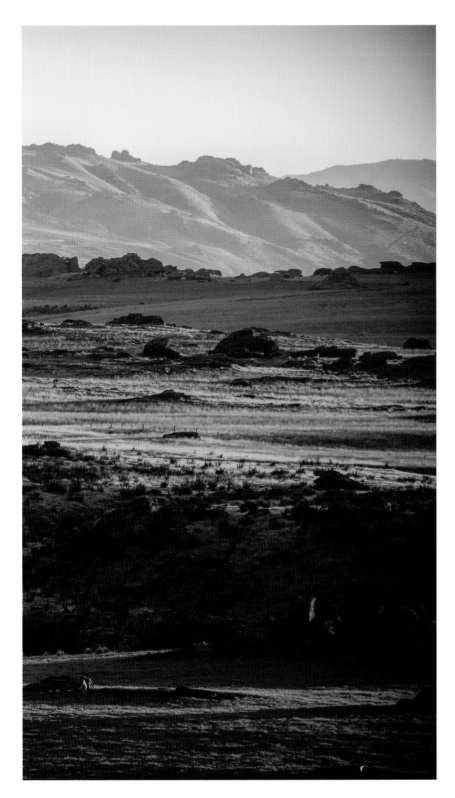

MIDDLEMARCH

Middlemarch is reached by road or train and my suggestion is the return trip on the Taieri Gorge Railway from Dunedin, a fantastic introduction to Middlemarch and the Strath Taieri, although the drive to Middlemarch is equally inspiring. A great place to stop for coffee is the charming village of Outram. As the road leaves the plains, it climbs over a number of rolling hills until you enter the Strath Taieri.

Middlemarch lies in an ancient glacial valley overlooked by the Rock and Pillar Range, a land of sparse population, rocky tors, seasonal magnificence and amazing light. The town is a terminus for the Central Otago Rail Trail, which follows the railway line built over 160 years ago. The trail left when the railway closed in 1990 is a fantastic way to explore. While the location where the *Company* are attacked by orcs en route to *Rivendell* is on private land and inaccessible, a number of public places evoke this scene. Schist rock outcrops dominate the tussock hills, and a walk to Sutton Salt Lake is recommended. Nestled among eroded tors, the only saline lake in New Zealand is filled by rainwater and may be dry in summer, with a salty brine edge. The walk takes an hour but allow half a day. The opportunity to re-create the scene is irresistible, though prepare for intense heat in summer and biting frost in winter.

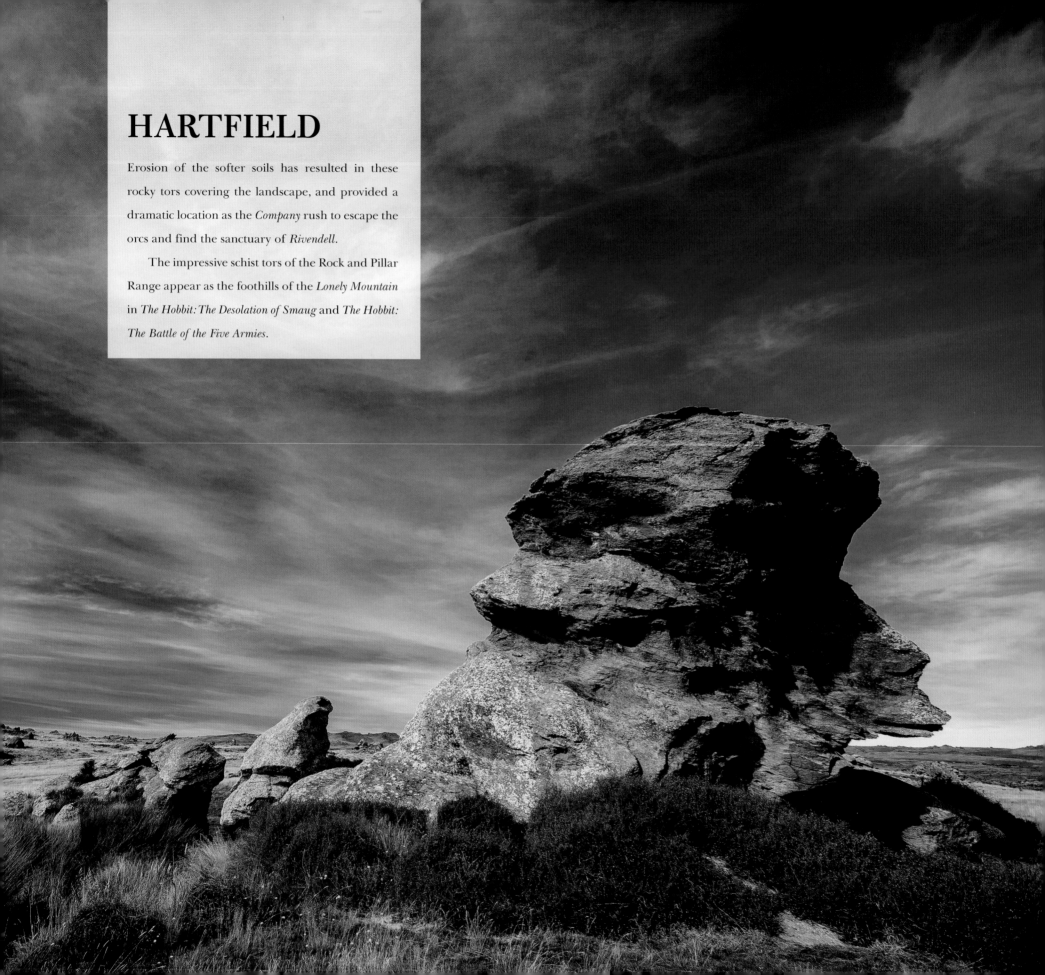

HARTFIELD

Erosion of the softer soils has resulted in these rocky tors covering the landscape, and provided a dramatic location as the *Company* rush to escape the orcs and find the sanctuary of *Rivendell*.

The impressive schist tors of the Rock and Pillar Range appear as the foothills of the *Lonely Mountain* in *The Hobbit: The Desolation of Smaug* and *The Hobbit: The Battle of the Five Armies*.

ST BATHANS

If you continue past Hyde towards Alexandra, detour to St Bathans, which arose in the 1860s as gold was excavated, with more than 2000 miners and 13 hotels. The gold and the miners have long gone, and nowadays the population of 10 enjoys a quiet life among the Hawkdun Range, the Blue Lake ... and the ghost in the Vulcan Hotel.

The sun-dried mud-brick hotel makes a pleasant stop for a coffee on a sunny day. The adjacent Blue Lake began as a small hill. As miners searched for the mother lode, the hill became a pit, then a deep depression. After they left, water slowly filled the shafts and created a stunning blue lake, its colour produced by minerals in the surrounding cliffs.

Autumn is a magical time — while the gold in the hills may have long gone, it remains in every poplar and birch tree.

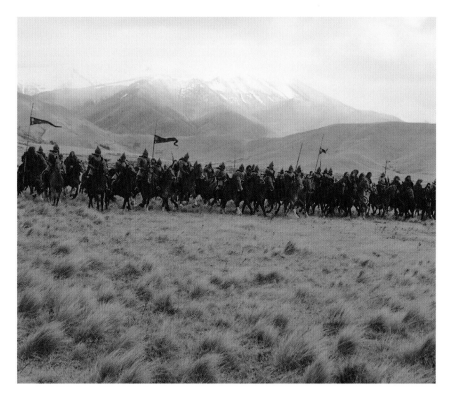

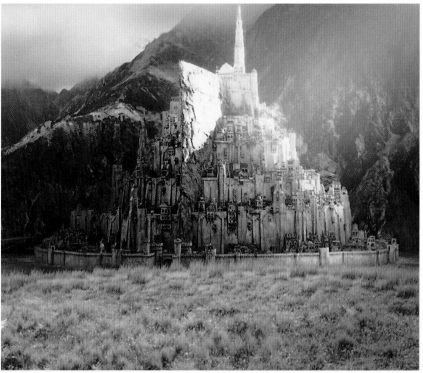

TWIZEL

Named after Twizel Bridge in Northumberland, the town was built to house the thousands of workers in the 1970s who constructed the Upper Waitaki Power Scheme. Most have since gone but the town is now a popular holiday destination, with Lake Ohau and its associated ski field nearby. Also close is the man-made Lake Ruataniwha, with both rainbow and brown trout. Snuggled under the foothills of the Southern Alps, the vicinity is one of extreme weather conditions as snow cloaks the area in winter while hot nor'westers in the summer can bring temperatures of over 30°C. There is a wide variety of accommodation and restaurants available, including a camping ground and farm home-stays.

The largest battle scene filmed in the *Lord of the Rings* trilogy was the *Battle of the Pelennor Fields*. The area around Twizel provided the perfect ingredients: the *Ered Nimrais*, grassy fields, a remote location with no signs of habitation and a town nearby to provide necessary infrastructure.

Most of the town was employed on the film and for over a month it was an amusing scene in the local bars every night as the combatants (still with make-up on their faces) discussed the day over a beer.

Tours are available to the *Pelennor Fields* from Twizel and can be booked from the local Visitor Information Centre. As the location is on private land, this is the only means of access. The tour is more than just a visit to some hills, however — your guide will probably be a *Rohirrim* or *Gondorian Rider* or a vicious orc. As well as explaining the intricacies of filming over 200 horses in majestic battle scenes, your guide will also give you an insight into high-country farming and the difficulties of working in such a harsh environment. The tour is highly recommended.

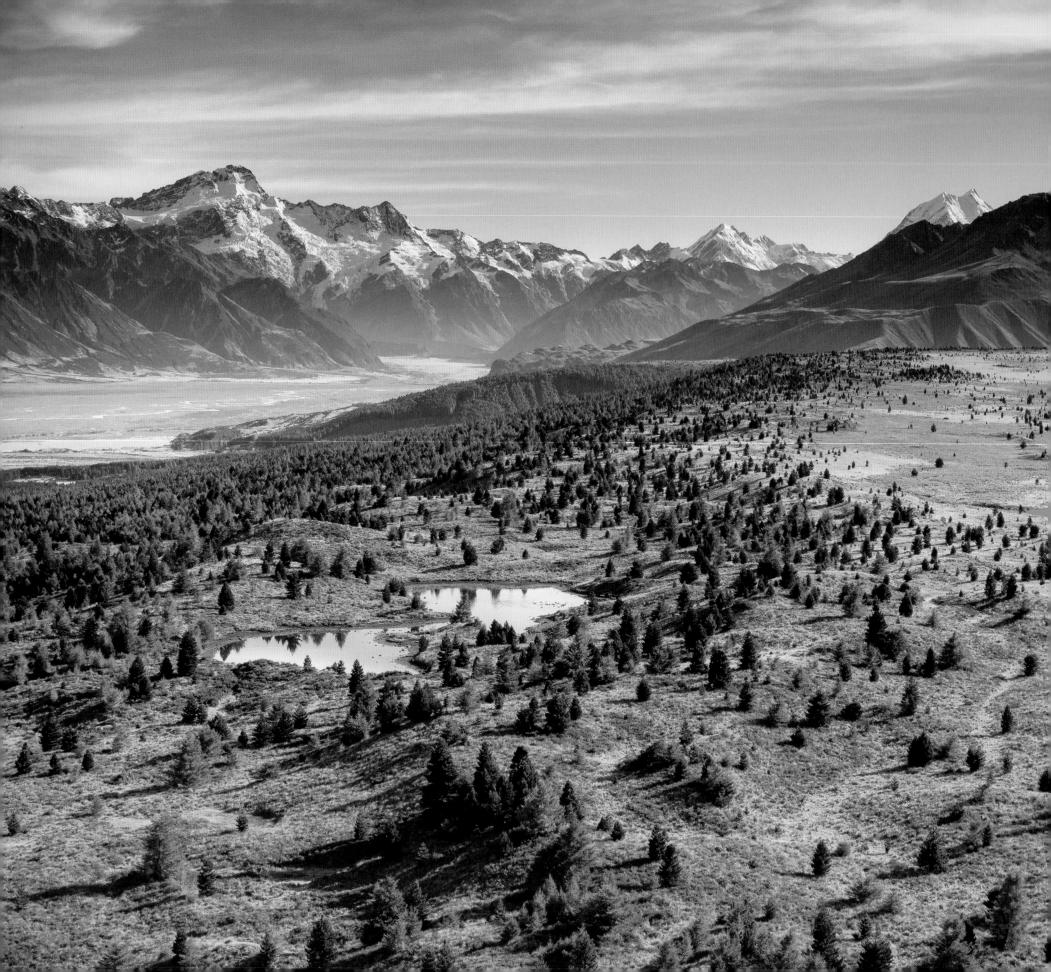

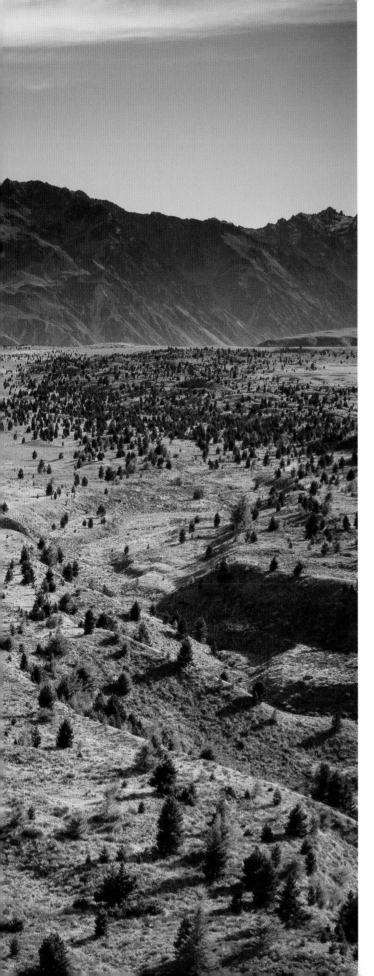

LAKE PUKAKI

When you first see Lake Pukaki, it's as if somebody dropped a colour bomb. Formed when receding glaciers blocked the valley, its distinctive colour is created by glacial flour — finely ground rock ejected by the Tasman Glacier.

The rolling hills on the lake's eastern side were used for the epic chase by orcs and wargs as the *Company* searched for the entrance to *Rivendell*, with a view towards the Southern Alps and Aoraki/Mt Cook standing in for the *Misty Mountains*. The shores of Lake Pukaki can be seen in *The Hobbit: The Battle of the Five Armies* as the refugee camp on the shores of *Lake-town*.

Heliworks, based at Mount Cook Airport, was involved with filming and provides a stunning flight across Lake Pukaki. After lift-off and views of Aoraki/Mt Cook and the Tasman Glacier, you travel across the head of the lake towards the location. Skimming over the tussock you'll also see the location for the aerial scene as the *Company* escape the *Misty Mountains* after defeating the *Goblin King*.

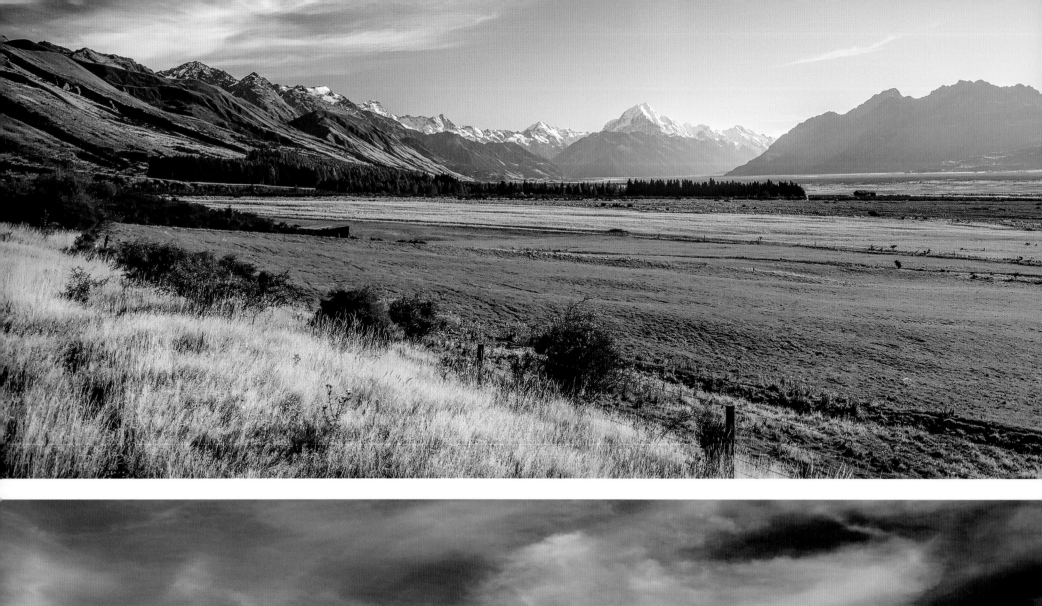
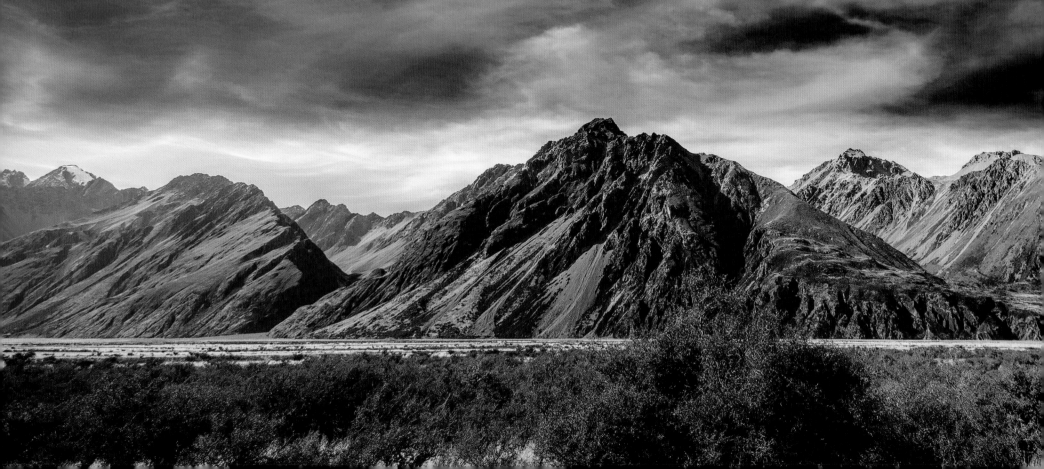

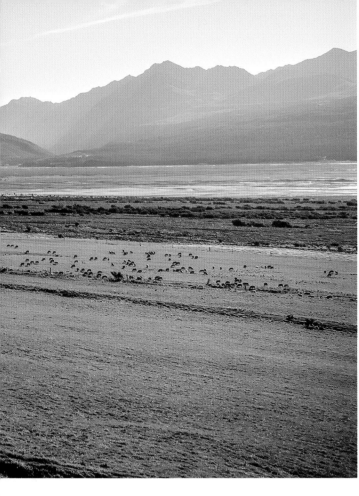

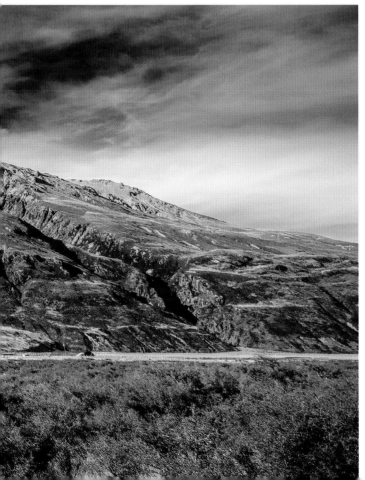

AORAKI/MT COOK

When travelling through the Mackenzie Basin, drive up to the alpine village of The Hermitage, nestled under the Southern Alps in Aoraki/Mount Cook National Park. Aoraki/Mt Cook, New Zealand's highest mountain, was first climbed on Christmas Day, 1894; it was also a training ground for famous New Zealand mountaineer Sir Edmund Hillary, conqueror of Mt Everest.

From The Hermitage, alpine walks have wonderful views of the mountains and glaciers, and it's also the departure point for scenic flights to nearby movie locations.

If time is limited, one of the best walks is through the Hooker Flats (four hours return) on a well-formed track to Sefton Stream with a view of the terminal moraine of the Hooker Glacier.

Staying at The Hermitage is a treat — magnificent lodgings surrounded by the *Misty Mountains*. Nearby Glentanner Park also has accommodation, or you can return to Twizel.

INDEX